# SOUVENIRS OF THE FUR TRADE

Northwest Coast Indian Art and Artifacts
Collected by American Mariners
1788–1844

Peabody Museum Press

# SOUVENIRS OF THE FUR TRADE

### Northwest Coast Indian Art and Artifacts
### Collected by American Mariners
### 1788–1844

## Mary Malloy

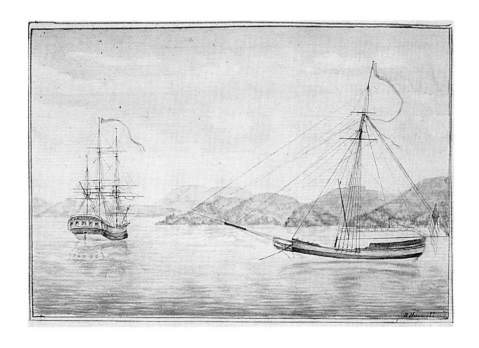

Peabody Museum of Archaeology and Ethnology
Harvard University
Cambridge, Massachusetts
2000

*Production Credits*

Cover and text design: Jean LeGwin, LeGwin Associates
Copyediting: Donna M. Dickerson
Composition: Donna M. Dickerson and Jean LeGwin, LeGwin Associates
Proofreading: Janice Herndon and Patricia Onorato
Indexing: Mary Malloy
Production management: Donna M. Dickerson
Art scanning: DS Graphics, Lowell, Massachusetts
Printing and binding: DS Graphics, Lowell, Massachusetts

*For Stuart*

*For Stuart*

# CONTENTS

# ACKNOWLEDGMENTS

I would never have written this book if I did not feel that artifacts have a power to inspire and inform us, to transport us across continents and across centuries, and to allow us to understand lives other than our own. My first thanks, then, must go to the Northwest Coast Indian people who made the things that are the subject of this book. From humble fishhooks and utilitarian paddles to articles of clothing and artistic masterpieces, these things have filled me with awe and wonder for twenty years. To the American mariners who shared my fascination with the material culture of the Northwest Coast and bartered for examples, I also acknowledge a debt of thanks.

At the institutions that hold the collections today I received an enormous amount of help. I am especially grateful to three women who meticulously cross-checked the information in their institutional catalogues with my list of artifacts: Viva Fisher at the Peabody Museum at Harvard, Anne Bentley at the Massachusetts Historical Society, and Suzanne Flynt at the Pocumtuck Valley Historical Association. I also appreciate the help I received from Rubie Watson, Donna Dickerson, Tim Cullen, Susan Haskell, and Anne Marie Victor-Howe at the Peabody Museum at Harvard, from John Grimes and Susan Bean at the Peabody Essex Museum, from Ellie Bailey at the Historical Society of Old Newburyport, from Kellen Haak at the Dartmouth College Museum, and from Audrey Meyer and Amy Johnson at the Sea Education Association.

This project began when I was a graduate student, first at Boston College and then at Brown University. I am indebted to Jeanne Guillemine at Boston College and to Patrick Malone and Shepard Krech III at Brown, who were all inspirational mentors. Bill Holm and Robin Wright graciously reviewed the manuscript and made helpful suggestions.

As with every project I have worked on in the last decade, my husband, Stuart Frank, made it a lot more fun and interesting by being a knowledgeable and supportive partner, and for that I thank him.

Mary Malloy
Foxborough, Massachusetts
4 September 1999

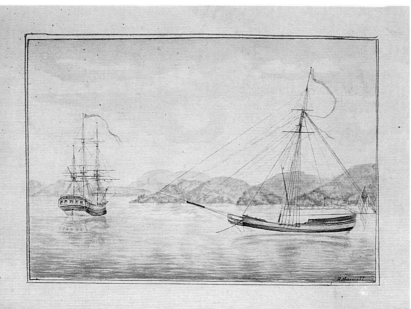

A VOYAGE

ROUND THE WORLD

ONBOARD THE SHIP

COLUMBIA-REDIVIVA

and Sloop

WASHINGTON.

Title page from Robert Haswell's journal, circa 1788.
Courtesy of the Massachusetts Historical Society.

# "THE MASK IN THE SEA CHEST"

Around the year 1820, a Haida master carver created a series of masks, of which a dozen or so have survived into the present. Haida people wore masks like these for ceremonial and ritual purposes. Using the masks to assume identities, dancers told the stories of the people. Sometimes these were chronicles of historical events or mythic tales. Sometimes they fulfilled a cosmological function, celebrating or cementing bonds with the natural or spiritual world, marking important passages in the lives of individuals, or preparing members of the community to face upcoming tasks or challenges. The stories told in this way were instantly recognizable to the participating audience. Through the dances their collective history was preserved and transmitted; the masks were documents of their culture.

At the time these masks were made, a trade in sea otter pelts flourished between Haida people and American sailors, and several of the masks changed hands. The new owners were young men on a great adventure. For them the masks represented *their* experience. They preferred masks that showed a woman wearing a prominent lip-distending labret, as that was a cultural feature they found particularly exotic and wished to illustrate to their own people back home. They also purchased other cultural artifacts offered to them by their trading partners, and assembled a collection on shipboard, which served as a three-dimensional documentation of the encounter between the shipboard community and the people of the Northwest Coast.

In New England, sailors found that the masks and other souvenirs they collected during the course of their voyage were of interest not just to their families and friends, but to the local intellectual community. Growing "learned societies" acquired such collections to illustrate the natural world and the exotic people who inhabited it. In museum "cabinets of curiosities," Northwest Coast Indian masks were displayed alongside masks from other

parts of the world. Comparisons and judgments could then be made about where each group fit into a growing informational map of the globe. While nominally scientific in nature, this information also documented the expansion of American trade and influence into all the world's oceans.

As sea otters declined in the waters surrounding the Queen Charlotte Islands and the adjacent mainland coast, the trade in pelts declined. Mounting pressure from church and state and movement of people from traditional villages to towns and cities forced the decline of native ceremonials. Interest in the masks waned for several decades until anthropologists arrived on the Northwest Coast in the last quarter of the nineteenth century. They also sought masks and cultural artifacts, the older the better. They desired clear provenance of use in winter ceremonials and were less interested in items made as souvenirs for trade. Unlike the American mariners, who saw the artifacts as a part of *their* experience and documents of *their* adventures, anthropologists purposefully attempted to remove themselves from the cultural context in which ethnological artifacts were acquired and to see the artifacts as representations only of the native people who manufactured and used them.

Simultaneously, in New England the masks collected by (and possibly made for) American mariners had moved from the cabinets of curiosities, which had defined the institutions of the late eighteenth century, into museums of natural history and ethnology, which were flourishing in the late nineteenth century. Sometimes this move was made physically from one institution to another, but in at least one case, the organization reformed and modernized itself—when the East India Marine Society became the Peabody Academy of Science.

As the nineteenth century waned, an ever-increasing store of artifacts from the Northwest Coast arrived at museums in Chicago, New York, Boston, and Washington. They formed a nucleus around which the discipline of anthropology developed and was formalized. As the masks collected in the maritime trade were incorporated into these larger collections, they were no longer exhibited as souvenirs of voyages or representations of American expansion, but as anthropological artifacts. Rather than being compared to masks from other cultures, they were now contextualized with related Haida cultural material.

The circumstances under which artifacts were acquired were no longer as important as the circumstances under which they had been created and used by the native people of the Northwest Coast. Consequently, the influence that intensive trade with Americans had had on these and other artifacts more than a hundred years earlier was not often acknowledged in

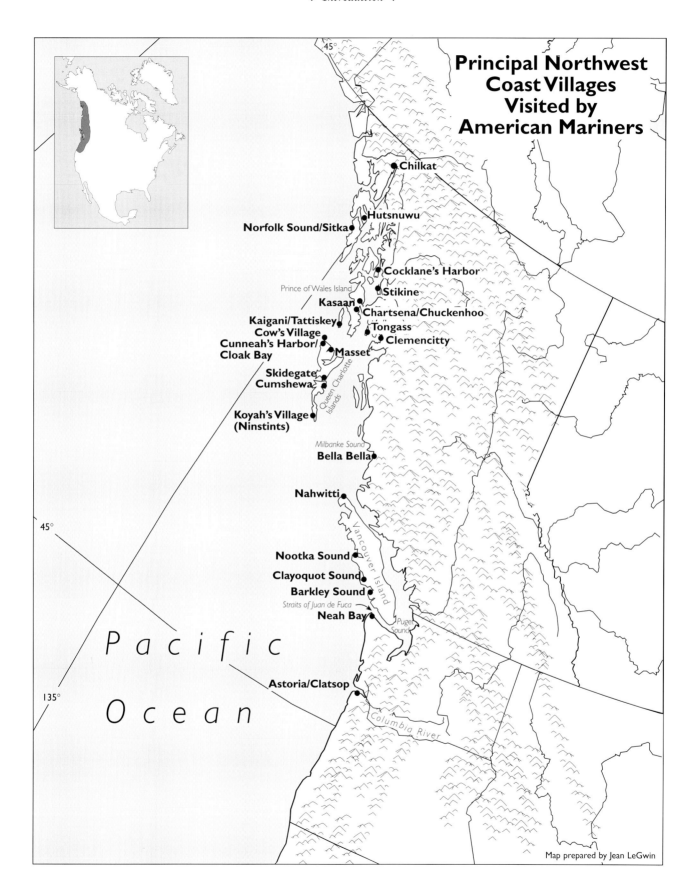

**Principal Northwest
Coast Villages
Visited by
American Mariners**

45°

●Chilkat

●Hutsnuwu

Norfolk Sound/Sitka●

●Cocklane's Harbor

Prince of Wales Island

●Stikine

Kasaan●

●Chartsena/Chuckenhoo

Kaigani/Tattiskey●

●Tongass

Cow's Village●

●Clemencitty

Cunneah's Harbor/
Cloak Bay●

Masset●

Skidegate●
Cumshewa●

Queen Charlotte Islands

Koyah's Village●
(Ninstints)

Milbanke Sound

Bella Bella●

Nahwitti●

Vancouver Island

Nootka Sound●

Clayoquot Sound●

Barkley Sound●

Straits of Juan de Fuca →

Neah Bay●

Puget Sound

Astoria/Clatsop●

Columbia River

*Pacific*

*Ocean*

45°

135°

Map prepared by Jean LeGwin

anthropological exhibitions. (Even as late as 1993, a publication of the Smithsonian Institution identified iron blades—of a sort forged on shipboard and traded by the thousands from American ships to villages on the Northwest Coast—as "made of metal taken from shipwrecks," thus effectively removing from the equation the presence of American traders.[1])

In the second half of the twentieth century, the masks, which had now been in museum collections for a century and a half, were scrutinized by young carvers from the Northwest Coast as the tradition of making them was revived and began to flourish again among both native and non-native artists. Acknowledged for the first time as artistic masterpieces, Northwest Coast Indian artifacts began to command high prices in the marketplace. In the last decades of the twentieth century, the objects collected first by sailors and later by anthropologists began to be exhibited in museums as works of art. Without any contextualizing information whatsoever, a mask might be mounted in a case for viewers to experience and appreciate simply for the power of its artistry.

Even as the artistic genius of their culture began to be recognized for the first time, Northwest Coast Indian people demanded a say in the determination of their political future in both the U.S.A. and Canada. Among other issues raised was the disposition of the cultural artifacts that had been collected by outsiders over a period of almost two hundred years. Some had clearly been part of a free exchange of commodities, but others raised serious questions. Among the artifacts were human remains, grave goods, and deeply significant and powerful religious objects. Who could legitimately claim ownership of cultural property, and who had the right to make such a determination?

The masks have now existed over the span of many human lives, passing from hand to hand and being reinterpreted in each stage of the process. They are powerful works of art, but what else are they? They are certainly vivid representations of Haida culture. They are also a medium of exchange in trade and souvenirs of an exotic encounter. A number of questions are raised. Did the carver, in fact, make these masks not for ceremonial use but to barter to Yankee sailors as souvenirs? The artist who created these masks had a very high degree of artistic talent and skill—he must have made other masks for ceremonial use within his own community. Does it make a difference if *these* masks were made for a different purpose? On at least one occasion, a mask collected on one part of the Northwest Coast was traded back into native hands by an American sea captain, transferring it from one tribal setting to another. If it were collected again, as it almost certainly was, would the collector recognize its origin?

It is unlikely that any American sailor thought about whether the masks were made as souvenirs or for native use—most of them never even went ashore. They seldom saw ceremonial events and so had little idea of the masks being intended for anything other than portraiture; the two earliest surviving masks collected by American mariners were described at the time as being actual representations of a specific woman or women. Is the predominance of portrait masks of labret-wearing women a result of the carver's desire to meet what he perceived to be a Yankee interest or Yankee preference? Certainly American sailors were intensely interested in and confounded by labrets—a fact that they repeated over and over in their shipboard diaries and apparently made abundantly clear to their trading partners in the Queen Charlotte Islands.

Of all the roles these masks have played, the one least explored is the one they played in the act of exchange. The objective of this work is to provide a catalogue of Northwest Coast Indian artifacts and works of art collected by American sailors between 1788 and 1844, and to contextualize them as documents of the mercantile relationship between the two groups.

Two points are worth making here. The choice of artifacts to be traded to American mariners in this period was made almost entirely by Northwest Coast Indian people; and the production of cultural artifacts made specifically for the souvenir trade had become an important adjunct to the sea otter pelt trade by 1815.

These souvenirs comprise the earliest Northwest Coast Indian artifacts accessioned by American museums, and a number of the individual objects are the earliest documented examples of their types. They have been examined and exhibited over the years, but almost always to illustrate native daily life, rituals, or technological processes on the Northwest Coast. The circumstances of collecting were generally acknowledged only to provide a date of manufacture for comparison to other similar pieces. When scholars and curators *were* interested in establishing a provenance back to the point of collection for these early artifacts, they often found the records more confusing than illuminating. American shipboard documents from the maritime fur trade are scattered and incomplete, and the accessions records of the various institutions, some of which go back over two hundred years, show a bewildering lack of consistency, especially when objects were transferred from one institution to another as they frequently were. Consequently, the history of collecting on the Northwest Coast has mostly been described without including any specific details on the acquisition of these early souvenirs.

The first mariner collections to receive serious scholarly attention were those assembled by British naval officers in the late eighteenth century. Each of these voyages was documented by multiple contemporaneous publications, and the anthropologists who did the work on them had a solid base on which to build their research. The first such work to appear was Erna Gunther's 1972 book *Indian Life on the Northwest Coast of North America, as Seen by the Early Explorers and Fur Traders during the Last Decades of the Eighteenth Century*, in which she provided the first cross-institutional catalogue of "Eighteenth-Century Objects in European Museums." Gunther also discussed the American maritime fur trade and used seven shipboard logbooks to provide background and context, though she did not then attach that information to artifacts collected by Americans. Adrienne Kaeppler prepared material for an exhibit and catalogue of artifacts collected on the Pacific voyages of Captain James Cook, which appeared in two publications in 1985,[2] and J. C. H. King presented a thorough documentation of the Cook collection at the British Museum in 1981.[3]

The first time American collections were introduced specifically as souvenirs of trade was in 1982 in *Soft Gold*, an exhibition and catalogue based on the Northwest Coast Indian collection at the Peabody Museum at Harvard.[4] This important collection includes a number of early objects originally deposited in New England cabinets of curiosities, including the Massachusetts Historical Society and the American Antiquarian Society. Unfortunately, no real attempt was made to place the objects in the context of the American fur trade in which they were acquired. The accompanying text by Thomas Vaughan, who was responsible for establishing the trade context of the collection, deals very little with American merchants. Bill Holm's ethnological observations place the artifacts in their native context, with references to the circumstances of collecting when they were present in the Peabody Museum's catalogue. Two years later, in *Shapes of Their Thoughts*, Victoria Wyatt documented changes in traditional materials and forms that resulted from trade, and in the process coincidentally identified some of the artifacts collected by American fur traders.[5]

The most important work on the collecting of Northwest Coast Indian artifacts appeared in 1985 when, in *Captured Heritage*, Douglas Cole introduced a new level of scholarship to the field. Otherwise completely comprehensive, Cole chose not to describe the early collections, noting only that "a number of pieces were given by the maritimers or their relatives to various scientific societies and some, poorly documented, are now at the Peabody museums of Yale and Harvard and in the Maritime Museum of Salem, Massachusetts."[6]

The same year that Cole's *Captured Heritage* was published, the Smithsonian Institution mounted a massive exhibition on the Wilkes Expedition and displayed a number of Northwest Coast Indian artifacts collected in 1841. These objects were obtained primarily from the crew of the Hudson's Bay Company vessel *Columbia* at the mouth of the Columbia River. In the catalogue that accompanied the exhibit, Adrienne Kaeppler claims that this collection "constitutes the first significant collection of such pieces for an American collection,"[7] consequently dismissing entirely the first generation of collecting by American mariners engaged in the Northwest Coast fur trade.

The Northwest Coast volume of the Smithsonian *Handbook of North American Indians* includes a fairly lengthy discussion of early collections of Northwest Coast Indian artifacts, which concludes that collections made by explorers and traders are important and interesting, but that those of American traders are largely "undocumented."[8] Not surprisingly, most of the chapter on collecting comes from information presented by Douglas Cole in *Captured Heritage*. However, while Cole deals exclusively with collections begun in 1875, chapter authors E. S. Lohse and Frances Sundt also attempt to discuss some of the collections made prior to that date. Artifacts acquired by Juan Josef Perez Hernandez in 1774 and on subsequent Spanish voyages are described with good references, as are those obtained on the British voyages of Captain James Cook and Captain George Vancouver. The authors also describe Russian collections, mostly unknown to American audiences until very recently, and those of the Wilkes Expedition and the Hudson's Bay Company. Of "the curio trade" they say:

> Before, during, and after these expeditions, the coasts of Northwest
> America teemed with vessels employed in the maritime fur trade.
> Captains like Nathaniel Portlock, George Dixon, John Meares, and
> James Magee left records. Most did not. New England maritime soci-
> eties and early museums have objects brought back by these seamen.
> Particularly notable is the Peabody Museum of Salem, Massachusetts,
> inheritor of the collection of the East India Marine Society of Salem, an
> organization of shipmasters, factors, and supercargoes, who were
> encouraged to collect information respecting other lands and cultures.
> 'Exotic' artifacts were displayed in the society's halls.[9]

The collections of those American mariners are the subject of this volume. By 1841, when the Wilkes party was on the Northwest Coast, the lives and material culture of the native people had already been dramati-cally affected by a half-century of contact with explorers and maritime fur

traders. The maritime fur trade had flourished and declined, and the East India Marine Society of Salem and the Massachusetts Historical Society of Boston had been collecting Northwest Coast Indian objects for over forty years. By 1875, the date from which Cole begins his study, iron neck-rings made by New England shipboard blacksmiths seventy-five years earlier were being collected by museums as examples of indigenous culture, along with artworks made in the heyday of fur-trade wealth.

This work is a companion piece to *"Boston Men" on the Northwest Coast: The American Maritime Fur Trade*, in which I attempted to document the American vessels that visited the Northwest Coast to trade in sea otter pelts and to comprehensively survey the surviving shipboard manuscripts of that trade. It would have been impossible to approach the current work without having laid that groundwork. In the two chapters of Part I, shipboard records are used to document cultural observations made by American mariners on the Northwest Coast and to describe the process by which artifacts changed hands. Part II consists of a catalogue of all the artifacts brought back by American sailors and presented to New England institutions during the period that the maritime fur trade was current.

American maritimers often recorded in their seafaring journals descriptions of Northwest Coast Indian people and details of trade with them. Shipboard documents contain a wealth of information about the physical appearance of Indians in the period of the maritime fur trade, primarily in the form of observations about clothing, ornaments, body paint or oil, and hairstyles. There are also occasional references to stature, complexion, and demeanor and judgments of attractiveness. Because most sailors did not go into native villages, there are fewer descriptions of living quarters and household goods, though some such descriptive material is almost universally found in the journals of those men who spent some time ashore. There are also tantalizing references to songs, dances, and rituals, which could only be inadequately described in a hastily written text by persons who had little or no knowledge of local languages. Where American mariners describe the process by which ethnological artifacts changed hands, I have tried to include it. Unfortunately, there was only one case in which a description of collecting found in a shipboard logbook could be tied to a specific surviving artifact—a bow collected at the Columbia River in 1800 and now at the Peabody Museum at Harvard.[10]

And what happened to the objects that traveled in the other direction? Did perceptions of those goods purchased by Northwest Coast Indians from American ships change over time? The greatest distinction between the artifacts transferred from the Northwest Coast to New

England and those that traveled in the other direction as trade goods is that the former were held separate from the mainstream culture of the collectors, while the latter were more fully incorporated into traditional daily life. The Americans in the maritime fur trade primarily intended to acquire sea otter pelts, which they then took to Canton and exchanged for tea, which they then transported to Boston for consumption. The souvenirs were always an ancillary objective. Similarly, Northwest Coast Indians chose useful goods like blankets, buttons, and metal blades in return for their pelts. But they were also interested in the occasional highly exotic item.

In 1794 the crew of the Boston ship *Jefferson* found that their cargo was not going to fetch them a good return in skins, but that there were customers for the captain's cabin curtains, crockery, and looking glass. Eventually they would also trade away much of their personal clothing, a Japanese flag, and ladies' garments made by their sailmaker out of the ship's sails. In July 1801 Ralph Haskins aboard the Boston ship *Atahualpa* traded a violin and a pocket watch to a Haida merchant; he later got a prime skin in exchange for the ship's cat.

What did that watch or that fiddle mean to the Northwest Coast Indian collector, who had no knowledge of the context in which it was understood back in Boston? Were his thoughts similar to those of the American captain who stood on the deck of his ship with a mask in his hands? How was the watch perceived back in the village? Those people who had not visited the American ship were one more step removed from the context of the watch; they had not seen it removed from Haskins's vest pocket and examined. Visitors to the "cabinets" in Boston were similarly one step removed from the environment in which the masks had been collected. And in the next generation, when the use of a watch would have become well known on the Northwest Coast, was that example from the *Atahualpa* still a prized possession, or had it lost its interest when it was understood as a functional object? Certainly for anthropologists, the masks *gained* value when their function was understood.

So what do the objects described here tell us after the passage of almost two centuries? They illustrate the availability of certain common and portable items in profusion, the interest of foreign visitors in specific cultural practices, the points of common interest in marine technology, and the adaptability of Northwest Coast Indians to new materials and new market demands. They are documents of culture; they are also documents of the encounter.

# ✤ PART I ✤

# COLLECTING ON THE COAST

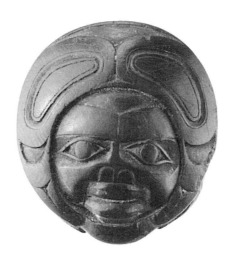

# YANKEE OBSERVATIONS OF NORTHWEST COAST INDIAN LIFE

These are the particulars relative to these people's manner of living, etc. . . . The journalist on such a voyage can unavoidably be led into mistakes or commit things to paper that might bear further investigation; however, to insert truth agreeable to his best information is all that can be expected. . . . For my own part I shall not endeavor to prove my own memorandums by anything further than my own assertion but leave every particular to speak for itself. If on future examination anything should be found wrong, I can only say it arose from my slight knowledge of their language. I have not consulted fancy in any instance but studied to learn every particular from the natives and committed them to paper agreeable to their information.

—Captain Joseph Ingraham, the Brigantine *Hope*, 1791[1]

This is a book about artifacts created by Northwest Coast Indians and collected by American mariners in the late eighteenth and early nineteenth centuries. The term "artifact," which became popular in the eighteenth century, was meant to distinguish the *artificial* object, which was produced by human hands, from the *natural* phenomenon. At the time in which this study is set, the cultural context in which the objects were created was poorly understood by Americans and Europeans. People encountered on voyages—especially to the Pacific Ocean—were seen to be closely connected with the natural world. Their cultural products were, consequently, returned to Europe and America and exhibited side-by-side with *natural curiosities*, unlike the artifacts of their Euro-American counterparts.

It is a basic supposition of this work that American seafarers acquired Northwest Coast Indian artifacts to encapsulate their own experience rather than to illustrate the culture of the people with whom they traded. This is not meant to imply, however, that they were not interested in or

observant of Northwest Coast Indian life and customs. Though they did not document their collecting of artifacts with the same attention to detail as the anthropologists who would follow them to the Northwest Coast, many mariners described regional cultural practices in their logbooks and journals. Shipboard documents that survive from the maritime fur trade include descriptions of Northwest Coast Indian appearance, habitations, technology, art, familial and political relationships, and ritual life. These references are sometimes colored by notions of the exotic or savage, but they are just as often straightforward observations.

The rationale for keeping a logbook or journal on a voyage was not, of course, simply to record cultural observations. Admiralty law and common usage required that an official logbook record navigational information including position, course, wind, weather at sea, the handling of sails, and any significant or unusual events. This document, customarily kept by the mate, was presented to the owners at the end of a voyage. The log might also record the essential business transactions of the voyage, though sometimes a separate ledger or account book was kept by a captain or supercargo, who managed all trade. Because ship owners used these logs to plan subsequent ventures and sometimes even gave captains the log of a previous voyage, they also tended to include geographical, oceanographic, and geological information including tides, currents, landfalls, harbors, and coastlines.

In addition to the official logbook, many sailors kept private diaries or journals. These sometimes followed the official log closely and were kept as practice by young mates or foremast hands anticipating a future position on the quarterdeck. More often they were memoirs of a once-in-a-lifetime adventure, speaking directly to family at home, indicating that their account of the voyage was meant to be shared. Other diaries were so personal that it cannot but be presumed that they were meant only for the author. Occasionally the writer actually seems to have had a sense of the historic nature of the business and was, in essence, making a record for posterity. Joseph Ingraham, quoted above, self-consciously kept such a record when he was captain of the *Hope*. The ship *Margaret* actually left Boston in 1791 with a historian listed among the officers and, according to Ingraham, he had come along specifically "to write a history of the voyage."[2]

While the Americans on the Northwest Coast around the turn of the nineteenth century were influenced by the attitudes of their time, few seem to have traveled there with specific notions about the indigenous people that were drawn from anything other than the published descriptions of their predecessors on the Coast. Bostonians in the late eighteenth century

had little experience with traditional Native American culture at home, and narratives of overland travel to the Pacific Coast were only just becoming available. Consequently, they did not base their descriptions of Northwest Coast Indian people and their customs on comparisons with culturally unrelated Native American groups.[3]

On the other hand, comparisons *were* drawn with other people encountered on a voyage. Northwest Coast Indian women (especially those who wore labrets) often fell short of the notions of attractiveness and sexual accommodation that sailors developed in the Hawaiian Islands. Some American sailors wrote compassionate and sensitive descriptions of the Northwest Coast Indian people they met, and others described them as savages. "Civilization" was defined by Protestant England and Protestant New England; even the Catholic Spaniards on the coast of California barely met the standard.

If some men on Boston ships thought themselves superior to everyone they met, they were not themselves a homogeneous group. Europeans from the great seafaring nations were present on most ships. The *Margaret* left Boston in 1791 with an Irish-born captain and an English historian; the mates were all Yankees, and the nineteen men and boys "before the Mast were all Americans except two Swedes & One Dutchman."[4] Ships that left Boston without a full complement would often hire Portuguese-speaking crewmen in the Cape Verde Islands off the coast of Africa, a precedent established on the first voyage of the *Columbia.* One such man, Marcus Lopius of Sao Thiago (then called St. Jago by American sailors), was killed by the natives of Tillamook Bay on the Oregon coast in August 1788, the first victim of violence in the American trade.[5] American-born men of African ancestry were also common on shipboard.[6]

Most of the surviving logs and journals of the Northwest Coast trade were kept by officers, though there are some charming exceptions. The background and education of the authors vary greatly, several having been at sea since adolescence. Joseph Ingraham reported that his early life had been "a series of storms, dangers, and troubles."[7] John Walters, the thirty-four-year-old boatswain of the brig *Pedler* on the voyage of 1819 to 1822, reported that he went to sea at the age of twelve, and in the years between had "strugeld against many stormes and ship wrecks and cannon balls and hu[n]gary belly and cold biter night."[8] Other young men came from merchant families and were relatively well educated. John Boit, a mate on the *Columbia*'s second voyage and commander of the *Union* at the age of nineteen, is thought to have attended the Boston Latin School.[9] Few of the authors could match the Harvard educations of William

Cushing, who traveled to the Columbia River on the *Chenamus,* and Richard Henry Dana, Jr., author of *Two Years Before the Mast,* but the stylish writing and poetic references found in several of the journals indicate a fairly well-educated class of young officers.

Ethnological information found in the logs and journals of officers was often recorded primarily to explain Northwest Coast Indian behavior, taste, and material culture for the advantage of traders who would follow. There seems to be very little exaggeration or exoticization—though not everything observed was admired. Many men kept daily journals without ever commenting on the appearance, activities, or artifacts of the native population with whom they came into regular contact, sometimes for a year or more. The most detailed descriptions come from the earliest years of the trade when Americans more commonly went ashore to native villages, and when the knowledge of traditional life had not yet been gained from personal experience, but was limited to the published narratives of British captains. As the years progressed and violent encounters increased, traders were much more cautious, allowing fewer Indians at a time on shipboard and avoiding village sites when they needed to go ashore for wood or water.

Northwest Coast Indian technology, art, and artifacts changed through the whole period of the trade as Yankee traders brought into coastal villages new materials from the Atlantic coast, Europe, Polynesia, California, and Canton. Foreign maritime traders unconsciously both contributed to and recorded those changes when they traveled on the coast. Either incidentally in descriptions of their own activities or specifically to inform the folks back home of the details of native life, sailors documented the transition of Northwest Coast Indian culture in their journals. Because native oral transmission of cultural and historical information was disrupted in subsequent generations by the ravages of diseases brought on European and American ships, the observations of mariners are especially important today. In many cases, the logs and journals of these outsiders provide the earliest surviving descriptions of certain native practices and the only written documentation from this period of rapid change.

Yankee traders quickly collected and recorded information that was perceived as important for navigation and trade. They knew the location of all of the major villages on the coast by 1800, and they knew individuals by name. They were aware of the patterns of summer and winter migration and followed the Indians from one settlement to another. They recognized linguistic differences and regularly utilized their knowledge to identify native people who were far from home for trade or warfare. American traders wrote often and in detail about the relationships between different

tribal groups on the Northwest Coast; they knew who traded with whom and who was at war with a neighbor or a distant enemy. All of this accumulated lore was used to promote trade. If the Yankee captain, for instance, could eliminate a native middleman and procure furs at a lower price, he would attempt to do so. If native people needed guns for a fight, the traders were happy to provide them in return for goods. Their descriptions are, for the most part, straightforward and businesslike, little affected by literary notions or pretensions.

Keeping in mind the fact that each traveler saw his own experience as unique and that few American mariners had their shipboard journals edited into more literate narratives (as was the case in all the published narratives of Northwest Coast voyages from British Navy sources), one can begin to compare descriptions of the same event or the same cultural practice and differentiate observed fact from interpretive bias. For example, the eyewitness account is commonly clouded by personal taste in descriptions of the labrets worn by women on the northern part of the coast, and a comparison of several examples is illuminating.

Robert Haswell, a mate on both the *Columbia* and the *Washington* during the course of their first voyages, recorded the earliest description of labrets in an American source. He had a strong negative reaction to their appearance and speculated incorrectly on how they were inserted:

> The Women wore a Lethern apron but of all thing the most preposterous that ever I saw is the orniments they ware to their mouth an insision is cut in the Lower lip reaching from one corner of the mouth to the other into which is forced a pece of wood in form ovel with a groove cut to Receive the Lip and the other part formed to Lay against the gums. this huge trencher nearly as large as a barbers Lather box as they speek flies up and down and when hanging couver all the chin canted up half the nose is hid. . . .[10]

John Boit, Haswell's shipmate on the second voyage of the *Columbia,* had a similar response to his first encounter with labrets at the Queen Charlotte Islands in 1791:

> The Women are entirely cover'd with Garments of their own manufactory, from the bark of a Tree. They appear to carry full sway over the men and have an incision cut through the under lip, which they spread out with a piece of wood about the size and shape of a Goose egg (some much larger). it's considered as an ornament, but in my opinion looks very gastly. Some of them booms out two inches from the chin.[11]

John Hoskins, the third member of the *Columbia* crew to keep a surviving journal of the second voyage, is the only one who attempted to place the labret in any native cultural context. He noted that "'tis not common for all to wear," speculated on its use as a symbol of rank (and determined that it was not, "for both the chief and lower class of women wore them"), commented on the different sizes worn by women of various ages, described the ornamentation found on several examples, and specified the method by which the lip was first pierced and then the hole gradually enlarged over a period of years. While neither admiring nor advocating the look or use of labrets, he nonetheless described them accurately, only at the end allowing himself to make a very unusual personal judgment:

> How frequently have I thought of the hardship of the curse denounced
> on women by God Almighty in the Garden of Eden. but when I saw
> this lip piece, I could not help exclaiming against this second curse prac-
> ticed by man.[12]

That same year both Ingraham and the keeper of the *Margaret* log also saw labrets in use for the first time. The former commented on the different notions of beauty in different cultures. "Upon the whole," said Ingraham, the labret was "as strange a fancy as was ever adopted by the human species and, however consonant with their own ideas of beauty, was to me a most shocking sight."[13] The *Margaret*'s observer wrote a dispassionate and rather scientific account of native women and their labrets:

> Those that have arrived to eighteen or twenty years of Age and upward,
> are distinguished by that Ornament, called the wooden Lip, that is
> Some of [them] have their underlips puncturd at an early and some at a
> later period, with a piece of brass or copper wire or pin, which they wear
> 'till it corrodes a hole sufficiently large to admit a small wooden Lip, and
> continually inlarging the Orifice by degrees till some of them will admit
> One as large as three or four Inches long and from One to two Inches
> broad.—These Artificial Lips are of an Oval Circumference, the upper
> and undersides of some are concave some are decorated with pieces of
> perl Shells set in.[14]

In a lecture delivered in 1848 on the "character of the Indians, and occurrences among them," William Sturgis, venerable captain and owner of several ships in the Northwest Coast trade, gave a complete and sensitive description of labrets. Not only did he describe what they looked like and how they were inserted, as others had before him, he also put them in

both a geographical and a cultural context by informing his audience of the region where they were worn and the ritual that surrounded the first piercing of the lip:

> The strangest ornament ever devised by man or woman is the "Wooden Lip," universally worn by the women of all the tribes, from the South end of Queen Charlotte's Islands in Lat. 52° to Prince William's Sound in Lat. 60°. This is a piece of wood, about half an inch in thickness, of an elliptical form, varying from one to three inches in length, according to the age and dignity of the wearer, and of a proportionate breadth, slightly concave on both sides and with a groove round the whole edge. To insert a full sized one, where no previous preparation had been made, it would be necessary to cut, from one corner of the mouth to the other, through the under lip, about one fourth of an inch below the surface, and lifting the part thus separated place the ornament vertically or edgewise in the opening, where it is retained by the edges of the gash pressing into the groove, and its weight soon causes it to drop to a horizontal position. It is not, however, introduced in this way, but years are required for the process. First the lower lip is perforated in the centre, at the proper distance below the surface, and a piece of copper or brass wire about six inches long, something larger than a large-sized knitting needle, headed at one end, is introduced from the inside and of course sticks out the whole length of the wire. This wire moves with every motion of the lip and thus enlarges the opening. In a year or two it is withdrawn and a short wooden peg inserted in its place, substituting larger ones as the orifice enlarges, and in the course of a few years increasing it to a respectable-sized wooden lip. The ceremony of perforating the lip is one of great importance and takes place when the girl is six or seven years of age. A feast is given by her parents and all the people of the village are invited. . . .

Sturgis then goes on to describe a particular woman with whom he was acquainted—a clear attempt on his part to make the practice less exotic and more human to his audience. He closed this portion of his lecture by reminding his listeners that women who lived in whalebone corsets shouldn't throw stones:

> Madam Connecor (well known to every early visitor of the Coast), the wife of one of the most distinguished chiefs, was remarkable for the enormous size of her wooden lip. She was remarkable, too, in some other respects; for as a trader, she was the keenest and shrewdest

among the shrewd. She professed great regard for white people, and often remarked, in a very flattering manner, "Wattlewi yeiyets Hardi Cagen tinnaketi," "All white men are my children."

But while we ridicule and laugh at their absurd notions of beauty that led them to disfigure and render hideous the human face, let us do them justice, and give them credit where they deserve it. And in one respect they deserve great credit, and set an example that may well be followed elsewhere; for they have the good sense,—Ay—and the good taste, too, to leave the female form in all its beautiful and graceful proportions, as it was fashioned by the great Creator, and neither destroy symmetry by artificial expansion, nor sacrifice health and endanger life by unnatural contraction.[15]

One of the aspects of labret wearing that was of obvious interest to sailors was the effect it had on the appearance of the women who wore them and consequently on their attractiveness as sexual partners. According to Boit, "The females was not very Chaste, but their lip pieces was enough to disgust any Civilized being, however some of the Crew was quite partial."[16] Ingraham thought that "many of the women might be termed handsome were it not for their vile ornament—the lip piece."[17] The British Captain George Dixon, who describes labrets in his journal on three different occasions (including the method of piercing the lip and the distribution of the practice on different parts of the coast and among different classes of society), thought that it ruined the symmetry of the face of a beautiful young Indian woman encountered in the Queen Charlotte Islands in 1787. Were it not for the labret, he said, "she was what would be reckoned handsome even in England."[18]

The missionary Jonathan Green, traveling on the Northwest Coast aboard the bark *Volunteer* of Boston in 1829, summed up the American view of labrets when he described the practice as one "which renders them objects of admiration among themselves, and of ridicule to all who visit them. . . . It is difficult to conceive how so absurd an appendage should be regarded as an ornament."[19]

While sailors refer occasionally to the shipboard visits of pretty girls, descriptions of Northwest Coast Indian women were generally either mocking or negative. In the Queen Charlotte Islands it was not unusual for women to take an active part in trade, and American captains did not appreciate that participation.[20] Mostly young and single, Yankee sailors were clearly uncomfortable with the roles played by high-ranking women on the Northwest Coast. Seen as unnaturally aggressive, these women were

often described in terms of the abuse they heaped upon their husbands. Hoskins, for example, reported in 1791 that

> the women in trade, as well as in every thing else, which came within our knowledge, appeared to govern the men; as no one dare to conclude a bargain without first asking his wife's consent; if he did, the moment he went into his canoe, he was sure to get a beating. this I have seen to be the case more than once, and there is no mercy to be expected without the intercession of some kind female.[21]

Ingraham made a similar report when he entertained his "old friend Skatzi," a Haida chief, on board the *Hope* that same year:

> Shortly after being at anchor old Skatzi came on board and brought two very fine skins. . . . Agreeable to his request I let him and a man who accompanied him sleep on board. The old fellow's reason for absenting himself from home was that one of his wives had beat him and he wished to keep his distance till her rage was subsided.
>
> Here, in direct opposition to most other parts of the world, the women maintain a precedency to the men in every point insomuch as a man dares not trade without the concurrence of his wife. Nay, I have often been witness to men being abused by their wives for parting with skins before their approbation was obtained. In short it seemed this precedency often occasioned much disturbance.[22]

Only Rev. Jonathan Green was able to describe this behavior in a positive light. According to Green, "their women are treated with more deference than they are among most heathen nations." In addition to being consulted in trade negotiations, Green also admitted that they were inclined to beat their husbands, but usually "when the husband is intoxicated" and resisted her better judgment and authority.[23]

Sexual encounters between American sailors and Northwest Coast Indians are only occasionally mentioned in shipboard documents.[24] John Bartlett, for instance, made this oblique reference to prostitution in 1791:

> When they are better acquainted they put aside all modesty. The young women were well featured. We had them on board at from ten to twenty years of age. Their fathers would instruct them how to behave while our men had to do with them.[25]

John Walters of the Brig *Pedler* was more straightforward in 1821:

> the Indians came on board but with a few furs the women hear and all to the north ware the wooden lip wich I seen 3 or 4 inches wide which

makes them look ugly in my Iye and they are very dirty with the smoke
their houses having no chimbelys . . . they paint them selves and in
morning black their face and goes crying about the shore and making a
dismal noise thoes pipol have slaves wich they buy and sell from one to
the other and when a chief dies they have som of their best slaves to be
killed and go with them they likewise make their slave girls go on board
of the ships and sleep with the men for what they can get which they
call stingistong that makes the girls of more vallue than the man slave.[26]

Green learned from Chief Cow that "all the young women of the tribe visit
ships for the purpose of gain by prostitution, and in most cases destroy their
children, the fruit of this infamous intercourse."[27]

All of these references to labrets, aggressive female behavior, and pros-
titution come from the Queen Charlotte Islands. The obsession that for-
eign sailors had with describing Haida labrets may, in fact, have been a way
of distancing themselves still further from women whose behavior was dis-
turbing to them. Ingraham wrote that he hoped the unnatural domination
of these women would "never become general across the continent, as I am
inclined to believe that even our ladies themselves will agree that female
submission is most convenient." To the twenty-eight-year-old unmarried
Ingraham, who had spent all of his adult life thus far on the deck of a ship,
"To fix a yoke on a man's neck is absurd; he would certainly break it."[28]

Though described as "hideous," "vile," "ridiculous," and "disgusting,"
labrets were clearly the most intriguing aspect of Haida culture encoun-
tered by the young men visiting there on American ships. This fascination,
often voiced, may be what led to the production of masks of labret-wearing
women for the souvenir market. Three masks and two dolls depicting
women wearing extremely prominent labrets entered Boston museums
during the fur-trade era. Another doll and eight additional masks (includ-
ing a unique example without a labret) were collected on European ships,
by the Wilkes Expedition, or have no surviving provenance.[29] Astonishingly,
all these masks are similar enough in appearance to be the work of one
artist, though the quality of the carving is not consistent. It may be that
once the demand was recognized less attention was paid to details, or it
may be that a "school" of carvers created them.

That so many similar pieces would be collected over a time period of
at least twenty years and over a stretch of coastline eight hundred miles long
(at locations as distant as Prince of Wales Island, on the coast of Alaska, and
the Columbia River) is evidence that they were widely traded and that the
subject matter held a powerful fascination. The two examples that first

entered museum collections in Massachusetts were each described as portraits of a particular woman. The one collected by Captain Daniel Cross on the 1821 to 1825 voyage of the Boston brig *Rob Roy* is described in various East India Marine Society records as a "wooden Mask, a correct likeness of a distinguished Chieftainess at Nootka Sound," an "Indian mask, representing the features of an aged female of the Casern tribe on the N.W. Coast of America," and a "Wooden Mask, once used by a distinguished Chieftainess of the Indians at Nootka Sound—said to represent exactly the manner in which she painted her face." A similar mask received by the American Antiquarian Society in 1826 was described as a "carved representation of the face of a high chief, female, on the Northwest Coast. Carved and painted by a native of that coast." It was described later as a "correct likeness of Jenny Cass, a high chief woman of the North west Coast."[30]

The mask collected by Captain Cross was borrowed from the East India Marine Society (EIMS) in 1848 by William Sturgis to illustrate his lecture on Northwest Coast Indians, in which he described the appearance of labrets and introduced the character of his acquaintance, Madame Connecor. Sturgis praised the accuracy of the representation as portraiture:

> I have obtained a specimen of a Wooden Mask which is an exact representation, a perfect facsimile of a woman's face with the wooden lip. This was carved by the Indians, who are quite skillful in making a likeness of whatever they attempt to imitate, such as large birds, the heads of animals, etc. . . . I am certainly within bounds in saying that I have seen these wooden lips three inches long and two broad, in the widest place, and it behooves me not to exaggerate or attempt to tell travelers stories, for there are several persons present who are familiar with the whole subject of my lecture and would instantly detect the slightest misrepresentation.[31]

Bill Holm has suggested that the reference to Jenny [or Jenna] Cass as the subject of the American Antiquarian Society mask might have been an attempt to capture the name of "'Djilakons,' an ancestress of the Haida Eagle moiety, who was usually represented as wearing a very large labret."[32] American mariners seem to have had so little sense of Northwest Coast Indian cosmology or lore, though, that even if the name "Djilakons" was *said* by the person who provided the mask, it is very unlikely that it was understood as representing anything other than a real woman, and possibly one personally known to the collector. This may even have been the very "Madam Connecor" mentioned by Sturgis. The orthography of Northwest Coast Indian names was always difficult for English-speaking

mariners, and variant spelling was made more confusing by regional accents on both coasts. "Connecor" or "Connecors" may have been heard when "Djilakons" was said, and either could have been translated and transcribed by a third party as "Jenny Cass."

Though the specific details of the transfer of these two masks into Yankee hands was not recorded, one can construct a possible scenario for such a transaction based on journals kept aboard the *Rob Roy* and the *Volunteer* (another Boston vessel on the Northwest Coast at that time). The Cross mask is noted in EIMS records as "representing the features of an aged female of the Casern tribe." The Kasaan people were among the Kaigani Haida who migrated from the Queen Charlotte Islands north to the Prince of Wales archipelago in the late eighteenth century.[33] The Kaigani lived in several villages including Kaigani, Kasaan, and Tongass. The inhabitants of Kasaan had a summer village at Chartsena or Chuckenhoo; the inhabitants of Tongass had a similar seasonal outpost at Clemencitty.[34] American ships regularly visited all of these villages and there mariners frequently encountered individuals known to be from one of the other villages. (It was, for instance, noted in the *Rob Roy* journal on 16 March 1824 that "Lemor the principal chief of Kigarny died at Casarn a few days since.") Therefore, it is possible that the mask of the "aged female of the Casern tribe" was collected at a village other than Kasaan itself.

The *Rob Roy* made its first landfall on the Northwest Coast at the village of Kaigani in February 1822, and within a few months Captain Cross and his crew had traded extensively among the Kaigani Haida, including stops at Tongass and Kasaan. A cruising pattern was subsequently established that brought the ship regularly between Vancouver Island and the Queen Charlotte Islands, with occasional ventures further north; but most of the ship's trade was concentrated in the region occupied by the Kaigani Haida, and a number of local individuals became well known to the ship's company. (Captain Cross even had a Kaigani companion for a time. At the end of August 1822, the journal notes that the ship was "bound for Kigarnee where Capt. C— is going to put his girl ashore.")

Neacoot (or Nacoot), identified by the Yankee mariners as the chief at Tongass, became especially intimate with the men of the *Rob Roy*. Neacoot came aboard the ship for the first time on 26 August 1822, and it was recorded that he was "going a trip with us he is a grate drunkard but the cleverest indian on the coast." At Kaigani on the first of September, Neacoot "got the principal <u>Enors</u> most into[le]rably drunk." The keeper of the journal described the incident:

> I first discovered him out in the Main shrouds with a bottle of Rum &
> a tumbler swinging it out to three of the principal chiefs wives of the
> village—the Rum soon had the desired effect & they began to pull hair
> & tear out the wooden lips while Neacoot stood enjoying the frollick.

Neacoot was on and off the *Rob Roy* for as long as the ship was on the Coast, sometimes with his wife and children and often for weeks at a time. The Yankees found in him a frequent passenger, a pilot, a translator, an occasional collaborator, and a friend. He made himself at home on the ship, drinking copiously but also impressing his hosts with his intelligence. When the vessel was being prepared to leave for Hawaii in the first week of October 1824, the crew spent almost two weeks in the harbor at Tongass, and "at parting gave Necoot a beaker of Rum as a token of Friendship." The last comment about him echoed the statement made at first meeting, that Neacoot was "the cleverest Indian on the coast and the greatest drunkard I have ever seen."

It is likely that there was an exchange of gifts at this time, though no mention is made of what Neacoot may have presented to Captain Cross. Could it have been the mask? The men of the *Rob Roy* had made their fascination with labrets clear. In the journal, the "female part[s] of the tribe" are described as "conspicuous by a very large Wooden Under Lip set in to the flesh some of them two inches in Length and one in breadth which makes them look most horribly."[35] It does not seem unreasonable to think that Neacoot, who knew the officers of the *Rob Roy* well and who would, through his position of rank, have access to such a mask (or to the artist who carved it), might have procured it as a documentation of the practice of wearing a labret for his friends on the ship.

If Neacoot made such a gift to Captain Cross, he might also have given one to Captain James Bennett of the *Volunteer,* on which vessel he also traveled extensively. The *Volunteer* arrived on the Northwest Coast in the spring of 1818 and cruised in much the same pattern as the *Rob Roy* until September 1820. Neacoot was on board the *Volunteer* for more than a month in the fall of 1819.

The *Volunteer* returned to Boston on 1 June 1821, ten weeks before the departure of the *Rob Roy.* James Bennett could easily have been the person who conveyed the mask into the collection of the American Antiquarian Society. Either he or Cross might have had a second mask, which eventually made its way into the hands of William Sturgis. (Sturgis was a principal owner of the *Rob Roy,* as well as of the *Derby,* which James Bennett commanded on the Northwest Coast in 1810.) Although Sturgis

claimed in his 1848 lecture that he "brought home several" such masks but that he "did not preserve them," his grandson donated another mask to the Peabody Museum at Harvard. It may have been located later by Sturgis, or it could have been presented to him by another mariner-collector, like Bennett or Cross.[36]

A number of other high-ranking individuals from the Northwest Coast developed close, personal relationships with the officers of American ships, and the exchange of commodities, technology, and gifts was continuous. The interaction between American mariners and Northwest Coast Indians even promoted the fluorescence of certain artistic traditions, the most significant of which was the totem pole.[37]

Since the last quarter of the nineteenth century, totem poles have been regarded as the preeminent symbol of the artistry of Northwest Coast people and of the complexity of their culture. Captain Cook described interior house posts at Nootka Sound in 1778, and John Webber's illustration of them was published in the official narrative of Cook's third voyage. The British Captain George Dixon described carvings that he saw in the Queen Charlotte Islands in 1787 as "figures which might be taken for a species of hieroglyphics: fishes and other animals, heads of men and various whimsical designs, are mingled and confounded in order to compose a subject . . . yet they are not deficient in a sort of elegance and perfection."[38]

Even more than labrets, the monumental carvings of the Northwest Coast were startling and impressive. No shipboard journal keeper who had an opportunity to see a carved pole seems to have neglected to describe it, but the rate at which they were observed indicates that freestanding totem poles were a rare sight at the turn of the nineteenth century. A forest of poles (such as can be seen crowded in front of the Haida villages of Masset, Skidegate, and Cumshewa in late nineteenth-century photographs) was never described by a maritime fur trader. Instead they described interior and exterior house posts and individual mortuary poles; several also described the potlatch that was held when a pole, or a house with a pole attached, was dedicated.

The function of these carvings in native society was cause for some speculation. When Cook saw the carved house posts that Webber sketched, he thought that they might represent gods:

> but I am not altogether of that opinion, at least if they were they held
> them very cheap, for with a small matter of iron or brass, I could have
> purchased all the gods in the place, for I did not see one that was not
> offered me, and two or three of the very smalest sort I got. [39]

When the Boston ship *Columbia* arrived at Nootka Sound a decade after Cook, Robert Haswell recorded in his vocabulary list the word "Klummah," noting that it described "a wooden image."[40] In March 1789 Haswell compared the carvings at Clayoquot Sound with those he had seen earlier at neighboring Nootka Sound:

> Their Towns are larger and much more numerously inhabited
> than those of the Sound they are better built. And are cleaner their
> Clumas or carved pillars are more numerous and better exicuted some
> of these are so large that the Mouth serves as doarway into their houses
> some of their ridgpoals which are of incredible Length and bulk are
> neatly Fluted others are painted in resemblence of various sorts of beasts
> and birds we met with resemblences of the Sun both painted and carved
> the rays shoot from every side of the orb which like our Country Sign
> painter they pictur with eyes nose and mouth and a round plump face.[41]

The village Haswell described was probably Opitsat, which was destroyed three years later by order of Captain Robert Gray, Haswell's commander on the *Columbia*. (On the second voyage of the *Columbia*, Gray believed that the natives at Opitsat were planning to take the ship.) John Boit, who accompanied Gray on the second voyage, described the village before it was destroyed and voiced his regret that Gray had "let his passions go so far." He also commented on what he perceived to be the antiquity of the village and its carvings:

> *This* Village was about half a mile in Diameter, and Contained
> upwards off 200 Houses, generally well built for *Indians* ev'ry door that
> you enter'd was in resemblance to an human and Beasts head, the pas-
> sage being through the mouth, besides which there was much more
> rude carved work about the dwellings some of which was by no means
> *inelegant.* This fine Village, the Work of Ages, was in a short time
> totally destroy'd.[42]

Joseph Ingraham, who had served as second mate on the *Columbia's* first voyage, returned to the Northwest Coast in 1791 as master of the Boston brigantine *Hope.* He cruised extensively in the Queen Charlotte Islands and described totem poles seen at Cloak Bay:

> After the vessel was fast, I went in the boat accompanied by
> [Chief] Cow to view two pillars which were situated in the front of a
> village about a quarter of a mile distant from our vessel on the north

shore. They were about forty feet in height, carved in a very curious manner indeed, representing men, toads, etc., the whole of which I thought did great credit to the natural genius of these people. In one of the houses of this village the door was through the mouth of one of the before mentioned images.[43]

That same year, John Hoskins, the supercargo on the *Columbia* during the second voyage, took time after the ship left Masset in the Queen Charlotte Islands to describe the native people and their surroundings. As Hoskins seems to be speaking in general rather than in specific terms, his account would indicate that carved exterior house posts were not uncommon among the Haida in 1791:

> [T]heir head villages are neatly and regularly built the houses end on with pitched roofs in front is a large post reaching above the roof neatly carved but with the most distorted figures at the bottom is an oval or round hole which is either the mouth or belly of some deformed object this serves for a door way.[44]

John Bartlett was the first American sailor to attempt to sketch one of the carved Haida poles in his journal. In June of 1791 he also described a traditional house at Cloak Bay in the Queen Charlotte Islands:

> We went ashore where one of their winter houses stood. The entrance was cut out of a large tree and carved all the way up and down. The door was made like a man's head and the passage into the house was between his teeth and was built before they knew the use of iron.[45]

Bartlett's drawing shows a flat-topped house with vertical board sides and a carved pole at the front, which is about twice the height of the building. There are what appear to be human faces at the top and bottom, and there are a number of other figures on the front and sides between them. While the sketch is crude and cartoonish, there is a liveliness and charm about it. Bartlett clearly did not understand what the figures on the pole represented, nor could he capture in his drawing the highly developed style in which they were carved, but he was impressed enough by the experience to try to document it.

When the ship *Jefferson* was in the Queen Charlotte Islands in 1794 the crew helped to prepare and erect a mortuary pole at the request of the Haida chief, Cunneah. Several entries from the journal of Bernard Magee chronicle the process and describe the potlatch that marked the dedication of the pole—an event that also included the ritual piercing of the lips and/or septums of several girls:

[I]n the afternoon the Capt. with the Carpenter & some hands in the pinnace went to the village at the request of Cunneah to plane & smooth an ornamental pillar of wood—previous to its erection on the morrow. . . . [17 June 1794]

[I]n the morning I went in the pinnace with the Carpenter & 2 hands to the village took along with us 2 spair top masts for Sheers—& sufficient Tackling to set up the pillar—which in the afternoon got in its place—after finishing the necessary requisites for its intended purpose of sepulture of a daughter of Cunneah. . . . [18 June 1794]

I went to the village with some hands at the desire of Cunneah in the morning—to raise an Image on the monument lately set up—which the[y] Cut & Carved with a great deal of art—being the representation of some wild animile unknown to us—some what the Resemblance of a tode. . . . [8 July 1794]

To the village to the ceremony of distributing the presents to be made by Enow the father of the infant to whose memory the monument was Erected, a principal Cheeff & son or son inlaw to Cunneah—to the Cheeffs & people who were also invited upon the occasion as well as to perform the Ceremony of incision upon some young females at the same time—after dinner the Capt. with the Doctor & purser accompany'd Cunneah to the village to the house of Enow which was thronged with guests & spectators—the scene was then opened—by the Ceremony of introducing the wives of Enow & Cunneah & the Candidates for incision or boring . . . the presents were usher'd in & displayd to the view of all present—& thrown together in a heap being a perfuse Collection of Clamons Raccoon & other Cotsacks Cunstagas both Iron & Copper & a verity of ornaments this being done the Spectators were dismissed & the guests placed in order round the house, the incision was then preformed on the lips & noses of 2 grown & 2 small girls which ended the distribution was then begun of the above articles—the Capt. receiving 5 otter skins the other articles were distributed amoung the different Cheefs according to their distinction—after which the Capt. took his leave & returned on board. . . . [9 July 1794][46]

Among the gifts distributed at this potlatch, a number were probably brought to the Queen Charlotte Islands on American ships. *Clamons* (or *clemens*) were thick moose hides brought north from the Columbia River, and the *Cunstagas* were necklaces made of twisted iron or copper wire, which were invented by Joseph Ingraham, captain of the *Hope*. (In his

vocabulary of the Queen Charlotte Islands, Hoskins described twisted iron collars—which had been made by Ingraham's blacksmith but which Hoskins thought were traditional—as *kilestagah;* the same thing in copper was *hunestigah.*)[47]

Ralph Haskins on the *Atahualpa* remarked on the preparations for a great potlatch at Kaigani in June 1802. He noted, "The tribe are engaged at the village in building a number of houses. . . . The largest of them are for Eltatsy, Yakkee, Nockerchute, &c." Haskins thought that the planned distribution of gifts at the dedication of the houses was essentially to pay for the work of building them. He said, "It is an expensive job for a chief to build a house. . . . It requires a large number of people, and presents of valuable articles must be distributed among them. They value their labour very highly."[48]

Yankee sailors were interested in potlatches because the travel plans of various tribes affected their ability to trade. In February 1811 Robert Kemp, second mate of the Boston brig *Otter,* noted that a number of Haida from the Queen Charlotte Islands were then headed over to the mainland at Milbanke Sound for a potlatch to dedicate a new house:

> [A] Reasonable trade Continues as yet at the Rate of ten Skins per Day on an Average the Chiefs of this tribe are all gone Down to a Flollick or Frollick on the Chibisher Shore there Tophun one of the Head Chiefs has ben building a hous and as tis Customary for them to give Large presents when the House is Compleated so that all may Come and Share of the Repast So those Chiefs have gone to Reap the Benefit of this Jubilee . . .[49]

Thirty-five years after they were first seen by foreign traders, totem poles in the Queen Charlotte Islands were still being described primarily in relation to house fronts. Jonathan Green on the *Volunteer* described the Haida village of Skidegate in 1829:

> Just before we cast anchor, we passed the village of Skidegas. To me the prospect was almost enchanting, and, more than any thing I had seen reminded me of a civilized country. The houses, of which there are thirty or forty, appeared tolerably good, and before the door of many of them stood a large mast carved in the form of the human countenance, of the dog, wolf, etc., neatly painted.[50]

Green also observed the connection between potlatching and the dedication of a house and its associated totem pole:

> They occasionally build a decent house, and erect before it a mast or log of wood of great size carved and painted fantastically. At the opening of

a house of this kind, the owner makes a feast to which he invites his friends and the principal men of the tribe. The guests on such occasions eat and drink to satiety; and after dancing to the music of their rude drum, they receive presents of slaves, blankets, skins, etc., and retire. This ceremony costs a man no small share of his property; but it confers upon him great honor, which, to a North-West Indian, is an equivalent. On such occasions a slave is sometimes killed, at other times liberated. . . . They have nothing like laws. Every man has influence in proportion to his property, and his property is generally proportioned to his strength. . . . Poverty they consider disgraceful. He who has strength and skill enough to obtain property will acquire influence, and he who has sufficient influence to gather around him a class of warriors, is to all intents a chief.[51]

A number of the chroniclers of the Northwest Coast trade were greatly interested in the mortuary practices associated with many of these carvings. The anonymous journal keeper on the Boston brig *Rob Roy* wrote in 1822 that when a Haida "smoket" or "chief dies they enclose his boddy in a box and raise it on two of the longest poles they can find and leave it exposed to the winds."[52] Robert Haswell described the process by which a coffin could be elevated in a tree:

> They put the Dead of superior rank into boxes ornemented with the teeth of sea otters with their knees close up to their Chin into these Coffins they put the fishing geer or Weapon he was fond of duering his lifetime and carie this Box to the top of sum very high tree about 1/2 mile from the Village where they lash it securely bending the top limbs round the Box and as they decend they cut the limbs closs off to the Tree which renders it diff[icult] of access. [T]he lower class of people they put in boxes and lay under the trees or at the feet of rocks.[53]

Reverend Green was especially interested in learning about traditional notions of an afterlife and visited several grave sites on his cruise. He evidently thought that crest figures on mortuary poles were portraits of the deceased, as he twice referred to such carvings as "busts." At Kaigani, for instance, he made the following report:

> As I was going from house to house, I saw a bust at the mouth of a cabin, curiously carved and painted. I asked what it was. My Indian guide said it was Douglass, a chief of this tribe, who not long since died in a drunken frolick. He went with me to examine it. He drew back the board which closed the mouth of the tomb. The remains of the chief

were deposited in a box, or coffin, curiously wrought, and gaily painted. They usually deposit their dead in similar boxes, though they commonly elevate them several feet from the ground.[54]

Missionaries had been collecting ethnographic information from mariners for several years when Green arrived on the coast. Green records a letter dated 1827 "from a respectable ship master to Mr. Bingham" at the Hawaiian mission that describes Northwest Coast Indian people and their burial practice. Like many of his sailor brethren, the letter writer begins with the caveat that he possesses

> barely sufficient knowledge of their language for the purpose of trading, and am mostly occupied with this, it can hardly be expected that I should give you a very correct idea of their manners, customs, good or evil doings, other than what happens to fall under my own observation; and as I am not in the habit of visiting the shore often, my opportunities of observing are but few. . . .
>
> Their funeral ceremonies are these. A Chief or chiefess dying, after being washed, dressed, and painted, is kept in a chest for a few days in their house. The head is then severed from the body, and put into a small box, and suspended upon poles, near (commonly in part of) their hut; the body is consumed by fire, and the ashes buried; a common person is entirely consumed by fire. A slave is thrown on the beach, to be washed away by the tide.[55]

A number of observers described elevated coffins, grave boxes, and even burial canoes (the latter especially in the region of the Columbia River). Likewise, chroniclers often noted the difference in treatment of the dead according to rank, but American sailors seldom discussed spiritual or cosmological issues with their native counterparts. Bostonians were seldom able to recognize any crest animals other than frogs in the monumental carvings they encountered, and they never considered that the people who were providing them with pelts might regard with reverence the animals from which those pelts were obtained.

By coincidence, the most desirable fur obtained in the trade was from the sea otter, an animal with little cosmological or totemic significance in Northwest Coast Indian culture. In a letter to the *Boston Daily Advertiser* in 1822, William Sturgis noted that in the best years of the trade, when American ships could collect some eighteen-thousand sea otter pelts annually, it was difficult to get five thousand beaver and land otter skins, "notwithstanding every encouragement has been given to the natives to hunt

them."[56] Even the perceptive Sturgis had failed to note that beavers were a major crest animal for the northern tribes and that land otters were dreaded by common people on the northern coast because of their potent association with shamanism and witchcraft. (According to Aldona Jonaitis, land otters were "the most dangerous supernatural in the Tlingit world."[57]) Most beaver and land otter pelts came from the region of the Columbia River, where the animals did not have the same totemic or supernatural relationships with the Chinook as they had with the people of the northern coast.

While not subscribing to any ecological theory as encompassing as that proposed by Calvin Martin in *Keepers of the Game,* there can be no question that the native people of the Northwest Coast had a different relationship with animals than did the "Boston men" with whom they traded.[58] Unlike the Micmac and the Ojibwa cosmos described by Martin, which was already threatened by missionary activity and disease when fur traders began to arrive in large numbers in the eighteenth century, Northwest Coast Indian cultural practices were relatively stable during the entire period of the maritime fur trade. People of the northern coast simply did not supply beaver and land otter pelts to foreign traders because they had relationships with those animals that proscribed them from doing so.

Salmon, the staple food of the region, required certain rituals to insure its return season after season. When the trading post at Astoria was founded in 1811, the employees found that the Chinook were happy to trade the salmon they caught. At certain times during the summer, however, the Astorians were unable to procure the freshly caught fish to which they were accustomed because the Indians insisted on preparing it first according to certain prescribed rituals. According to entries from the journal of John Jacob Astor's agent at Astoria:

> The Indians have plenty of Salmon, but from a superstitious idea they entertain that boiling and cutting it across will prevent them from coming into the River until the next New Moon, they brought very few & they insisted on dressing & roasting these themselves. [6 June 1811]

> The Chiefs Comcomley and Kamaquiah paid us a visit. The former brought 15 small salmon for a Treat, But the whole to be eaten before Sunset & prepared by his own people. [14 June 1811][59]

Though Robert Haswell said that the people of Nootka Sound "pay great adoration to the Sun" and thought that they believed "in a supreem god and a Deavil"[60] as early as 1789, it was not really until Minister Jonathan Green began to ask specific questions about a "Supreme Being" in 1829

that identifiable stories emerged about Raven and his role in the creation of a hospitable human environment on the Northwest Coast. "Of a Creator, powerful, wise, and good," found Green, "they seem to have no idea." He continued:

> In answer to the inquiry, which I have frequently made, "Who formed the sea, the land, and the creatures which inhabit them?" they have generally replied, "We know not." The most intelligent among them, however, have told me that the old men on every part of the coast have a tradition, that the *"yealth,"* or north-west crow, is the creator of the world. There is no doubt that they have a superstitious regard for this bird.[61]

When he was at Kaigani aboard the *Volunteer,* Green "gathered many items of Indian tradition from an intelligent native. To the *crow* he [the native] attributes the formation of the world, and its original inhabitants."[62] It may be that Haswell's devil was also a strangely interpreted Raven story. According to Haswell,

> they have several strange stories of this strange monster they say they were doing some bad thing on the beach in some past ages when the dredfull fellow made his apearance they represent him as Black with fiery eyes he is of enormious size and has but one Leg. but so nimble that after eating twenty or thurty of them the blud runing a plentiefull streem down each side of his mouth he at one hop went across the sound and they now suppose he dwells in the woods.[63]

The journal keeper on the brig *Rob Roy* in 1822 collected a story that he clearly associated with that of Noah's Ark. "This tribe," he said, "have a tradition that all the world was once covered with water & that one man his wife & children were all that were saved they say he built a large Canoe and took all kinds of animals and at the expiration of one moon the water subsided and left him high and Dry."[64]

Several journal keepers articulated their belief that at least some of the Northwest Coast Indians were cannibals. Ingraham, for example, says,

> I believe they are cannibals, yet this arises from no ocular demonstration but from their own confession and declaration that they had eaten men and that their flesh was good. There can be little doubt, however, that people resembling those I had seen to the southward in so many particulars should not deviate from them in this. On the contrary, if I can form any judgement from their manners, they are more ferocious than any other people I ever saw.[65]

Ingraham is careful to make a distinction between what he observed and what he only heard about. His shipmate on the first voyage of the *Columbia,* Robert Haswell, insisted that "the people are canables and eat the flesh of their vanqu[i]shed enemies and frequently of their slaves who they kill in Cool blud they make but little serimoney in owning the fact and I have seen them eat human flesh Myself."[66]

In July of 1829 the Boston brig *Griffin* was at Milbanke Sound, and the officers observed a Bella Bella cannibal dance ritual that they described in some detail for Green. Their account so closely resembles George Hunt's description of the Kwakiutl Hamatsa Cannibal Dance, published by Franz Boas in 1930,[67] that there can be little doubt of its being the same ritual. Boas was informed that the cannibal dance had originated among the Bella Bella and was acquired by the Kwakiutl of Fort Rupert by killing the original owners.[68] Green used the episode to illustrate the power of "a class of men called *'Shargers,'* who may be styled the Indian priesthood. . . . These Shargers are thought to have the power of inflicting disease upon an absent person, which can be cured only by their agency."[69] As described to Green, this particular incident involved "several of the Bilballa Indians who reside at a place called Mill-Bank Sound."

> The officers of the brig informed me, that they observed, on a certain
> day, the Indians on shore in a state of great commotion, running about
> with great celerity, followed by the Shargers. So great was their perturba-
> tion, that several of their canoes, filled with women and children, came
> alongside of the brig for protection. Among these were several who had
> lost pieces of flesh from their arms, bitten, as they said, by these
> Shargers, who were determined to eat them. Failing to destroy the living,
> they hasted to a place where two children had been interred, and taking
> them from their repose, they passed close by the brig, carried them to the
> village, and, as the Indians declared, ate of their flesh. The individuals
> who were bitten and the chiefs declared, that this was "lux"—"good."[70]

Green attempted to find out whether this practice was widespread, asking the people of Milbanke Sound to confirm the report (which they did), and then asking a Tlingit native of Tongass and a Kaigani Haida if "the same ceremony was practiced among all the tribes of the coast." From the former he heard that it had been widespread at one time "but was now confined to a few tribes."[71] The latter preferred not to speak about the subject.

The issue of cannibalism emphasizes problems inherent in shipboard sources as ethnographic documents. No sailor but Haswell claims to have actually *witnessed* cannibalism, but they believed it to be a fact because

native people *told* them that it was. Whether they actually consumed human flesh or not, the cannibal dancers wished their audience to *perceive* that they did, and that perception was described as fact by foreigners who did not understand that there might be a difference.

As time went on, eyewitness accounts became polluted by information that observers already had when they arrived on the Northwest Coast. As an example, Josiah Sturgis was at the Columbia River on board the Ship *Levant* in 1818 and did not travel elsewhere on the coast. He wrote that "the houses are decorated with rude carved Images, which they call Clamas or gods, but they do not seem to pay any kind of homage or attention to them."[72] It is difficult to know here whether Sturgis described what he actually saw or depended upon information from sources that he must have read. His description is very similar to one given by Cook of houses at Nootka Sound two hundred miles north and forty years earlier. The word "Clamas" is even similar to the "Klummah" of Cook and Hoskins.

It is certain that other traders at the Columbia River had read Cook or had heard details from the published narrative of Cook's third voyage, since they make reference to things said by Cook, in the process not only misquoting the British captain but transferring his references from Nootka Sound to the Columbia River. Alexander Henry, at Astoria in 1813, described a canoe used in a traditional burial by the Chinook. It was "a large, handsome sea canoe, well studded, outside and inside, with sea shells of various kinds, the same as those Captain Cook mistook for human teeth."[73] Henry likely took the reference, not from Cook directly, but from Alexander Mackenzie's journal, which was published in 1801. Mackenzie had seen a similar canoe at the Columbia River, "built of cedar . . . painted black and decorated with white figures of fish of different kinds. The gunwale, fore and aft, was inlaid with the teeth of the sea otter." Mackenzie then made a special note:

> As Captain Cook has mentioned, that the people of the sea-coast
> adorned their canoes with human teeth, I was more particular in my
> inquiries; the result of which was, the most satisfactory proof that he
> was mistaken; but his mistake arose from the very great resemblance
> there is between human teeth and those of the sea otter.[74]

Mackenzie either misunderstood Cook or did not actually read the explorer's narrative. Cook, referring to canoes seen much farther north, had actually said that

their canoes are of a simple structure; but to appearance, well calculated for every useful purpose. . . . For the most part, they are without any ornament; but some have a little carving, and are decorated by setting seals' teeth on the surface, like studs; as is the practice on their masks and weapons. A few have, likewise a kind of additional head or prow, like a large cut-water, which is painted with the figure of some animal.[75]

If the men who actually traveled to the Northwest Coast were willing to expand on their own eyewitness accounts with cultural amalgams from additional sources, it can be no surprise that the writer Washington Irving (who never visited the Northwest) could come up with an entirely mistaken description of totemic carvings along the Columbia River in his popular book *Astoria*. Nothing like the freestanding, fully carved totem poles of the Queen Charlotte Islands were found as far south as the Columbia River, though smaller representational figures of humans and animals were occasionally found there, and there is some evidence, according to Bill Holm, that house posts were decorated with carving.[76] No sailor ever presumed to go so far in interpreting the place of these carvings in native society as Washington Irving did, even if the sailor had seen them, sketched them, and participated in their erection and dedication. According to Irving,

> [t]hese Indians have likewise their priests, or conjurers, or medicine men, who pretend to be in the confidence of the deities, and the expounders and the enforcers of their will. Each of these medicine men has his idols carved in wood, representing the spirits of the air and of the fire, under some rude and grotesque form of a horse, a bear, a beaver, or other quadruped, or that of bird or fish. These idols are hung round with amulets and votive offerings, such as beavers' teeth, and bears' and eagles' claws.

Irving goes on to say that if there was a dispute among shamans, "to settle [it] they beat their idols soundly against each other; whichever first los[t] a tooth or a claw [was] considered as confuted, and his votary retire[d] from the field."[77]

Eventually the very presence of Americans began to have a dramatic effect on the cultural landscape of the Northwest Coast. Totem poles flourished, not only with new tools but with new wealth. As individuals began to parlay the goods accumulated in exchange for their furs into status, the symbols of that new status were erected on the beaches in front of native

villages. While new positions in the social and cultural hierarchy were apparently being carved out, ancient ones were being lost to the ravages of disease. By 1829 Green could say with surety that "the Indians on the coast are without a doubt decreasing."

> This they readily admit, and this is the concurrent opinion of all who
> have been acquainted with them for a few years. Some thirty or forty
> years since, the small-pox made great ravages among them. This disease
> they call *Tom Dyer,* as some suppose from a sailor of this name who
> introduced it. . . .[78]

When William Cushing, a recent Harvard graduate, came to the Columbia River from Massachusetts in 1844 on the *Chenamus,* a vessel owned by his family, he found that the region was teaming with immigrants from the Atlantic coast—missionaries, trappers, farmers, and settlers. Like many Americans of the time, he viewed the ultimate extinction of the native people as inevitable:

> Within a few years the Indians have decreased very rapidly in this
> neighborhood. [T]he principal cause of this has been the ague which
> broke out among them some 12 or 15 years ago and has carried off
> large numbers every season since. [T]he Indians say that the "Bostons"
> brought this disease into the country. Last year a sort of flux made its
> appearance and raged with considerable virulence. [F]ew who were
> attacked by it survived. Probably in a few years, not one of that number
> who, a short half century ago, were the sole possessors of the soil will be
> left to tell of the departed glory of his ancestors. Thus is it—wherever
> civilization has planted herself the extinction of the natives has followed.
> [O]ur own country is an example of this—the islands of the Sea prove
> it. Oregon is fast losing her original people & ere many years have
> passed not a red man will be found in all the lengthe and breadthe of
> America—from Hudson's Bay to the Gulf of Mexico—from the shores
> of the Atlantic to those of the broad Pacific.[79]

A half-century after he was first on the Northwest Coast, William Sturgis worried not only that Northwest Coast Indian *people* would be decimated by Yankee violence and disease, but that their *culture* would be annihilated in the process:

> The native population on both sides [of] the continent are
> doomed to the same fate—injustice, oppression and speedy extermina-
> tion. . . . If the causes already operating do not sweep off the natives fast

enough to meet the views of settlers and clear the way for the tide of emigration now rushing in that direction, violence will be resorted to. The Christian white man is never at a loss for a pretext for making war upon heathen savages when their lands are wanted—in such a war many will be destroyed. . . .

It is now, I fear, too late to do the Indian justice. There is not, within my knowledge, any full and faithful description of what he was in his original state, or of the events that have brought him to his present condition, and I doubt if materials for such a work, or an individual possessing sufficient knowledge of Indian character, and other requisites to use them, can now be found.[80]

Neither Cushing nor Sturgis could have predicted that both the population and the culture of the Northwest Coast would rebound from the blows dealt them in the nineteenth and early twentieth centuries, but Sturgis's comments especially were well taken. In a society where historical and cultural information is transmitted orally, the premature death of those persons whose responsibility it is to *remember* can result in permanent loss of the information. While culture is a fluid and changing thing, and while human nature allows us to plug new information and traditions into the gaps left by such missed transmissions, sometimes specific information can be recovered from other sources. In the case of Northwest Coast Indian culture, Sturgis could never have known how important he himself would become as such an alternative source. The fact that he and other "Boston men" observed and noted aspects of Northwest Coast Indian life allows certain elements of that life to be reconstructed two hundred years later, after the seeds of change that they inadvertently sowed had sprouted, grown, and been harvested.

It is important when considering such sources to keep a wary eye on the documentable history of both cultures. Anthropologists have been led astray in the past by misinterpreting shipboard history and culture,[81] and historians have dramatically changed their interpretation of past events simply by asking a different series of questions of the same source materials. Used with caution and sense, however, and placed in a carefully considered historical context, the seemingly ethnocentric ramblings of young mariners have a great deal of information to impart about traditional practices. Anthony Pagden compared similar narratives for other regions to more contemporary anthropological sources:

For most of the writers I have discussed in this book the problem, then, was precisely how to understand 'otherness' in terms which made sense

both as an account of 'their' lives or beliefs, *and* as an account of the lives and beliefs of beings who were still sufficiently like 'us' to be clearly recognizable as part of what all contemporary Europeans understood to be the 'brotherhood of man.' . . . Modern ethnographical descriptions may seem, at first glance, more complex and more persuasive than their eighteenth-century predecessors. But that is generally an illusion which disappears on a second reading. We have a different set of concerns, a different 'grid' through which we read the evidence we have before us. But it need hardly be said that that grid is as powerfully present as it was two hundred years ago. . . . The plight of much contemporary anthropology, reduced to professional introspection, or historical self-criticism, is a reflection of the awareness of this.[82]

One hundred years after the Boston ships *Columbia* and *Washington* initiated the American trade, Franz Boas arrived for the first of a series of influential visits. Yankee traders had described Northwest Coast Indians in their own ethnocentric terms and according to their own cultural perceptions and experience. Boas found that the reverse was also true. Attending a potlatch among the Kwakiutl, Boas observed a dramatic masked characterization of a "Boston man," a Yankee sailor from the era of the maritime fur trade. Visions of the exotic "other" worked both ways, and each group documented the interaction in the manner consistent with their own cultural practices.

Ultimately, many of the changes brought about by the maritime fur trade were so fully incorporated into Northwest Coast Indian life that they were virtually indistinguishable from pre-contact traditions to either foreigners or native people. The collectors who descended on the Northwest Coast in such great numbers after 1876 had no concept of how much of the material they were collecting had, in fact, been made in the heyday of fur trade wealth.[83] The ultimate in ceremonial clothing today, throughout the length of the Northwest Coast, is a dancing robe made of a trade blanket with a traditional crest figure outlined in the mother-of-pearl buttons that were first introduced by Boston traders.

# SOUVENIRS AND SCIENTIFIC COLLECTING

## "THAT EVERY MARINER MAY POSSESS THE HISTORY OF THE WORLD"

Sailors had been collecting souvenirs on their voyages for well over a thousand years when American vessels first traveled to the Northwest Coast, but the artifacts that returned to New England on Yankee ships in the late eighteenth and early nineteenth centuries met a different sort of reception than had existed previously. For the first time, public-spirited institutions waited to receive them. There had been both private collectors and royal collections in Europe for several centuries, but the simultaneous expansion of international commerce and the creation of learned societies in Boston after the American Revolution made it a unique and important center for the collecting of "curiosities." Native American artifacts were particularly welcome, as many of these institutions were self-consciously attempting to define a uniquely American history and culture and came to regard the New World's native people as a potential counterpart to the ancients of the Old World.

The explicit rationale for institutional collecting at the time was science. Scientists could bring botanical, zoological, geological, and ethnological specimens from newly discovered territories into the laboratory for identification and comparison. "Natural curiosities," specimens from nature, and "artificial curiosities," those fashioned by human hands, were gathered at every landfall and brought to "cabinets of curiosities," where the intellectual institutions of the young America could create a scientific taxonomy of nature and culture.

The American Philosophical Society had been founded in Philadelphia before the Revolution, but it was in Boston that the learned societies of the United States really blossomed and flourished in the years following the War of Independence. The American Academy of Arts and Sciences, patterned closely on the Philadelphia model, was founded in 1780,

followed by the Massachusetts Society for Promoting Agriculture in 1785, the Massachusetts Historical Society in 1791, the Anthology Society in 1804 (which became the Boston Athenaeum in 1806), the Linnean Society of New England in 1814, and the Boston Society of Natural History in 1833.[1] The American Antiquarian Society was established at Worcester, Massachusetts, in 1812, "forty miles distant from the nearest branch of the sea" in order to protect its collection "from the ravages of an enemy, to which seaports in particular are so much exposed in times of war."[2]

These intellectual, historical, and scientific societies founded after the American Revolution were definitely *not* conceived as an egalitarian means to edify or educate the masses; all were private organizations and several had strict limitations on membership. While the low social status of common sailors would generally have kept the seafaring community separate from the members of such institutions, the nature of the collecting enterprise brought the two groups into regular contact. Many merchants and several sea captains had social connections or philanthropic means and inclinations that made them welcome in the founding circles of Boston's learned societies. More importantly, mariners had access to artifacts collected on foreign voyages, and a collection of such objects was a necessary component of the complete scientific society. The growth, during the Victorian era, of the disciplines of natural history and its progeny ethnology was increasingly dependent on these collections.

Master mariners did not depend only on professional scientific institutions to house and describe the curios they brought from overseas. In 1799, the local captains who founded the East India Marine Society in Salem determined that they would not only share navigational information and provide funds for the widows and orphans of men lost at sea (the primary objectives of most marine societies), but they would create a museum and fill it with their own exotic souvenirs. They summed up their feelings about the endeavor in a toast proposed at one of their meetings in 1804: "Natural history. May commerce never forget its obligations, and a Cabinet. That every mariner may possess the history of the world."[3] These collectors found an essential harmony between memorializing their own adventures in tangible souvenirs and returning scientific specimens to the learned and marine societies, where their curiosities could be incorporated into the evolving scientific taxonomies that placed newly encountered cultures into a context of the known world.

While the notion that a merchant had a scientific obligation to society was a new one at the turn of the nineteenth century, the tradition of souvenir collecting went back at least to the fifth century B.C. when the

Carthaginian Captain Hanno returned home with gorilla skins from the west coast of Africa.[4] Columbus brought bird and animal skins back to Spain from America, and it was common after that for European monarchs to request that collections be made for them by explorers and traders.[5] European cabinets of the sixteenth and seventeenth centuries had already been described as "archives of nature" by Antonio de Ulloa, a Spanish explorer of the Enlightenment.[6] The tradition of assembling collections of exotic souvenirs went hand in hand with the acquisition of religious relics, and the former were not only often displayed side by side with the latter, they were occasionally described in similar terms. The best cabinets were, naturally, in the major seaports and were often visited by educated tourists and occasionally even by sailors.[7]

Voyages to the Northwest Coast had resulted in a number of collections prior to the arrival of Americans in 1788. The first Spanish expedition in 1774, under the command of Captain Juan Josef Perez Hernandez, assembled a collection of artifacts that was later presented to the viceroy of Mexico. It included:

> A cloak that appears to be of coconut burlap.
>
> Another of the same made with greater ability and bordered on one side with white and black, with little pieces of sea-otter skin in the form of little squares on both sides like a checker board.
>
> A belt or sash that looks like wool and well-woven with the edges bordered with black.
>
> A skin cap that looks like a he-goat with a sort of vizor of black seal skin adorned with two rows of teeth alongside, which appear to be those of a fish.
>
> A hat woven with a great deal of ability which appears to be of fine basketry.
>
> Another of the same, of Chinese style and much more beautiful because of its weaving and because it has depicted thereon the canoes which they use, and made of basketry material dyed black.
>
> A quadrangular pouch also of basketry and without any stitching, with twenty-four little sticks of wood, well carved and delicate, which they use for playing music during their dances.
>
> A pouch or bag of very delicate basketry, very beautifully made, and on it, a species of bird made of bone with its upper beak broken, acquired from an Indian woman who wore it around her neck along with a number of little teeth, which looked like those of a small alligator.[8]

When Captain James Cook arrived on the Northwest Coast in March 1778, he was surprised to see silver teaspoons, remnants of the Spanish visit, in the possession of a high-ranking Indian. The use of metal was not unknown to the Indians and, to Cook's surprise, there was some limited native use of iron and copper. The familiarity that the Indians had with iron was enough to make it extremely desirable, and a brisk trade ensued once Cook reached Nootka Sound:

> They shewed great readiness, however, to part with any thing they had, and took from us whatever we offered them in exchange; but were more desirous of iron, than of any other of our articles of commerce; appearing to be perfectly acquainted with the use of that metal. [9]

Cook and his entourage remained at Friendly Cove in Nootka Sound for over a month making repairs to their ships. Several members of the party, including Cook and artist John Webber, went ashore and were fêted in the home of the local chief, Maquinna. During their stay at Nootka Sound and elsewhere along the coast, the crewmen were allowed to trade freely with the Indians who came alongside in their canoes:

> A great many canoes, filled with the natives, were about the ships all day; and a trade commenced betwixt us and them, which was carried on with the strictest honesty on both sides. The articles which they offered to sale were the skins of various animals, such as bears, wolves, foxes, deer, rackoons, polecats, martins; and, in particular, of the sea otters, which are found at the islands East of Kamtschatka. Besides the skins in their native shape, they also brought garments made of them and another sort of clothing made of the bark of a tree, or some plant like hemp; weapons, such as bows, arrows, and spears; fish-hooks, and instruments of various kinds; wooden vizors of many different monstrous figures; a sort of woolen stuff, or blanketing; bags filled with red ochre; pieces of carved work; beads; and several other little ornaments of thin brass and iron, shaped like a horse-shoe, which they hang at their noses; and several chissels, or pieces of iron, fixed to handles. . . . For the various articles which they brought, they took in exchange knives, chissels, pieces of iron and tin, nails, looking-glasses, buttons, or any kind of metal. Glass beads they were not fond of; and cloth of every sort they rejected. [10]

During their period in residence at Nootka Sound, Cook first noticed the indigenous trade that occurred on the coast, not only in furs but in ethnographic material.

We also found, that many of the principal natives, who lived near us, carried on a trade with more distant tribes, in the articles they had procured from us. For we observed, that they would frequently disappear for four or five days at a time, and then return with fresh cargoes of skins and curiosities, which our people were so passionately fond of, that they always came to a good market.[11]

The length of time spent on the Northwest Coast, especially at Nootka Sound, coupled with the unparalleled freedom afforded to ordinary seamen to barter on their own for provisions, souvenirs, and sexual favors led to a frenzy of private trading at Nootka Sound that was unmatched in any subsequent voyage:

Nothing would go down with our visiters but metal; and brass had, by this time, supplanted iron; being so eagerly sought after, that before we left this place, hardly a bit of it was left in the ships, except what belonged to our necessary instruments. Whole suits of clothes were stripped of every button; bureaus of their furniture; and copper kettles, tin cannisters, candlesticks, and the like, all went to wreck; so that our American friends here got a greater medley and variety of things from us, than any other nation whom we had visited in the course of the voyage.[12]

Cook learned a lesson about the damage this free trade could cause a ship in need of provisions or intending to trade for a specific commodity. On the way to Hawaii in November 1778 he wrote,

[a]s it was of the last importance to procure a supply of provisions at these islands; and experience having taught me that I could have no chance to succeed in this, if a free trade with the natives were to be allowed; that is, if it were left to every man's discretion to trade for what he pleased; for this substantial reason, I now published an order, prohibiting all persons from trading, except such as should be appointed by me and Captain Clerke; and even these were enjoined to trade only for provisions and refreshments. Women were also forbidded to be admitted.[13]

Cook and his company gave some of the collected objects to Russian traders at Kamchatka, but they brought a large number to Great Britain, which was then distributed among the British Museum, Trinity College in Dublin, and Sir Ashton Lever's museum. The entire collection of the Leverian Museum was sold at auction in 1806, thus distributing the Cook material all over Europe.[14]

In 1786, when the next authorized British expedition arrived on the Northwest Coast, private adventure by members of the ship's company was prohibited. Captains Nathaniel Portlock and George Dixon were charged with exploring the potential for trade among London, the Northwest Coast, and Canton. In order to insure that the price of furs and provisions was not inflated by secondary trading, they strictly controlled the distribution of English products. Nonetheless, Captain Dixon assembled a modest collection of biological specimens and ethnographic artifacts for Sir Joseph Banks, to whom he also dedicated his journal.[15]

In the Queen Charlotte Islands, Dixon was determined to collect an impressive labret for Banks:

> There were likewise a few women amongst them, who all seemed pretty well advanced in years; their under lips were distorted in the same manner as those of the women at Port Mulgrave, and Norfolk Sound, and the pieces of wood were particularly large. One of these lip-pieces appearing to be peculiarly ornamented, Captain Dixon wished to purchase it, and offered the old woman to whom it belonged a hatchet; but this she refused with contempt; toes, basons, and several other articles were afterwards shewn to her, and as constantly rejected. Our Captain began now to despair of making his wished-for purchase, and had nearly given it up, when one of our people happening to shew the old lady a few buttons, which looked remarkably bright, she eagerly embraced the offer, and was now altogether as ready to part with her wooden ornament, as before she was desirous of keeping it. This curious lip-piece measured three and seven-eighth inches long, and two and five-eighth inches in the widest part: it was inlaid with a small pearly shell, round which was a rim of copper. [Dixon's footnote: "This lip-piece is now in the possession of Sir Joseph Banks, Bart."] [16]

Though Joseph Banks never went to the Northwest Coast himself, he donated twenty Northwest Coast Indian items to the British Museum, which had been collected by Dixon and others. These include a Nootkan whalebone club, an example of Tlingit weaving, numerous baskets, fishhooks, harpoons, combs, knives, and two carved wooden dishes.

Collections were also made on the voyage of British naval commander and cartographer George Vancouver (1791–1795), by the Spanish explorer Malaspina (1791–1792), and by members of the Russian-American Company, who operated further north on the coast for several decades.[17]

When the first Americans arrived on the Northwest Coast, they showed an immediate interest in cultural artifacts and began collecting

them for the syncretic world of science and souvenir back home. The first attempts were unsuccessful. On 10 August 1788 as the sloop *Washington* made its first approach to the coast, Mate Robert Haswell reported an encounter with the occupants of a canoe who "were armed with bows and arrows they had allso spears but would part with none of them." Near Cape Flattery in Makah territory a few weeks later, they encountered "two Indion Whaleing canoes each having 6 people." According to Haswell, "there whaleing utentials were very curious but they would part with none of them." Eight months later after a cruise north, the *Washington* returned to Cape Flattery where the crew of a Makah canoe offered the Americans "their own manufactored blankets which weir realy curious," but a "disagreable chop of a Sea" prevented closer communication.[18]

Aboard the companion ship *Columbia*, Captain John Kendrick traveled to the Pacific with a specific mandate to collect souvenirs of the native people and environment for the Reverend William Bentley of Salem. The relationship between Kendrick and Bentley was similar to that between Dixon and Banks. Bentley was a distinguished cleric and early member of and donor to both the Massachusetts Historical Society and the American Antiquarian Society; he was also instrumental in guiding the East India Marine Society of Salem towards establishing a cabinet of curiosities.[19] As he had a keen interest in science and knew that the *Columbia* and *Washington* would be the first American vessels to follow in the wake of Captain Cook, it is not surprising that Bentley asked the commander of the expedition to assemble a modest representative collection for him.

Because Kendrick did not return to Boston, and because relations between him and his junior captain, Robert Gray, were strained, the collection Kendrick made for Bentley was sent home from Canton on two Salem vessels. It arrived before Gray completed his historic circumnavigation and returned to Boston on the *Columbia* in August 1790. As Bentley noted in his diary on 31 May 1790, "My good friend Capt Hodges [of the ship *William and Henry*] presented to me a Pike or Spear of Wood, with a Bow & two Arrows brought by the American Ship *Columbia* from Nootka Sound to Canton, & Specimens of Cloth from Sandwich Islands." A week later he reported of "curiosities delivered to me by Capt H. Elkins [of the ship *Atlantic*] . . . Specimens of Cloth from the *Columbia*. Hooks of Bone & Mother of Pearl from the Natives of America, with Lines." [20]

In 1801 Bentley donated Northwest Coast Indian artifacts to the Massachusetts Historical Society, at least some of which must have been part of his gift from Kendrick. Two of the owners of the *Columbia* and *Washington* donated objects that must also have been collected on the first

American voyage to the Northwest Coast. Joseph Barrell gave a basketry hat as well as a "cloak and mantle, pieces of cloth, etc. from Nootka Sound" to the Massachusetts Historical Society in 1791. John Derby, who was a partner in the first voyage only, gave fishhooks and "bows, arrows, & spears from the N.W. Coast" to the East India Marine Society in his hometown of Salem in 1799. Robert Gray, master of the *Columbia* on its return to Boston, gave "a bow and arrow from the Northwest Coast of America" to the Massachusetts Historical Society in 1793, at the conclusion of his second voyage.

Clearly, a notion that they were participating in the science of the age motivated the collecting habits of several Northwest Coast captains. The link between geographic origins and language was a popular subject of study and discourse at the time. Thomas Jefferson was an avid collector of Indian languages, and several publications, especially Benjamin S. Barton's *New Views of the Origin of the Tribes and Nations of America*, were influencing the way amateur scientists, including those on the decks of ships, viewed the world. Accordingly, not only did mariners collect artifacts and natural history specimens for various scientific societies, but they collected Indian lexicons as well. And while the knowledge of native languages was no doubt an aid to commerce, some collectors also speculated about linguistic differences and what they might signify about the origins of the people of the Northwest Coast.

Joseph Ingraham, who first traveled to the Northwest Coast as mate on the *Columbia*'s first voyage, returned there in command of the Boston brigantine *Hope* on a voyage of 1790 to 1793. He kept a journal complete with numerous drawings of birds, fish, geological formations, and native people and compiled a vocabulary of Haida words. Frustrated by his inability to transfer hard-won language skills from one part of the coast to another, he speculated on the linguistic differences of the region:

> Of their language I can say but little and present my vocabulary collected with as much care as time and circumstances would admit of. In many instances it is guttural in the extreme so that it cannot be reduced to our orthography. What I have committed to paper is as it struck the ear and, I presume, may serve to convey an idea to those who may view it from curiosity or amusement and be serviceable to those who may have occasion to practice it.
>
> The foregoing vocabulary I have collected with all possible care in Cummashawaa's harbor, but it is to be observed (especially by those who may have occasion to practice the language for the benefit of trade) that

there is some difference in the dialect of those in the southern part of
the isles and those in the north [here he gives several examples]. . . .
How does it happen that so many different languages are spoken on the
western side of the continent, many of which are without the least simi-
larity, and that the languages of all the South Sea Isles bear so strong
similitude to each other that they are generally supposed to have sprung
from the same stock? [21]

Ingraham goes on to posit that the Polynesian people of the South Pacific
must have emigrated "from the westward—say the Caroline Islands or near
them—from which circumstance they cannot differ so materially in their
language." Ingraham concludes that the indigenous people of the North-
west Coast are the descendants of different Asian cultural groups, each hav-
ing migrated with its own language intact:

My opinion is that the present inhabitants of the N.W. Coast from the
far north . . . to the Gulf of California immigrated from the north-
ward . . . [and] must be the sons and daughters of the Chinese, Tartars,
Siberians, Russians, Japanese, Kamschatkans, and many others well
known to everyone that is the least acquainted with geography. Hence
the wonders of the different languages among them must cease. . . .[22]

William Sturgis, who made four voyages to the Northwest Coast
between 1798 and 1808 and later became one of the most prominent mer-
chants in the trade, presented a series of lectures on the subject to Boston
audiences between 1845 and 1850.[23] Sturgis had as much experience trad-
ing on the coast as anyone then living and had, over the intervening years,
reflected on his own experiences and on the significance of the trade. Like
Ingraham, he was intrigued by the notion that linguistics could provide
information about the origins of American Indian peoples and clues to
connections among various tribal groups. He had himself collected vocab-
ularies on the Northwest Coast and was a gifted linguist. In his second lec-
ture he made the following comments:

The languages spoken by different nations along the Coast differed
from one another so radically that I could discover no resemblance, and
only in a few instances trace analogies, excepting that like the languages
of all aboriginal inhabitants of this continent they were copious in terms
describing sensible objects, and expressing their qualities and relations,
but very deficient in those expressing generalization or abstract ideas.
There is a great difference in the sound, some being soft and others so
harsh and guttural that the pronunciation can only be acquired early in
life, while the organs of speech are flexible. . . .

One fact, however, in this relation is worthy of note; and that is, the remarkable resemblance of the language spoken at Nootka, Clayoquot and its vicinity upon Quadra and Vancouver's Island, to that spoken in Mexico at the time of its conquest by Cortez. This language is totally different from any other in use upon the Coast. In fact the Indians seem to be of a different, and in some respects superior, race . . . essentially different from any now existing in North America. Mr. Prescott in his chapter upon the different races that occupied Anahuac (which included Mexico, Tlacopan and Tezcuco) preceding and at the time of the conquest, speaks of "a numerous and rude tribe, called the Chuhimecs, who in the twelfth century entered the Country from the region of the far North West," and adds that a large portion of this tribe was soon after amalgamated with the Tezcucans. It may be interesting to those who are curious in such matters to ascertain how far can be traced the resemblance, or identity, of the language now spoken upon Quadra and Vancouver's Island with that of Tezcuco when conquered by the Spaniards . . . The peculiar terminations of many words, - proper names and others, - intl, lt, or lth are common to both languages, and I believe are peculiar to them. I could point out plausible theories, founded upon less probable conjectures than that the "Chickemecs" were from the North Western shores of the Pacific, and at no very remote period in the history of the world had a common origin with the tribes now inhabiting the neighborhood of Nootka Sound.[24]

Henry Meigs, a U.S. Congressman from New York (1819–1821) transcribed a journal of daily activities at Astoria as part of the evidence collected for the "Oregon Question" debates. Transcribing an entry about trading for "wapatoes," a native potato of the Columbia River, he could not resist making an editorial notation that it was "the same word nearly, on the two sides of the Continent."[25]

The birth of the scientific societies seems to have inspired a number of captains to make collections of artifacts specifically for them. James Magee left Boston commanding the ship *Margaret* in October 1791, about eight months after the founding of the Massachusetts Historical Society. He assembled a large collection of artifacts at the Hawaiian Islands and on the Northwest Coast, which he presented to the society in October 1794, about a year after his return.[26]

That Magee should want to make such a gift to a newly formed scientific institution in his hometown is not strange. More unusual is Roderic McKenzie's gift of forty "articles from the North West, Pacific Ocean & c."

to the American Antiquarian Society in Worcester from Terrebonne, Quebec, in 1818.[27] In this case, the presentation of a large collection is by someone unrelated to a particular institution or locale, where the advancement of science can be the only explanation for the donation. McKenzie had no previous relationship with the society, which had been founded only five years earlier, but he must have been impressed by their mission to afford "a safe repository for the discoveries which have resulted from the researches of scientifick and inquisitive men."[28]

McKenzie was in a good position to make a collection of artifacts from the western half of the North American continent. A cousin of the explorer and fur trader Alexander Mackenzie, Roderic McKenzie had charge of the North West Company's trading operation when it was established at Fort Chippewayan on Lake Athabasca in 1789, and he was later a chief trader at their headquarters in Terrebonne, near Montreal. The company had a number of trading posts on the Northwest Coast, including, for a time, Fort George (the former Astoria). Unable to ship furs directly to Canton, the North West Company also had, from 1817 to 1821, a contractual relationship with the Perkins firm of Boston; it may have been this connection that linked McKenzie to the "Boston men" and their cultural institutions.

The most common types of objects donated in the early years from the Northwest Coast were paddles, fishhooks, weapons, hats, and clothing—the things most readily available in a casual encounter, where the exchange of souvenirs was spontaneous. These were items that Northwest Coast Indians had in their canoes for their own use when they approached foreign vessels. In 1817 Peter Corney, first mate of the British schooner *Columbia,* observed "nets, hooks, harpoons, and fish-gigs, etc., also long spears for spearing salmon"[29] in a Chinook canoe on the Columbia River, all part of the customary gear.

Captain George Vancouver, whose British naval expedition of 1790 to 1795 was charged with charting the coastline, gives perhaps the best description of a spontaneous trade in artifacts:

> Convinced of our amicable disposition towards them, near the whole of
> the inhabitants, men, women and children, gratified their curiosity in
> the course of the day by paddling round the ship; for neither the ladies
> nor the children ventured on board. This was the case also with the
> generality of the men, who contentedly remained in their canoes, row-
> ing from side to side, bartering their bows and arrows; which, with their
> woollen and skin garments, and a very few indifferent sea-otter skins,

composed the whole of their assortment for trading; these they exchanged, in a very fair and honest manner, for copper, hawk's bells, and buttons, articles that greatly attracted their attention. Their merchandise would have been infinitely more valuable to us, had it been comprised of eatables, such as venison, wild fowl or fish, as our sportsmen and fishermen had little success in either of these pursuits. All the natives we had as yet seen, uniformly preferred offering such articles as composed their dress, arms, and implements for sale, rather than any kind of food, which might probably arise either from the country not affording them a superabundance of provisions, or from their having early discovered that we were more curious than hungry. [30]

Not everything carried in a canoe was available for purchase of course. As noted by Robert Haswell in 1788 (and quoted above), items of everyday technology, such as bows, arrows, spears, and whaling gear were often more valuable to their native owners than were the Euro-American manufactures offered in exchange. Offers to purchase or trade for such artifacts, especially in the early years of contact, were as often refused as accepted. Nonetheless, many items were available, as Corney found on the coast of Oregon where several "canoes came off, and the natives appeared quite friendly. We bought several good sea otter skins; at an axe for each skin; many bows, arrows, daggers, etc., for small beads." [31] Among the Aleutian Islands, Corney found people "extremely fond of rum" and willing to "part with their garments and hunting utensils, to purchase a small quantity." [32]

Occasionally a weapon was offered up as a peace offering by the Indians to avoid a violent confrontation, such as Corney described at Tillamook Bay, south of the Columbia River:

> We had scarcely time to moor before we were surrounded with canoes; we triced our boarding nets up, and shut all our ports but one, at which the natives entered, keeping all the canoes on the starboard side; and, as the Indians came on board, we took their bows and daggers from them, at which they seemed much displeased. One man (a chief) would not give up his dagger, and we pushed him back into his canoe; upon which he immediately strung his bow, and pointed an arrow at me, as being the most active in sending him out of the ship. In an instant he had several muskets pointed at him, upon seeing which, he lost no time in laying his bow down. Shortly after he came on board, and seemed sorry for what he had done, and made me a present of a fine bow." [33]

As contact became more frequent and regular, it seems that the Indians began to bring along extraneous portable artifacts of the types

known to have been popular among European and American sailors—such as hats, fishhooks, mats, and clubs—in anticipation of trading them. It is important to note here that the choice of artifacts traded was determined more by the Indians who provided them than by the sailors who acquired them. Any object or type of object that the Indians might refuse to trade, or which they did not wish the foreigners to see, could easily be secreted from them simply by not bringing them along.

Almost all contact was on the water, with Yankees on the decks of their ships and native traders in their canoes. When the American ships were anchored adjacent to villages, high-ranking native individuals generally controlled trading, but the trade at sea while en route between villages was usually unsupervised. While the shipboard population was limited to men subject to the strict rules of captains and owners, Northwest Coast Indian people of both genders, all ages, and all social ranks flocked to arriving ships.

Yankee sailors had a much greater range of contact with all levels of society on the Northwest Coast than they had in those parts of the world where a professional merchant class (such as the Hongs at Canton) acted as the intermediary between artisans and producers and their Euro-American customers. Though not ashore and living among the native population, as became common in the Hawaiian Islands, American sailors could learn more about the material culture of Northwest Coast Indians during a cruise than they could learn about the Chinese later in the voyage when they traded their sea otter pelts for tea.

Because they did not spend extensive time ashore, American sailors did not have a selection from the whole range of Northwest Coast cultural materials, but they clearly desired certain types of artifacts more than others. Euro-Americans admired the canoes of the Northwest Coast and collected a number of models of different types, and they collected some objects for use, like fishhooks. Ingraham was forced to admit that his own technology for catching fish was inferior to that which he observed at the Queen Charlotte Islands in 1792:

> In the afternoon a canoe came off and very seasonably supplied us with
> plenty of good halibut. While they were alongside, the wind being
> almost calm, they put over their kelp lines and awkward looking hooks,
> and in a few minutes they hauled up three fine fish which we bought.
> We tried in vain with our implements—apparently so far superior—
> from which the Indians exulted in their success, saying our hooks were
> good for nothing, that we must give them more for the fish they had
> sold us, etc. [34]

If there was a single artifact that represented the exoticism of the Northwest Coast for Yankee sailors, it was the labret—the wooden ornament worn through the lower lip, and the collecting of labrets, and of masks that illustrated the use of labrets, was a priority. When William Sturgis introduced a Boston audience to the "character of the Indians, and occurrences among them," he chose only three objects as illustrations of the traditional culture of the Northwest Coast—two labrets and a mask of a woman wearing a labret. The fascinated revulsion, obvious in the descriptions of labret use that appear in shipboard records, demanded a physical representation as well as a written description; consequently, labrets were popular souvenirs. Two were part of the donation made by Captain James Magee to the Massachusetts Historical Society in 1794.[35] Four "wooden ornaments worn by females in a slit made in the under lip, from the N.W. Coast," were donated by Captain Israel Williams to the East India Marine Society in 1803,[36] and labrets were transferred from the American Antiquarian Society to the Peabody Museum at Harvard in 1910 (probably the examples used by William Sturgis to illustrate his 1848 lecture).

Artifacts were often collected at a distance from the place where they were produced because they were regularly exchanged between tribes or as barter goods in the maritime fur trade with Americans and Europeans. A long tradition of intertribal trade on the Northwest Coast preceded European contact by many centuries. In addition to extensive commercial networks, there was an elaborate system of exchange through potlatching. Also, shorthanded ships signed Northwest Coast Indian men to work as members of their crews, and in the process transported them (and their clothing, gear, and weapons) to other parts of the region and to more distant destinations in California, Hawaii, and Canton. This resulted not only in the wide distribution of objects across regions and cultures, but also in the frequent misattribution of their original sources and cultural contexts.

Traders certainly suspected that some objects were foreign to the place from which they were collected. Ralph Haskins of the ship *Atahualpa* received a "wood mask, curiously wrought" as a present from the Kaigani Haida Chief Cow in 1802 and supposed it was made "by the natives further northward."[37] Haskins himself had happily participated in such a transfer already. In October 1801 he purchased a canoe from the Nahwitti Chief Yackoclash, "being a hansome one," with the expressed "intention of carrying it to the Northward to dispose of."[38]

In addition, in the course of the maritime fur trade, ethnographic artifacts (as well as the raw materials to make them) were transported in bulk from one part of the coast to another. Abalone shells were carried

north from California, and dentalia shells gathered on the west coast of Vancouver Island were traded on the Columbia River. In 1794, Bernard Magee of the Boston ship *Jefferson* recorded the purchase at Barkley Sound of "about 200 small Shells—which is in great demand on the south coast. ... [W]hen our vessel was at Gray's river, the natives said that the[y] would give a prime skin for one string a fathom in length—for which we now gave 5 [lbs.] of [gun] powder—and but few we could purchase at that rate."[39] Likewise, at the Columbia River, elk and moose hides were collected that were bartered to the Nootka, Haida, and Tlingit as armor. These "clamons" or "klemens" had been traded through native means for some time and had been seen by John Hoskins on the west coast of Vancouver Island in 1792.[40] It did not take long before more of these hides were being carried by American vessels than by traditional canoes. At Norfolk Sound in 1799, Samuel Burling, on the Boston ship *Eliza,* described their trade:

> In the afternoon two more trading canoes came into the Cove; they, then, all hands, united their forces to beat us down to their price of one skin for a musket; but finding they spent their breath to no effect, they desisted. Their first inquiry always is for Kas or Clemmel: they are thick moose hides of which they make their war jackets and are impenetrable to any thing but a musket ball—these are generally purchased by the vessels that winter at Columbia River of the natives there, and are always in great demand on the Northern Coast.[41]

Native basketry, especially hats, was traded from one part of the coast to another. When the Lewis and Clark expedition arrived at the Columbia River in December 1805, William Clark described in his journal a hat that had a design woven into it with "faint representations of the whales, the Canoes, and the harpooners Strikeing them." At least one such hat, the unmistakable work of an artist from Nootka Sound, was collected by Lewis and Clark and brought back with them as a souvenir.[42] Such a hat would almost certainly have traveled from Nootka Sound to the Columbia River on board one of the American ships that was then regularly plying that route. When asked what ships were expected, the Chinook were able to provide the expedition leaders with the names of a dozen vessels.[43]

Lewis and Clark were impressed with the quality of Chinook basketry hats. "They are nearly waterproof, light, and I am convinced are much more durable than either chip or straw," Lewis wrote in his journal.[44] Miserable in the wet Northwest winter and finding the gear they brought with them inadequate for protection against the elements, Lewis and Clark commissioned local women to make hats for the members of the expedition to use.

They traded for others as souvenirs, illustrated four of them in their journals, and described seeing or purchasing hats on several occasions.[45] Along with the traditional native garb worn by the local Chinook population, Lewis and Clark also noted "sailor jackets, overalls, shirts and hats independent of their usual dress," and "a considerable quantity of sailor's cloaths, as hats, coats, trousers and shirts." Some of these styles had already been appropriated by local artisans, and Lewis and Clark also purchased a basketry hat "made in the fashion which was common in the UStates two years ago."[46]

Durable and well made, Chinook hats continued to be an important trade item for Americans, who transported them up the coast. Ross Cox, at the American trading post at Astoria, reported that among the trade goods assembled there for shipment in April 1814 were cases of gunpowder, kegs of beads, rolls of tobacco, bales of kettles, shot, cases of iron pots, new guns, and "2 Cases of Chinook hats."[47] Ten years later George Simpson, reporting on the "Standard of Trade" at the Columbia River, equated a "Chinook Hat 1st quality" with four beaver skins; a "common" Chinook hat was worth one beaver, and Chinook mats were worth one-half to two-fifths of the value of a beaver pelt, depending on the size.[48]

Hats had been transferred from one part of the coast to another through native trade for centuries, and the market that flourished in the era of the American fur trade was built on that strong foundation. Sometimes American vessels even promoted native trade. In April 1822 a Haida chief, "Cowell,"[49] was traveling around the Queen Charlotte Islands on the Boston brig *Rob Roy* as a "pilot and translator." At Hutsnuwu he was observed "leaning over the side bargaining for a hat with a fellow in a Canoe."[50]

Sometimes ethnographic artifacts received as gifts on one part of the coast were transported to a different part of the coast and given away in the context of another gift exchange. In this way Captain Richard Cleveland of the *Caroline* was able, in 1799, to cement his trade with a Tlingit chief at Norfolk Sound by giving him a mask that he had previously collected at an unspecified location. He reported in his log:

> Exceedingly pleasant all this day; the Indians endeavor'd (by reporting the arrival of another vessel & other means) to raise the price of their Skins; but in the afternoon finding their plan did not take, they began to trade, & by night we had purchased 104 Skins & 106 Tails: a Chief made me a present of a prime Skin, on condition that I would receive it in their fashion, which was to go into the boat & set down on the Skin in the midst of them, as there were only 5 canoes along side, I con-

sented; while I shook him by the hand, he appear'd much embarrassed, keeping his eyes fix'd on our Muskatoons, as tho' he was fearful we intended to hurt him; I tarry'd but a few minutes with my new acquaintance & on returning on board, presented him with a Coat, lacquer'd box, a mask, and a string of beads, with which he was much pleased and said I was (Nun) good; after this he sold us several prime Skins.[51]

The frequent travel among the Northwest Coast proper, the Alaska coast to the Bering Straits, the Hawaiian Islands, the coast of California, and Canton made it possible to collect goods produced in any one of those locations at virtually any other. Captain John Bradshaw was on the California coast in 1825 commanding the Boston ship *Sachem.* In 1832 he donated a Tlingit basketry hat with six "potlatch rings" to the East India Marine Society as a "cap from Nootka Sound." As Bradshaw had not been to Nootka Sound and could not have been expected to know local goods there from firsthand experience, he apparently attributed the hat to the important center of early trade, which he knew from the reports of his countrymen and from the publications of Cook and others.[52]

The most extraordinary example of an object collected far from its origins is the Aleut gut rainwear (or kamleika) given to Captain Thomas Meek by Kamehameha, the king of Hawaii, and thence by Meek to the East India Marine Society around 1820. Meek was certainly familiar with such Aleut clothing. As captain of the *Amethyst* in 1812, he traveled to Sitka, eventually selling his vessel to the Russians. He returned to the Alaska coast on the *Brutus* in 1817 and made a round-trip voyage from Sitka to Kamchatka, carrying cargo and men for the Russian-American Company. In 1818 he was at Sitka again in command of the *Eagle,* which vessel he took home, arriving in Boston in July of 1820. Large numbers of Aleuts were working for the Russian-American Company in Sitka and on the California coast. Meek had even been contracted by the company's governor, Aleksandr Baranov, to take the *Amethyst,* with Aleut hunters and their fifty-two skin boats (or baidarkas), to California for a season of hunting and a return trip to Sitka in 1812.[53]

The waterproof kamleikas were popular with American and Russian traders not only as souvenirs but as lightweight foul-weather gear. In 1816 Otto von Kotzebue, manager of the Russian-American Company's Unalaska station, had ordered that two of them be procured for each member of his crew.[54]

While Meek certainly knew that the kamleika associated with King Kamehameha was not native to the Hawaiian Islands, apparently Seth

Bass, the Salem doctor hired to catalogue the East India Marine Society's collection, did not. In the 1821 catalogue, it appears as "The Royal Robe of Tamahama, King of the Sandwich Islands, made of the intestines of the Ursine Seal, received of the old King by the donor."[55] Either Meek or some other knowledgeable collector, who knew both Hawaiian and Alaskan traditions, must have commented on this, because the entry is changed in the next catalogue (1831). The "royal" attribution is eliminated, and the robe "ornamented in the most highly wrought and delicate manner" is now described as "*worn* by Tamehameha, King of the Sandwich Islands, and by him presented to the donor."[56] While the difference may seem slight, it does represent movement toward greater accuracy. Meek was not trying to mislead the audience at home, but neither did he want to lose the historical connection that separated *this* kamleika from the many others collected.

Meek gave the East India Marine Society a number of other artifacts from the Northwest Coast and Hawaii, including an Aleut sea otter dart and a remarkable long-visored "Cap of the Principal Chief at Oonalaska— the work done with a knife ornamented with the whiskers of the Sea Lion."[57] This wooden hat, one of the earliest examples collected, was sent back to Salem from Hawaii in the custody of Captain William Osgood.

Hawaiian items went to the Northwest Coast as well. Joseph Ingraham described an exchange with the Haida of Hawaiian featherwork for sea otter pelts in August 1791:

> I showed everything which I thought would induce them to trade, among which were some feather caps and cloaks I had received as presents at the Sandwich Islands. With these they seemed vastly enamored. I sold a cap and two cloaks for five excellent skins. Skatzi praised them highly, which induced Skutkiss [Skidegate] to buy them, but after possessing them a little while he repented his bargain and asked for his skins again. But as sea otter skins were to me much better curiosities than caps and cloaks, I chose to adhere to the bargain.[58]

The second thoughts of the Skidegate chief about the value of the Hawaiian souvenirs would probably have made him willing to put them back into circulation by giving them away himself when the opportunity arose. A few years earlier, George Dixon had made a gift of Hawaiian tapa cloth, which was admired as it hung in the rigging of his ship; once traded, it was immediately modified and incorporated into Tlingit life:

> One of the Chiefs who came to trade with us, happening one day to cast his eyes on a piece of Sandwich Island cloth, which hung up in

the shrouds to dry, became very importunate to have it given him. The man to whom the cloth belonged, parted with it very willingly, and the Indian was perfectly overjoyed with his present. After selling what furs he had brought with great dispatch, he immediately left us, and paddled on shore, without favouring us with a parting song, as is generally the custom. Soon after day-light the next morning, our friend appeared along-side, dressed in a coat made of the Sandwich Island cloth given him the day before, and cut exactly in the form of their skin-coats, which greatly resemble a waggoner's frock, except the collar and wrist-bands. The Indian was more proud of his new acquired dress than ever London beau was of a birth-day suit, and we were greatly pleased with this proof of these people's ingenuity and dispatch; the coat fitted exceedingly well; the seams were sewed with all the strength the cloth would admit of, and with a degree of neatness equal to that of an English mantua-maker.[59]

A most remarkable example of the integration of a Polynesian object into traditional Northwest Coast Indian culture is a Tahitian feather gorget, known as the "Raven Cape," which was almost certainly collected before 1792 and which became an extremely important Tlingit crest item.[60]

The trade connection to California was almost as strong as it was to Hawaii. Large numbers of Alaska natives were transported on American ships to the California coast to hunt sea otters in the first two decades of the nineteenth century. The native hunters spent limited time ashore, but many traded with the American crews of the vessels that carried them, and transferred those artifacts to yet other vessels. In 1806 Captain John Hudson of the schooner *Tamana* received "a great curiosity" from Jonathan Winship, master of the *O'Cain*. Both vessels were on the California coast—the *O'Cain* with a crew of Kodiak hunters. Hudson says that "Capt. Winship presented me with a Russian or rather Codiac coat made of the Innards of Sea Lion."[61]

In later years when Russian vessels transported their own Alaska-native labor force to the California coast, they occasionally traded with the American vessels that they met. When Richard Henry Dana, Jr., was in San Francisco Bay in December 1835, he saw a "brig under Russian colors, from Asitka, in Russian America, which had come down to winter, and to take in a supply of tallow and grain." He continued:

> We made some trade with them, buying Indian curiosities, of which they had a great number; such as bead-work, feathers of birds, fur

moccasins, & c. I purchased a large robe, made of the skins of some animal, dried and sewed nicely together, and covered all over on the outside with thick downy feathers, taken from the breasts of various birds, and arranged with their different colors so as to make a brilliant show. [62]

It was probably under similar circumstances that the China trade captain Robert Bennet Forbes collected the "Coppers" Blanket, an extraordinary example of Chilkat weaving. Forbes was never on the Northwest Coast proper, but he was at the Russian settlement at Bodega on the California coast in 1825. There was frequent traffic between Bodega and Sitka (which was in Tlingit territory and not far from Chilkat), and it would not have been too unusual to find such a work of art in California in 1825.

Chilkat blankets and raven's tail robes were so important in their native cultural context and so time-consuming to produce that they were not readily traded. In August 1791 John Hoskins, the supercargo under Captain Robert Gray on the *Columbia's* second voyage, described seeing several, which he admired greatly and tried unsuccessfully to purchase:

> This was a wooling mantle fine neatly wrought and evidently of their own manufacture some white others only the ground work white beautifully diversified with various fancy figures and of the most lively colors of yellow, green, red, dark brown, black etc. these appeared to be wove in with the mantle and rais'd like the pile on velvet on others there were tassels which form'd the figures these as they walkt would naturally move which had a pleasing effect the top edge was trimmed with sea otter furr and on the bottom was a deep fringe upon the whole I think this one of the prettiest pieces of workmanship I have yet seen on the coast these people could not be induced to part with any of those garments though they were offered a very valuable consideration. . . . [63]

Only one other example of Tlingit weaving is known to have been collected by a Yankee fur trader, the raven's tail robe known as the Swift Blanket. It was donated to the Peabody Museum at Harvard in 1909 by a descendant of Captain Benjamin Swift, who is thought to have collected it on one of five voyages he made to the Northwest Coast between 1791 and 1809. [64]

Eventually the intensive contact and collecting occasioned by the sea otter pelt trade began to influence the production of cultural artifacts, with some pieces evidently made purposefully to sell to foreigners. The masks collected by Daniel Cross and others, for instance, show no sign of use and may have been made just for the souvenir trade. Other types of objects seem to have been developed specifically to meet the demands of the sou-

venir market, the most important of these being argillite pipes from the Queen Charlotte Islands. These pipes are not found in archaeological sites, and there is no mention of them in the earliest records of explorers and traders, but by 1820 they began to appear in New England museums. That year, the American Antiquarian Society reported the receipt of a "very curious stone pipe, highly sculptured, brought from the North West Coast." Not having seen anything like it before, the registrar "supposed [it] to be manufactured in the East Indies or China."[65]

By 1837 there were four argillite pipes in the collection of the East India Marine Society, one each given by Captains John Hammond and John Bradshaw and two donated by John C. Jones. Jones represented the mercantile interests of at least two Boston firms in Hawaii in the 1820s and became the U.S. consul in Hawaii in the 1830s. In this capacity he encountered almost every ship involved in the Northwest Coast trade over a twenty-year period and had plenty of opportunity to collect artifacts from the region and ship them back to New England. One of the pipes he sent to Salem between 1821 and 1831 is described simply as a "Stone Pipe from N.W. coast of America." It takes the form of an American ship with a scrolled fiddlehead prow. The other, carved in the stylized tradition of Haida wood carvings, is described as "surrounded with Grotesque figures. The mineral a peculiar kind of slate or indurated clay."[66]

The earliest record found in a journal of an object that is clearly an argillite pipe is in the journal of the missionary Jonathan Green, who was cruising the coast in 1829 on the Boston bark *Volunteer*. Speaking generally of the craftsmanship of the Northwest Coast, Green noted that the Indians were not "destitute of ingenuity":

> This they exhibit in the construction of their war canoes, in the carving of busts, in the manufacturing of hats and baskets, spoons, knives, pails, and other dishes, curious stone pipes, masks and other curiosities. Considering how few mechanical implements they possess, these indicate no inconsiderable skill.[67]

At Skidegate, Green noted that "here they manufacture, from grass, hats of an excellent quality, some of which they value as high as two dollars. Their pipes, which they make of a kind of slate-stone, are curiously wrought."[68]

Souvenir artifacts allowed a Yankee sailor to place himself on the Northwest Coast when he was back in the safety of his home turf. The interaction with native people and the potential for resulting danger was perfectly illustrated to the New England audience by a dagger made by the most famous victim of Northwest Coast aggression, John Jewitt, one of the

two survivors of an attack on the ship *Boston* in March 1803. A professional armorer or weapons maker, he lived in captivity at Nootka Sound until he was rescued by Captain Samuel Hill of the Boston brig *Lydia* in July 1805. After his rescue, Jewitt made a career out of having been the captive of the Mowachaht chief Maquinna. He published his journal in 1807, and by 1815 under the editorial guidance of publisher Seth Richards of Middletown, Connecticut, had expanded it into a narrative of his "adventures and suffering."[69]

During Jewitt's period of captivity, the cargo and fittings of the *Boston* were widely distributed, first by Maquinna and later by Jewitt himself. After the ship was destroyed, Maquinna held a potlatch, at which he distributed "no less than one hundred muskets, the same number of looking glasses, four hundred yards of cloth, and twenty casks of powder besides other things."[70] Over the course of time, Jewitt was able to engage in his own trade. Maquinna, he said, "allowed me the privilege, when not employed for him, to work for myself in making bracelets and other ornaments of copper, fish-hooks, daggers, &c. either to sell to the tribes who visited us, or for our own chiefs."[71] Jewitt also describes making daggers out of "old bolts" and other ship fittings on more than thirty occasions.[72]

One of Jewitt's weapons, made of "Bayonets bound together and used as a Dagger by the natives of Nootka Sound—supposed to be a remnant of the arms of the Ship *Boston,* which was taken by surprise and the crew murdered in [1803] by the celebrated chief Maquinna"—was given to the museum of the East India Marine Society in Salem in 1831 by Captain William Osgood, who probably got it, like the kamleika described above, from Thomas Meek.[73]

This dagger and another, donated almost twenty-five years earlier by Captain William Richardson, represented a new direction in collecting.[74] They were neither traditional native pieces nor examples of the transition to new forms, materials, or styles. They were, in fact, products of American manufacture, made for this trade by the same mariners who later collected them. Unlike the collectors of a century later who would acquire, as traditional artifacts, the twisted iron collars designed by Captain Ingraham and made by his shipboard blacksmith in 1791, Meek, Osgood, and Richardson definitely knew the origin of the daggers they collected. For these Yankee captains, the objects were important because they represented *their own history* as well as their contact with native people on the Northwest Coast.

The notion that their job put them regularly into potentially dangerous situations was one that Yankee traders on the Northwest Coast explored often in their journals. A dagger made by Jewitt during his cap-

tivity was a different, though equally powerful, documentation of the precarious nature of the adventure. Jewitt had actually seen the severed heads of his captain and shipmates on the deck of the *Boston* at Nootka Sound. No one who had read his adventures and looked upon this dagger could forget the scene.

Without any written information to contextualize them, other artifacts collected for their historical rather than their ethnological importance slipped quickly into obscurity. In 1801 Captain James Rowan donated "An European Scalp, Received from an Indian on the North West Coast of America" to the Massachusetts Historical Society.[75] Rowan had seen his captain and several shipmates murdered in 1796 at Cumshewa Inlet and on a subsequent voyage had captured the killers, who had the scalps of the victims in their possession. For Rowan, these scalps, the last remains of men he had known and with whom he had worked, must have been incredibly powerful and moving representations of a horrifying experience in his past.[76] According to William Sturgis, who saw them on the Northwest Coast but did not describe them until fifty years later, "they were found carefully enveloped in several folds of blue cloth, with the long hair—the fashion of that day—powdered with the down of sea fowl, just as they had been used, a short time before, in a war dance."[77] John Bartlett, in a much less romantic description from 1791, described men in the Queen Charlotte Islands who

> were ornamented with bird's feathers all over their heads and besmeared
> with grease and paint. On their heads there were a great number of tails
> or locks of hair which were full of lice and grease and made them look
> very frightful. We learned that whenever they kill a man in battle, they
> cut off his hair and mat it up in tails and tie it on their own heads.[78]

In the record of his donation to the Massachusetts Historical Society, James Rowan's name was erroneously given as "Capt. T. Roan" and the scalp[s] have since disappeared without a trace.

Whatever motives the collectors might have had, the "scientists" at the various museums and the visiting public reinterpreted the artifacts based on their own knowledge and experience. Some certainly saw the collections as primarily illustrative of the experience of the collectors. *The New York Journal of Commerce* reported on the collection in Salem in 1833, asking, "Has the reader ever visited the Salem East India Museum? We have many a time and we do not hesitate to say that to us it is the most interesting Museum we have ever entered. It affords a fine illustration of the enterprise, science and taste of the Salem ship masters. . . ."[79]

The arrangement of the exhibited collection in 1833 would certainly have led visitors to view it simply as souvenirs of voyages. The American author Nathaniel Hawthorne, a native of Salem and the son of a member of the East India Marine Society, visited in 1832 and noted a "tendency to whimsical combinations and ludicrous analogies, which seemed to influence many of the arrangements. . . . "[80] Drawings of the collection, displayed after 1824 in an elegant building erected for the purpose, showed ethnographic specimens used as decoration. Crossed fans and elaborately arranged spears served no interpretive function and could almost have been seen as trophies of the voyages made by society members. This organizational structure had, in fact, been carefully planned by Dr. Malthus A. Ward, who became supervisor of the museum around 1830. He and his successor attempted to "bring together such articles as bore a resemblance to each other or were used for the same purpose in the economy of life by the different nations, such as the cooking utensils, shoes, hats, warlike instruments, etc., etc."[81]

This exhibit scheme was then quite popular in Europe. No attempt was made to provide a cultural context; rather, the visitor was invited to draw comparisons of unrelated groups of people, based on objects that had been made and used for a similar function. The ranking of cultures as "sophisticated" or "primitive" could then be accomplished on a "scientific" basis. (This style of exhibition would reach its apex in the late nineteenth century with the Pitt Rivers Museum, now part of Oxford University. General Pitt Rivers proposed that such type-specimen collections could actually be arranged in an evolutionary order to show the "succession of ideas by which the minds of men in a primitive condition of culture have progressed from the simple to the complex, and from the homogeneous to the heterogeneous."[82])

For Susan Bean, curator of ethnology at the Peabody Essex Museum (the descendant of the East India Marine Society), the early exhibit scheme was an "American exercise in world construction . . . one which privileged the unfamiliar, the strange, and which used this collection to practice mastery, first intellectual and moral and ultimately commercial and political."[83] Speaking specifically about the collections made on the Indian subcontinent, Bean concludes that

> [f]or members, many of the objects and specimens stood for their experiences in India, having actually been part of them. For visitors these curiosities were ingredients with which to construct an imagined East. For Indian donors they were an opportunity to represent themselves in

the foreigners' world. For the superintendent who managed the museum, the method of grouping like things invited visitors to comprehend the curiosities as exotic extensions of known categories: the newly encountered could be annexed to the familiar. This exercise, because it was admired as scientific, elevated both the viewers and the proprietors. But it was in the nature of curiosities, because they were prized above all for their distinctiveness, to defy attempts at grouping, to be appreciated primarily as exotica, for their peculiarities of form and decoration. Perhaps most of all the presence in this magnificent hall of a sampling of natural and artificial curiosities from all around the world invited the members of the East India Marine Society and the visitors to their museum, to feel that the world had come to Salem, its civilizations and cultures miniaturized and contained.[84]

Tzvetan Todorov has argued that Europeans in the Age of Exploration were able to represent themselves because they possessed the ability to write, while Native Americans, lacking that ability, were not only unable to represent themselves, but were subject to cultural manipulation by literate Europeans.[85] Stephen Greenblatt counters that there seems to be

> no convincing evidence that writing functioned in the early encounter of European and New World peoples as a superior tool for the accurate perception or effective manipulation of the other. . . . The ability to communicate effectively is a quite different matter from the ability through writing or any other means to perceive and represent reality.[86]

The same idea may be applied to the interpretation of cultural artifacts. While it may have beem comforting to Boston and Salem residents to consider themselves superior to the labret-wearing savages on the distant shores of the Pacific, those New Englanders did not, through their possession of Northwest Coast Indian objects, "possess" or control Northwest Coast Indian people or their land.[87] They neither contained the culture nor diminished it for the people of the Northwest Coast or the traders and adventurers who had traveled there.

When American participation in seaborne commerce declined, so did the membership of the regional marine societies. By the third quarter of the nineteenth century, few people, even among society members, remembered who had collected which objects and where. In 1869 the members of the Boston Marine Society voted to follow the example of their counterparts at the Boston Society of Natural History and give the contents of their "cabinet" to the Peabody Museum at Harvard, without ever mentioning the

value of the artifacts as representations of their own maritime history. As Ebenezer Davis, president of the Boston Marine Society wrote, they had decided

> to concur in the action of the Boston Society of Natural History in turning over to the Institute at Cambridge . . . those implements of art and war received from our Society, and I would further add, it gives us great pleasure to aid in the furtherance of so valuable a science as that of ethnology.[88]

In his short story "Youth," Joseph Conrad describes the "romance of illusions," a process by which memory softens and romanticizes the hard and dangerous experiences of the past. Mariners were particularly prone to engage in this exercise. Decades after the voyage was done, the now venerable "Boston man" looked back on his time spent on the Northwest Coast not as cold wet weeks and months alternating between fear and anxiety on the one hand and loneliness and boredom on the other, but as a romantic and even "scientific" adventure. They had not been scared teenagers engaged in a highly competitive commercial trade, but ethnologists engaged in science, and their work was about to be acknowledged by Harvard University. Human experience is often difficult to recapture because human memory is fallible.

And so the artifacts, as documents of a time and place, take on a heightened importance. Different contexts can be explored, human memories can be challenged, shipboard diaries can be analyzed; but the constant is the unchanging mask, staring silently through the ages.

# ✠ PART II ✠

# NORTHWEST COAST INDIAN ARTIFACTS IN NEW ENGLAND COLLECTIONS

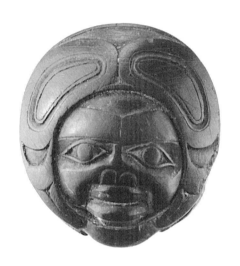

# NORTHWEST COAST INDIAN ARTIFACTS IN NEW ENGLAND COLLECTIONS 1788–1844

Coinciding with the rise of international commerce after the Revolutionary War, a number of individuals began developing organizations that would collect and preserve the unique history and heritage of the new nation. The resulting collections generally comprised a library and a "cabinet of curiosities," or museum. In Massachusetts, several such institutions flourished during the years that Boston traders were active in the maritime fur trade, and a number of Northwest Coast Indian artifacts found their way into these cabinets while their collectors were still active on the coast.

There can be no question that the founding of these organizations was tied to the rapid growth of phenomenal new fortunes amassed by men involved in Boston's burgeoning trade with Asia. Because sea otter pelts were the most valuable currency a Yankee could carry to Canton, the route to China via the Northwest Coast was the most common one sailed by Boston vessels. Thus, it is not surprising that the Northwest Coast was so clearly a focus of institutional collecting in Boston at the turn of the nineteenth century.

The following list is the first attempt to create a comprehensive catalogue of all of the Northwest Coast Indian artifacts that entered into those institutions while the maritime fur trade was active. The process of documentation was approached from a direction opposite that usually employed in curatorial research. Rather than begin with the object and work back through the accession records to find out when, where, and by whom it was collected, the starting point was a review of the earliest descriptions of donations to the various "cabinets" from the late eighteenth century. The records were then followed forward through changes in numbering systems and transfers of venue in the hopes of arriving at the surviving collections

with a solid provenance. Not surprisingly, many of the earliest artifacts described can no longer be identified, but some interesting and significant information emerges for those that can. Even when the specific details of the exchange are lacking, the general contours of the process become much better understood when one combines the information from voyages with that of museum archives.

Of the ten collecting institutions described here, only one, the Peabody Essex Museum, still maintains the original collection (though not the original institutional name). The earliest information comes from records of the Massachusetts Historical Society, though its ethnological collections were deaccessioned in 1867. The Dartmouth College Museum received several artifacts collected by Captain John Kendrick on the first American voyage to the Northwest Coast; some of them were transferred to the museum of Deerfield Academy around 1797, but none of the others can be located today. The Northwest Coast Indian collection of the American Antiquarian Society came primarily from a single source who was not in the American maritime trade, but it is included here because of its early date and its link to the British fur-trading companies. Other institutions represented are the Boston Marine Society, the Boston Athenaeum, the Boston Museum, and the Peabody Museum of Archaeology and Ethnology at Harvard; the last named received the early collections of the four preceding institutions and also a few objects directly, for which a very solid fur-trade provenance can be established. Additional objects were discovered in the records of the Newburyport Historical Society (The Cushing House) and the Newburyport Custom House Maritime Museum, which holds many of the records and collections of the Newburyport Marine Society.

Names of donors are given here as they appear in the earliest record available. Where information could be provided about the collector or on the probable circumstances of acquisition on the Northwest Coast, it has been added as a note. The list contains a number of items from the Aleutian Islands and the Alaskan mainland, which, though not culturally a part of the Northwest Coast, were considered part of the area by traders and were an important part of the trade. Many of these artifacts are described in the early records as originating on the "Northwest Coast," and they were collected on the same voyages while pursuing the same pelts.

# Salem East India Marine Society
# 1799

*(Also known at different times as the Peabody Academy of Science, the Peabody Museum of Salem, and, currently, the Peabody Essex Museum)*

The East India Marine Society was founded in Salem, Massachusetts, in 1799 as a support and social organization for successful master mariners. To qualify for membership one had to have "actually navigated the seas beyond the Cape of Good Hope or Cape Horn, as masters . . . of vessels belonging to Salem."[1] In addition to the usual marine society goals of sharing navigational information and providing financial support for the families of mariners facing hard times or lost at sea, the East India Marine Society uniquely determined to establish a "cabinet of natural and artificial curiosities" as part of its mission.[2] Salem mariners were active in the post-Revolutionary world of American trade, and the cabinet represented their voyages to Asia, Africa, Europe, and the Pacific.

The cabinet of the East India Marine Society quickly became one of the most active museums in America. President John Quincy Adams was present at the dedication of the permanent hall in 1825, and Presidents Monroe and Jackson visited the museum during their administrations. Donations were made not only by the active and rapidly expanding membership, but by people from all over the world who heard about the collection. A manuscript catalogue was begun in 1799, which was seemingly kept with care and precision through about 1803 and thereafter with less attention to details. By 1820, many of the objects could no longer be confidently identified or attributed. A committee formed to examine the cabinet found that "many important articles were not entered upon the catalogue, and nearly half the curiosities in the museum were without any marks by which they could be identified in the old catalogue and the names of donors ascertained."[3] They also found, to their embarrassment, that "some articles have been taken away from the museum. Fortunately

however the number of missing articles is small, and (except in one or two instances) not of much importance."[4]

A local physician, Dr. Seth Bass, was hired to organize and recatalogue the collection, a process that was underway when the committee reported. Numbers had "been painted on most of the articles, and . . . the catalogue corresponding to the numbers [was then] in considerable forwardness."[5] The catalogue published in 1821 included among the first entries five "paddles from the Northwest Coast of America." Objects received after the publication of the first catalogue were noted in a manuscript list attached to one of the copies, and a second catalogue, which included these additions, was published in 1831.[6]

Between the publication of the first and second catalogues, the society considered the possibility of exchanging objects in its collection with those of other scientific organizations. A second committee on the collection reported early in 1824 that "notwithstanding the recent rapid growth of the Cabinet the collection would at this time have been much more valuable and extensive it is thought, if the power of making mutual exchanges of duplicate and triplicate specimens, with other Cabinets, had been confided to some one or more of the officers of the Society."[7] The committee then argued strongly for such exchanges, concluding that the donors would not "lose the credit which they would so justly deserve inasmuch as their names might stand in the catalogue as donor of the several articles thus taken in exchange."[8] This policy, destined to confuse future students of the collection, is not known to have affected the documentation of any of the Northwest Coast Indian objects appearing in the 1831 catalogue, but it might explain the impossibility of connecting some of the original donors with the Northwest Coast trade.

In 1867, with foreign trade from the region in decline, the members of the East India Marine Society considered selling East India Marine Hall and its collections to the local historical society, the Essex Institute. An alternative solution was offered by the philanthropist George Peabody, who provided $140,000 to combine the scientific collections of the two institutions under the name Peabody Academy of Science. At that time some early ethnological collections from the Essex Institute were transferred to East India Marine Hall. The two institutions were permanently merged in 1993 as the Peabody Essex Museum.

Each of the 1821 and 1831 catalogues begins with number one, the first catalogue containing 2,269 "curiosities," the second 4,299. Not all of the entries in the 1821 compilation were repeated in the 1831 catalogue, even though some of the missing objects are still in the collection today. An

addendum published in 1837 contains an additional 371 items. The following list presents, in order, Northwest Coast Indian artifacts that appear in the manuscript "catalogue of the Museum of the Salem East India Marine Society," begun in 1799; then those from the 1821, 1831, and 1837 catalogues, respectively. A few objects obtained after 1837 but before 1850 have been added from a manuscript addendum, and two objects transferred from the Essex Institute complete the list.

I have attempted to eliminate all repetitions and to note when an object's number has changed from one catalogue to the next. In the twentieth century all of these objects became part of the "Ethnology" collection of the museum and were accordingly given an "E" number designation (hereafter described as the E-file). When that information is known, I have added it, along with data in the current catalogue that adds to or disputes the information in the earlier catalogues. Descriptions in quotations (including numbers found within quotation marks) are taken directly from the catalogues; sequential reference numbers pertain to the object list in this publication.

# OBJECT LIST

## 1. "19. Indian Pike from the N.W. Coast"

*Donor:* "Captain Benjamin Carpenter, 1799."

*Provenance:* MS "catalogue of the Museum of the Salem East India Marine Society."

*Current Status:* This object does not appear in any of the subsequent published catalogues but is possibly E3591, a "lance throwing stick" from the Northwest Coast, which was collected before 1803; this object's numbers were confused or wrongly transposed early in the cataloguing process, as is noted in the Ethnology Department files.

*Notes:* Benjamin Carpenter was a founding member of the East India Marine Society and president of the organization from 1806 to 1808. The Canton Factory Records of the British East India Company place him in Canton aboard the ship *Massachusetts* in the fall and winter of 1789.[9] The vessel was sold to the Danish East India Company at Canton, and nine members of the crew continued on to the Northwest Coast aboard the *Gustavus III.*[10] While at Canton, the *Massachusetts* encountered Captain John Kendrick and his crew, recently arrived on the *Lady Washington,* and a number of other American vessels that could have transported Carpenter (and this artifact) back to New England. Carpenter gave other gifts to the society, including the crystal chandeliers that still hang in East India Marine Hall.

## 2. "53. Fish hooks from N.W. Coast"

*Donor:* "John Derby, 1799."

*Provenance:* MS "catalogue of the Museum of the Salem East India Marine Society."

*Current Status:* One of these wooden halibut hooks became number 396 in the 1821 and 1831 catalogues. Another is probably either 390 or 391 (now E3548 and E3546), attributed in those catalogues to A. Folger. See number 13 below. [There is another fishhook with East India Marine Society number 405 painted on it and currently numbered E3634 without any other data.]

*Notes:* John Derby was one of the original owners of the *Columbia* and the *Washington* and later invested in the Salem trader *New Hazard,* which made a voyage to the Northwest Coast in 1811 (documented in a remarkable journal by Stephen Reynolds in the Peabody Essex collection). The early date of this donation and the following one (see number 3, below) would seem to indicate that these objects were collected on the first American voyage to the Northwest Coast.

## 3. "60. Bows, Arrows, & Spears from the N.W. Coast"

*Donor:* "John Derby, 1799."

*Provenance:* MS "catalogue of the Museum of the Salem East India Marine Society."

*Current Status:* There is no indication of this group of objects in the 1821 or 1831 catalogues, although there are a number of unattributed items that could fit the description, including "2088, A Bow and arrows from the N.W. Coast." The current E913 and E914, an arrow and a harpoon, respectively, are possibly part of Derby's donation.

*Notes:* John Derby was one of the original owners of the *Columbia* and the *Washington;* the early date of this donation and the preceding one would seem to indicate that these objects were collected on the first American voyage to the Northwest Coast.

## 4. "83. Fishing line (from N.W. Coast)"

*Donor:* "Capt. Nathaniel Silsbee, 1800."

*Provenance:* MS "catalogue of the Museum of the Salem East India Marine Society."

*Current Status:* This object appeared in the 1821 and 1831 catalogues as "522, A Fishing-line from the N.W. Coast of America" and is E3551 in current records and listed as Alaskan and "made from the intestines of some animal."

*Notes:* Though he never made a voyage to the Northwest Coast, Nathaniel Silsbee traveled to almost every other destination of American ships at the time. Between 1790 and 1832 he owned or commanded some 22 vessels active in the foreign trade from Salem. He likely acquired his Northwest Coast Indian artifacts from Northwest traders encountered in Asia, or through Captain Richard Cleveland, who had sailed with him on a voyage of the Salem ship *Benjamin* to the Indian Ocean in 1792. It was nineteen-year-old Silsbee's first command, and Cleveland rose to the position of second mate en route. Silsbee offered Cleveland a berth as first mate on his next voyage, but the owner of the vessel, Elias Hasket Derby, overruled the young captain and sent his own nephew as mate instead. Silsbee and Cleveland developed a close friendship over the years, and it seems likely that the Northwest Coast objects donated by Silsbee in 1800 might actually have been collected by his friend Cleveland on a voyage he made to the Northwest Coast as master of the Boston ship *Caroline* in 1799. Though Cleveland was a native of Salem and had doubled both Cape Horn and the Cape of Good Hope as captain of his own ship, he never commanded a Salem vessel and consequently was not eligible for membership in the East India Marine Society.

**5. "85. A piece of Whale's gut"**

*Donor:* "Nathaniel Silsbee, 1800."
*Provenance:* MS "catalogue of the Museum of the Salem East India Marine Society."
*Current Status:* This portion of a garment or bag, made of two strips of whale intestine joined by decorative leatherwork, subsequently became number "588, A Garment made of the Intestines of a Whale" (1831 catalogue) and is now E3643.
*Notes:* See number 4 above.

**6. "117. Fish Jig from the N.W. Coast of America"**

*Donor:* "Nathaniel Silsbee, 1800."
*Provenance:* MS "catalogue of the Museum of the Salem East India Marine Society."
*Current Status:* This appears in the 1821 and 1831 catalogues as: "411, A Fish Gig, from the N.W. Coast of America." It is currently E7348, "Bone end of harpoon—Alaska, Capt. N. Silsbee, 1800."
*Notes:* See number 4 above.

**7. "142. A Fish Gig from Bay Francisco"**

*Donor:* "George Taylor, 1800."
*Provenance:* MS "catalogue of the Museum of the Salem East India Marine Society; East India Marine Society 1821 catalogue; 1831 catalogue; E-file.
*Current Status:* This iron harpoon point mounted in a bone setting became number 394 in the 1821 and 1831 catalogues and is currently numbered E3555; the history of evolving catalogue systems is especially apparent with this piece, where all three numbers are still clearly visible.

**8. "189. Two [models of] canoes from N.W. Coast"**

*Donor:* "Capt. Clifford Crowninshield and Capt. M. Folger, May, 1802."
*Provenance:* MS "catalogue of the Museum of the Salem East India Marine Society."
*Current Status:* The Crowninshield and Folger acknowledgment did not appear in any of the subsequent catalogues. In the 1821 and 1831 catalogues, one of the models, an Aleutian kayak, was renumbered 164 and ended up as part of a group of six canoe models attributed to Captain William P. Richardson (see number 27, below); it is currently numbered E7350. The other one, also a kayak, was exchanged with the Peabody Museum at Harvard in 1869 and is currently numbered 69-9-10/1203 (see number 233 below).
*Notes:* Clifford Crowninshield, whose family was prominent in Salem's East Indies trade, was a founding member of the EIMS in 1799. In the fall of 1799 he apparently contracted with the owners of the ship *Minerva* to send the vessel on a sealing voyage to the Pacific and Canton under the command of Captain Mayhew Folger of Nantucket. The ship returned to Salem in 1802, the first vessel from that port to circumnavigate the globe. Though the *Minerva* never stopped on the Northwest Coast proper, Folger encountered other vessels bound from there and at some point acquired a collection of artifacts, which was subsequently donated to the EIMS museum in the names of the two men. Folger, a cousin of Benjamin Franklin, went on to gain fame as commander of the *Topaz* when he discovered the fate of the *Bounty* mutineers on Pitcairn Island in 1808.

**9. "198. Fish gig from N.W. Coast"**

*Donor:* "Capts. Crowninshield & Folger, 1802."
*Provenance:* MS "catalogue of the Museum of the Salem East India Marine Society."
*Current Status:* This object does not appear in the 1821 catalogue but does appear in the MS addendum to that catalogue, with the date (1802) corresponding to the original citation. In the 1831 catalogue it appears in the group "3666-8, Arrows, or Harpoons with lines for shooting fish from the N.W. Coast." In the current numbering system, the original number 198 became E3586, and it is described as "probably [a] sea otter arrow." There is a similar object, designated E3587, which is apparently part of the 1831 group. It may have become associated with the previous item only because of its early date and similarity and is not clearly part of the original Crowninshield and Folger donation.
*Notes:* See number 8 above.

**10. "199. Two 'Pahooas' from N.W. Coast"**

*Donor:* "Capt. Clifford Crowninshield and Capt. M. Folger, May, 1802."
*Provenance:* MS "catalogue of the Museum of the Salem East India Marine Society."
*Current Status:* Unknown. Captain Cook commented on the similarity between the bone or stone clubs of New Zealand and those at Nootka Sound, and it is possible that Captains Crowninshield and Folger did too; however, the whereabouts of specimens of either type is currently unknown.
*Notes:* See number 8 above.

**11. "204. Cap from N.W. Coast"**
*Donor:* "Capt. Clifford Crowninshield and Capt. M. Folger, May, 1802."
*Provenance:* MS "catalogue of the Museum of the Salem East India Marine Society."
*Current Status:* This became number 607 in the 1821 catalogue, where it was listed as "A Cap, from the N.W. Coast of America, made of the Intestines of the Sea-Lion *(Ursine Seal, L.),*" donated by Crowninshield and Folger. In the 1831 catalogue it became "A Head-dress for a man, from Behring's Straits" donated by Wm. Osgood; in the current E-file it is E3644, a "Bag: Pouch of intestine." The width of the strips would indicate that it is whale intestine.
*Notes:* See number 8 above.

**12. "207. Pipe from N.W. Coast"**
*Donor:* "Capt. Clifford Crowninshield and Capt. M. Folger, May, 1802."
*Provenance:* MS "catalogue of the Museum of the Salem East India Marine Society."
*Current Status:* This small wooden pipe, probably not of Northwest Coast origin, appeared in the 1821 and 1831 catalogues as "548, A Tobacco Pipe, from the N.W. Coast of America;" it is currently E3495.
*Notes:* See number 8 above.

**13. "208. Halibut Hook from N.W. Coast"**
*Donor:* "Capt. Clifford Crowninshield and Capt. M. Folger, May, 1802."
*Provenance:* MS "catalogue of the Museum of the Salem East India Marine Society."
*Current Status:* In the 1821 and 1831 catalogues, this single halibut hook doubles to become: "390, 391, Hooks from the N.W. Coast of America," mistakenly attributed to "A." Folger.

The second of these hooks was probably part of the initial donation of John Derby in 1799 (see number 2 above). Number 390 is currently E3548, and 391 is E3546.
*Notes:* Number 390 has an ivory or bone barb attached with split spruce root and is carved with totemic figures. See number 8 above for information on Captains Crowninshield and Folger.

**14. "220. Canoe from the N.W. Coast"**
*Donor:* "Mr. Thaddeus Gwinn."
*Provenance:* MS "catalogue of the Museum of the Salem East India Marine Society."
*Current Status:* Though there is a note in the catalogue that this canoe model became number 19 in the 1821 catalogue, there is no record of it in any of the subsequent catalogues. It probably ended up in the group of six attributed to Captain William P. Richardson in the 1821 and 1831 catalogues (see number 27 below).
*Notes:* Thaddeus Gwinn may have been related to Captain James Gwinn, a New Bedforder who commanded the British whaler *Anne* on two voyages around Cape Horn (1803–1807 and 1807–1809). Though the *Anne* never stopped on the Northwest Coast, Captain Gwinn may have encountered fur traders on the coast of Chile or during extensive cruising in the South Pacific.

**15. "221. Fishing lines & hooks from N.W. Coast"**
*Donor:* "Thaddeus Gwinn."
*Provenance:* MS "catalogue of the Museum of the Salem East India Marine Society."
*Current Status:* Unknown
*Notes:* See number 14 above.

**16. "222. Paddle from the N.W. Coast"**
*Donor:* "Thaddeus Gwinn."
*Provenance:* MS "catalogue of the Museum of the Salem East India Marine Society."
*Current Status:* The 1821 and 1831 catalogues list a total of five "paddles from the North-west Coast of America" attributed to Thaddeus Gwinn as numbers 46 through 50.
*Notes:* See number 14 above.

**17. "229. Canoe from N.W. Coast"**
*Donor:* Not recorded.
*Provenance:* MS "catalogue of the Museum of the Salem East India Marine Society," E-file.
*Current Status:* This object does not appear separately in any subsequent catalogue. Like several others, it became associated with a group of six canoe models attributed to Captain William P. Richardson in the 1821 and 1831 catalogues (number 27 below). This two-holed kayak or baidarka, with the associated gear, received the number 162 at that time and subsequently became E7354. It has an affixed label that reads "From North-West Coast; A model of the Canoes made there."

**18. "309. A North West Coast Spear"**
*Donor:* "Capt. Johnson Briggs, 1803."
*Provenance:* MS "catalogue of the Museum of the Salem East India Marine Society."
*Current Status:* This object does not appear in any subsequent catalogue, though it is possibly the four-pronged fish spear that is currently E3565.
*Notes:* Captain Johnson Briggs became a member of the East India Marine Society in March 1803, about the time that this spear and the following basket were donated to the society's cabinet.

The timing of his gifts (see also number 19 below) makes it almost certain that he is the "Jona" Briggs listed by William Tufts (in Swan's *The Northwest Coast*) as captain of the schooner *Hetty* of Philadelphia, which was on the Northwest Coast in 1802.[11]

### 19. "322. A North West Coast Basket"
*Donor:* "Capt. Johnson Briggs, 1803."
*Provenance:* MS "catalogue of the Museum of the Salem East India Marine Society."
*Current Status:* This became, in the 1821 and 1831 catalogues: "447, A Basket, or Bucket, from the N.W. Coast of America;" currently it is E3620 and is described as Aleutian.
*Notes:* See number 18 above.

### 20. "339. A Great Coat made from the gut of a Sea Lion"
*Donor:* "Purchased of Capt. Thos. Bowditch, 1803."
*Provenance:* MS "catalogue of the Museum of the Salem East India Marine Society."
*Current Status:* In the 1821 catalogue this appears as: "575, A Frock, with a hood, made of the intestines of the Sea Lion, *(Ursine Seal)* from N.W. Coast of America;" it is absent from the 1831 catalogue at that number but might be one of two early Aleutian kamleikas, known to be East India Marine Society pieces but currently unattributed. They are numbered E982 and E1123 and are of similar size and decoration.
*Notes:* Captain Thomas Bowditch is not known to have been to the North Pacific, but he commanded the Salem brig *George Washington* on a voyage that returned from Sumatra to Salem via New York in November 1802. The timing of this purchase would indicate that he rendezvoused at some point along the route with a vessel that had been on

the coast of Alaska and acquired the gut "frock" described here. Thomas Bowditch became a member of the East India Marine Society in March 1825.

### 21. "361. Bow & Arrows from N.W. Coast America"
*Donor:* "Presented by Mr. J. Franks through Capt. Israel Williams, 1803."
*Provenance:* MS "catalogue of the Museum of the Salem East India Marine Society."
*Current Status:* In the published catalogues, this collection was divided into separately attributed donations of Franks and Williams. The 1821 catalogue lists a bow and arrow as number 119, which is credited solely to J. Franks; this subsequently became E3569 and was traded to the Museum of the American Indian in July 1962. Meanwhile, number 116 in the catalogue was a collection of arrows contributed by Captains A. W. and Israel Williams. One of ten arrows now attributed to them was from the Northwest Coast and received the number E3215.
*Notes:* Both Captain Israel Porter Williams and his son, A. W. Williams (who died at sea at age 19 in 1831), donated Northwest Coast materials, though neither can be identified as ever having made a Northwest voyage. Israel Williams commanded several voyages of one of Salem's most famous vessels, the *Friendship*, beginning with her maiden voyage in 1797, and he possibly encountered the mysterious Mr. Franks

en route. Williams was subsequently an extremely influential and prosperous merchant; another son, Henry L. Williams, became mayor of Salem.

### 22. "362. Lip Ornament worn by the Women on the N.W. Coast America an incision being made transversely in the under lip to receive it."
*Donor:* "Captain Israel Williams, 1803."
*Provenance:* MS "catalogue of the Museum of the Salem East India Marine Society."
*Current Status:* In the 1821 and 1831 catalogues this became: "496, An Ornament worn in a slit made in the under-lip, by the natives on the N.W. coast of America"; it is currently E3484. There are three labrets attributed to Williams in the 1821 and 1831 catalogues, numbered 496, 1043, and 1044 (see illustration on this page).
*Notes:* See number 21 above for information on Williams, and see number 36 below.

### 23. "363. Calabash, or Gourd, from the N. W. Coast of America"
*Donor:* "Captain Israel Williams, 1803."
*Provenance:* MS "catalogue of the Museum of the Salem East India Marine Society."
*Current Status:* This appeared in the 1821 catalogue as "449, A Gourd, from N.W. Coast of America." It does not appear in the 1831 catalogue and is currently unknown.
*Notes:* See number 21 above.

**Object 22**
Lip ornaments. PEM E3484. 3.1 cm x 5.8 cm x 7.6 cm.

**24. "407. "A fishing line — (& a Quantity of Shells) & a — bill / a Quantity of Shells from the N.W. Coast by Mr. Wilkins"**

*Donor:* "Capt. J. Barton, 1803."
*Provenance:* MS "catalogue of the Museum of the Salem East India Marine Society."
*Current Status:* Unknown.
*Notes:* This is a somewhat confusing entry in the original MS catalogue, where it is not clear whether the two items are meant to be one lot conveyed by Captain Barton for Mr. Wilkins, or if the second part, which lacks a separate number, is in fact a different accession. In any case, there is a notation that the "fishing line" became 1076 in the 1821 catalogue.

**25. "518. A Large Number of Bows, Arrows, Paddles, Spears, Fish Giggs, & War weapons from Port Jackson & Nootka Sound"**

*Donor:* "Captain William Richardson, 1807."
*Provenance:* MS "catalogue of the Museum of the Salem East India Marine Society."
*Current Status:* The only object that can be absolutely identified among this unspecified collection of Australian and Northwest Coast Indian artifacts appears in the 1821 catalogue as "147, An Iron dagger, used by the natives on the N.W. coast of America." It is not listed in the 1831 catalogue, but it is still in the collection as E3561 (see illustration on this page). There is a bow from W. P. Richardson in the collection today, which is identified as Fijian and is numbered E3225. See also number 62 below.

*Notes:* A founding member of the East India Marine Society, Captain William Richardson commanded at least three Salem vessels. He was in the South Pacific and at Canton commanding the *Eliza* of Salem on a voyage of 1805–1806, but he is not known to have stopped anywhere on the Northwest Coast. These and other Northwest Coast artifacts may have been obtained in a swap with another captain during the course of a voyage.

Peabody Essex Museum folklore attributes this heavy iron dagger donated by Richardson to John Jewitt, the armorer of the ship *Boston* who was captured at Nootka Sound in 1803 and one of only two members of the crew to survive an attack by Maquinna and his followers. Jewitt was rescued in 1805, and the timing of Richardson's gift makes the attribution to Jewitt very likely. In the daily journal he kept during his captivity, Jewitt describes making daggers of "old bolts" from the ship on a number of occasions. This very heavy dagger has no pommel, having instead a very "bolt-like" rod mounted transversely to the blade. For another dagger attributed to Jewitt, see number 59 below.

**26. "519. Three pieces of Grass Cloth & Three Vests of the same from Nootka Sound"**

*Donor:* "Captain William Richardson, 1807."
*Provenance:* MS "catalogue of the Museum of the Salem East India Marine Society."
*Current Status:* These could possibly be articles of cedar bark, now unknown, or they could be Polynesian items wrongly identified, as is the case with other donations from Captain Richardson. (For example, number 522 is erroneously identified as "A Carved Box by Natives of Nootka Sound, New Zealand.") Either way, the current identity and location are unknown.
*Notes:* See previous entry for information on Captain Richardson's career.

**27. "[26] A Model of a Canoe from the North West Coast"** [12]

*Donor:* "Captain William P. Richardson, 1810–1812."
*Provenance:* MS "catalogue of the Museum of the Salem East India Marine Society."
*Current Status:* The MS catalogue clearly indicates a single canoe model, donated circa 1802; however, six models are attributed to Richardson in the 1821 and 1831 catalogues: "160, 161, 162, 163, 164, 165, Models of Canoes used by the natives of the N.W. coast of America." One of them clearly *was* donated by Richardson, number 161, an Aleutian kayak model with three holes, which is currently E7353. Among the others that can still be identified, 162 is definitely number 17 above and 164 number 8 above. One of the remaining is possibly number 14 above or number 75, described below.
*Notes:* Captain William Putnam Richardson commanded the Salem brig *Active* on a voyage of 1810–1812. Like his uncle of the same name, Captain

Object 25
Iron dagger. PEM E3561. 38.1 cm x 6.7 cm.

Richardson traveled to the South Pacific but is not known to have stopped anywhere on the Northwest Coast.

### 28. "113, 114. Bows, from the N.W. Coast of America"

*Donor:* "Capt. Bacon."
*Provenance:* East India Marine Society 1821 catalogue and 1831 catalogue.
*Current Status:* One of these bows is currently numbered E3235 (see illustration this page). The Peabody Essex Museum's Ethnology Department catalogue notes indicate that 113 is from "just North of the Columbia River"; 114 can no longer be identified but is possibly one of several other arrows from the Columbia River region that are dated "1820." These are E3574–6 and include four arrows: one with an iron point, one with an obsidian point, and two (both numbered E3576) that are incomplete.

*Notes:* Captain Daniel C. Bacon made at least two voyages to the Northwest Coast, as mate under Captain William Sturgis on the *Atahualpa* of Boston, 1806–1808, and as master of the *Packet* of Salem, 1811–1815. These bows were probably collected on the later voyage. See also numbers 32 and 47 below.

### 29. "606. A Waistcoat made of the Intestines of the Sea-Lion"

*Donor:* "Henry Tibbets."
*Provenance:* East India Marine Society 1821 catalogue and 1831 catalogue.
*Current Status:* This might be one of two early Aleutian kamleikas, known to be East India Marine Society pieces but currently unattributed. They are numbered E982 and E1123 and are of similar size and decoration. See number 31 below.

### 30. "608. A Shawl made of the Intestines of an Animal"

*Donor:* "George Dutch."
*Provenance:* East India Marine Society 1821 catalogue and 1831 catalogue.
*Current Status:* Unknown.

### 31. "609. Dress of a Native of the N.W. Coast of America"

*Donor:* Not recorded.
*Provenance:* East India Marine Society 1821 catalogue and 1831 catalogue.
*Current Status:* This might be one of two early Aleutian kamleikas, known to be East India Marine Society pieces, but currently unattributed. They are numbered E982 and E1123 and are of similar size and decoration. See number 29 above.

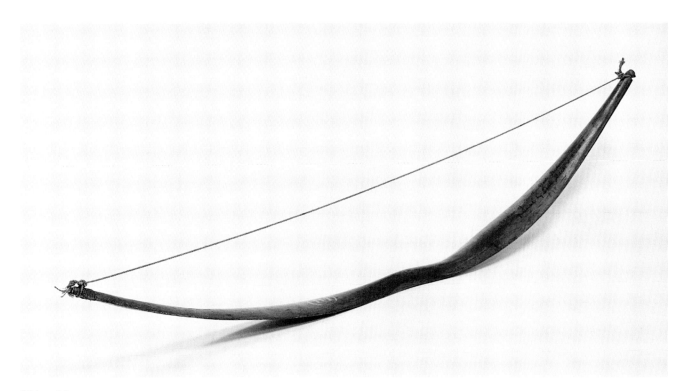

**Object 28**
Bow. PEM E3235. 114 cm x 2.8 cm.

**32. "613. A Dress of a Native of the N.W. Coast of America, made of the Intestines of the sea-lion, *(Ursine Seal)*"**
*Donor:* "Capt. Bacon."
*Provenance:* East India Marine Society 1821 catalogue and 1831 catalogue; E-file.
*Current Status:* E7343. For reasons unknown, this item, which was first listed in the 1821 catalogue as number 613, appeared in the 1831 catalogue as number 3868.
*Notes:* Captain Daniel C. Bacon made at least two voyages to the Northwest Coast: as mate to William Sturgis on the *Atahualpa* of Boston, 1806–1808, and as captain of the *Packet* of Salem, 1811–1815. This kamleika was probably collected on the later voyage. See also numbers 28 above and 47 below.

**33. "683, 684. Spear heads, made of Stone, from N.W. Coast of America"**
*Donor:* "Daniel Ward."
*Provenance:* East India Marine Society 1821 catalogue and 1831 catalogue.
*Current Status:* unknown.

**34. "784. A Harpoon, from N.W. Coast of America"**
*Donor:* "Tho's Meek."
*Provenance:* East India Marine Society 1821 catalogue and 1831 catalogue; E-file.
*Current Status:* E3229, "Aleut sea otter dart." There is a second "sea otter dart, Aleut" (number E15,222) attributed to "Thomas Meek, before 1821."
*Notes:* Captain Thomas Meek of Marblehead made a number of voyages to the Northwest Coast, as master of the ship *Amethyst* (1811–1812), the brig *Brutus* (1813), the ship *Eagle* (1817–1818), and the brig *Arab* (1820–1824). For additional donations by Captain Meek, see numbers 35, 38, 44, 45, and 52 below.

**35. "793. A Model of a Canoe, used by the natives on the N.W. Coast of America"**
*Donor:* "Thomas Meek."
*Provenance:* East India Marine Society 1821 catalogue and 1831 catalogue.
*Current Status:* This Aleutian kayak model was renumbered, and it appeared in a duplicate entry, first in the manuscript addition to the East India Marine Society catalogue, and then again in the 1831 catalogue where it appeared as "3616. Model of an Esquimaux Canoe" with no donor attribution and an incorrect date of 1826. (Both numbers are visible on the model.) It bears the inscription, written in pen directly onto the skin of the kayak, "Model of the Canoes, used by the natives on the Northwest Coast of America. By Capt. Meek of Marblehead." It was transferred to the Peabody Museum at Harvard in 1869 and today is identified by the number 69-9-10/ 1204. See number 234 below.
*Notes:* Meek was an active captain on the Alaska coast. See number 34 above for more complete details of his voyages.

**36. "1043, 1044. Wooden Lip-Ornaments, from N.W. Coast of Am."**
*Donor:* "Israel Williams, 1803."
*Provenance:* East India Marine Society 1821 catalogue and 1831 catalogue; E-file.
*Current Status:* E3484 (see the illustration on page 67).
*Notes:* See numbers 21 and 22 above.

**37. "1080 [sic. '2080'] A Fishing Line, made of the intestines of an animal"**
*Donor:* Not recorded.
*Provenance:* East India Marine Society 1821 catalogue.

*Current Status:* No donor is given. The Ethnology Department catalogue indicates "before 1821" and "Alaska, Aleutian Islands"; it is now numbered E3550.

**38. "1649. The Royal Robe of Tamahama, King of the Sandwich Islands, made of the intestines of the Ursine Seal, received of the old King by the donor"**
*Donor:* "Capt. Thomas Meek of Marblehead."
*Provenance:* East India Marine Society 1821 catalogue; and the 1831 catalogue, where it is described as "A Robe, made of intestines of the Ursine Seal, ornamented in the most highly wrought and delicate manner, which was once worn by Tamehameha [Kamehameha], King of the Sandwich Islands, and by him presented to the donor"; E-file.
*Current Status:* Aleutian seal-gut rain-gear, number E3662 (see illustration on next page).
*Notes:* This object poses an interesting puzzle because Thomas Meek, who spent more than a decade in command of ships in the North Pacific and frequently visited both the Aleutian Islands and the Hawaiian Islands (see numbers 34 and 35 above), must in fact have known the real origin of this Aleutian gut outfit. Though museum records identified it as Hawaiian for more than a century, Thomas Meek himself probably did not. The gift must have been made in 1820 since Meek arrived in Boston aboard the *Eagle* on 25 July 1820 and departed in the *Arab* on 28 November. For more analysis of the collecting of this piece, see pages 47–48. See also number 40 below.

**39. "2033. A Stone Pipe, grotesquely wrought, from the N.W. Coast"**

*Donor:* "John Hammond."

*Provenance:* East India Marine Society 1831 catalogue; E-file.

*Current Status:* E3493 (see illustration on next page). This pipe does not appear in the MS addendum to the 1821 catalogue but must have entered the collection between 1821 and 1831.

*Notes:* This carved argillite pipe depicts the story of Nanasomgat and is illustrated in Marius Barbeau's *Haida Myths,* page 275. The donor is generally thought to have been Captain John Hammond of Salem, who is associated with the East Indies trade, a specialty of the port of Salem. He became a member of the East India Marine Society in 1827 and was the first member to deposit a logbook in the collection; his career is well enough documented to insure that he never made a voyage to the Northwest Coast. While no connection to a Northwest Coast voyage has been established, another possible donor of the pipe may be a John Hammond who signed on as second mate of the *Nautilus* under Captain Charles Bishop at Port Jackson, New South Wales (Australia), on 28 May 1799, traveling thence to Macao and Canton, where Hammond evidently disembarked on 19 August. One of his shipmates on that voyage was John Bartlett, whose journal of a voyage to the Northwest Coast is in the Peabody Essex collection.[13] The captain and many of the crew of the *Nautilus* had recently come from the Northwest Coast on board the *Ruby,* which was sold in the East Indies. While 1799 would be an extraordinarily early date for an argillite carving, Hammond could have made connections on this voyage that bore fruit in the form of an exchange of souvenirs in later years. (There was also a John Hammond on the first voyage of the *Columbia,* who

**Object 38**
Aleutian seal-gut raingear. PEM E3662. Measurements not available.

signed on board at St. Jago in the Cape Verde Islands in December 1787 and died the following September on the Northwest Coast.)[14]

### 40. "2754. A pair of Pantaloons made of the intestines of Seals from Oonalaska"

*Donor:* Not recorded.
*Provenance:* MS addenda to East India Marine Society 1821 catalogue; 1831 catalogue.
*Current Status:* A handwritten East India Marine Society label attached to these trousers ("Dress of King Tamahamha of Seal's Intestines. Capt. Meek, Sandwich Islands") identifies them as part of the donation of Captain Thomas Meek, described in number 38 above, but there is no corroborative indication in the records. The current number is E3662.
*Notes:* These trousers are a wonderful concoction of Aleut technology and Euro-American styling. They are modeled after sailor pants, complete with a square front flap. The waistband and flap are reinforced with cotton muslin, and the buttons are covered with tanned sealskin. They are badly damaged between the knees and the cuffs.

### 41. "2919. A Horn of a Deer *(Cervus . . . ?)* from the N.W. Coast of Americas, brought in the ship *Sachem* of Boston 1824. Presented by Nathan Newport from John Bradstreet"

*Donor:* "John Bradstreet" [Bradshaw].
*Provenance:* MS addition to East India Marine Society 1821 catalogue.
*Current Status:* Unknown. This object is listed in the 1831 catalogue as a "Horn of a species of Deer . . ." and was probably discarded in 1942 when the Museum cleaned house to concentrate more on the local region in their collection of zoological specimens. While many of the valuable pieces from this collection were presented to the Museum of Comparative Zoology at Harvard (unfortunately not in a well-documented transfer), many were "tossed out of a second story window into the backyard" where they were "fought for by a swarm of urchins, who carried the critters off in triumph."[15]
*Notes:* The name John Bradstreet is probably an error. Two vessels left Boston for California a day apart in August 1824, the ship *Sachem* and the schooner *Spy*. Henry Gyzelaar commanded one, Captain Bradshaw the other. That this horn was collected on board the *Sachem* would indicate that it was Bradshaw ["Bradstreet"] who com-

manded that vessel. Captain Bradshaw donated other important artifacts, which were probably collected at the same time. See numbers 63, 67 and 68 below.

### 42. "3255. A Birdskin Robe from Oonalaska"

*Donor:* "Capt. J. W. Cheever."
*Provenance:* MS addition to East India Marine Society 1821 catalogue; 1831 catalogue.
*Current Status:* In the 1831 catalogue this is called "a Robe made of the skins of sea birds," but it cannot currently be associated with any artifact in the collection.
*Notes:* Though James W. Cheever cannot be placed on a voyage in the Aleutian Islands, he was certainly active in Salem's Asiatic trade, as captain and as investor in the Salem ship *Perseverance* on two voyages circa 1822–1824, the period during which this donation was made. He was an active member of the "Observation Committee" of the East India Marine Society, the group of captains that collected, organized, and disseminated navigational information, and in that capacity he would have interacted with most of the Salem masters involved in the Pacific trade.

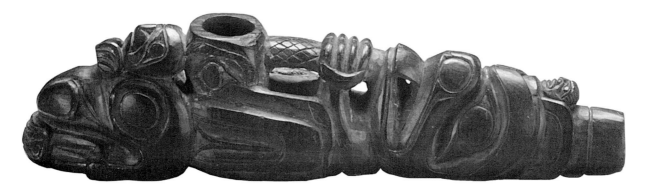

**Object 39**
Haida argillite pipe. PEM E3493. 20.8 cm x 5 cm x 4.3 cm.

**43. "3616. Model of an Esquimaux Canoe"**
*Donor:* Not recorded; donation dated 1826.
*Provenance:* MS addition to East India Marine Society 1821 catalogue; 1831 catalogue.
*Current Status:* This entry in the EIMS catalogues was an error, duplicating the entry described in number 35 above, with both entries appearing simultaneously in the 1831 catalogue. This Aleutian kayak model was transferred to the Peabody Museum at Harvard in 1869 and now bears the number 69-9-10/1204. See number 234 below.
*Notes:* Meek was an active captain on the Alaska coast. See number 34 and others above for more complete information on his voyages.

**44. "3720. A cup made of grass from Owyhee used by King Tamahamaha to contain liquids"**
*Donor:* "Capt. Meek."
*Provenance:* MS addition to East India Marine Society 1821 catalogue; 1831 catalogue; E-file.
*Current Status:* E3504. Described in the E-file as a "Deep dice cup. Rather golden straw. Double black circle and black oblongs near bottom. Height 12.7 cm. Dia. 7.8 cm."
*Notes:* See also number 34 above for information on Captain Meek's career and number 45 below.

**45. "3746. A drinking cup made of Grass from Otaheite"**
*Donor:* "Capt. Meek, 1827."
*Provenance:* MS addition to East India Marine Society 1821 catalogue; 1831 catalogue; E-file.

*Current Status:* E3505, described in the E-file as: "Woven container of split root and native fibers. [C]olors of container, yellow, golden yellow and brown. Container small. [H]eight 16.2 cm. Dia[meter] Approx. 8.3 cm. Spruce Root and dyed grass. Probably form known as a 'salt water cup.' Peter Fetchko, 1973." There is evidently a second cup, E3506, which is also referred to in the E-file as "3746: Capt. Meek, 1827, dice cup."
*Notes:* The confusion here is due to another entry in the 1831 catalogue: "1594. Two Cups for drinking, made of braided grass, from Owyhee, donated by Meek." One of the cups attributed to Owyhee [Hawaii] was in fact probably from the Northwest Coast, sent by Meek from Hawaii on board some other vessel. (See number 44 above.) The other became associated with the number 1596 and is currently E3618.

**46. "3807. A wooden Mask, a correct likeness of a distinguished Chieftainess at Nootka Sound"**
*Donor:* "Capt. Daniel Cross, 1827."
*Provenance:* MS archives; MS addition to East India Marine Society 1821 catalogue; 1831 catalogue; E-file.
*Current Status:* E3483 (see the color plate on p. 80); described in a March 7–May 3, 1827, collection note in the EIMS archives as: "Indian mask, representing the features of an aged female of the Casern tribe on the N.W. Coast of America. Captain Daniel Cross of Beverly."[16] It was described in the 1831 catalogue as: "3807. Wooden Mask, once used by a distinguished Chieftainess of the Indians at Nootka Sound—said to represent exactly the manner in which she painted her face."

*Notes:* This Haida mask is by the same maker as a doll in the Peabody Essex collection (E53,452, donated later) and as several masks and dolls in other collections, including the "Jenny Cass" mask at the Peabody Museum at Harvard and another in the same collection donated by William Sturgis Bigelow (see numbers 184 and 235 below). Daniel Cross was master of the Boston brig *Rob Roy* on a voyage to the Northwest Coast between 1821 and 1825. For a discussion of the possible circumstances leading to the collecting of this mask and others by the same carver, see pages 12–16. This mask was borrowed by William Sturgis to illustrate the wearing of the labret for a lecture in 1848 on the "Character of the Indians, and occurrences among them." (See Malloy, ed., *Most Remarkable Enterprise*," 35.)

**47. "3868. Dress of the Natives of the N.W. Coast made from the Intestines of the Ursine Seal *(Otaria Ursina)*"**
*Donor:* "Capt. Bacon."
*Provenance:* MS addition to East India Marine Society 1821 catalogue; 1831 catalogue; E-file.
*Current Status:* E7343, seal intestine parka.
*Notes:* For reasons unknown, this item, which was first listed in the 1821 catalogue as number 613, appeared in the 1831 catalogue as number 3868. Daniel C. Bacon was second in command to Captain William Sturgis on the *Atahualpa* and was later master of the Salem ship *Packet*. Captain Bacon donated early Northwest Coast Indian bows and a rare seal-gut parka (numbers 28 and 32 above).

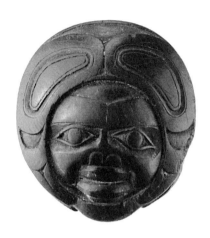

**Object 48**
Argillite pipe. PEM E3497. 3.3 cm x 2.2 cm.

**48. "4079. A Pipe used by the natives of the bay of Trinidad N.W. Coast"**
*Donor:* "J. P. Williams, 1829."
*Provenance:* MS addition to East India Marine Society 1821 catalogue; 1831 catalogue.
*Current Status:* E3497 (see illustration on this page). This is an extraordinary small and finely carved argillite pipe in the shape of a clam shell, with a round and smiling face on the top.
*Notes:* "J. P." Williams is probably an error; see the entry for Israel Porter Williams, number 21 above.

**49. "4093. A Model of a Canoe & of the natives Kodiac Indians from Bodaga—N.W. Coast"**
*Donor:* "Capt. A. W. Williams, 1829."
*Provenance:* MS addition to East India Marine Society 1821 catalogue; 1831 catalogue; E-file.
*Current Status:* E3630 (see illustration on this page); described in the 1831 catalogue as: "Model of a Canoe of the Kodiac Indians together with that of the natives seated in it, from Bodaga, a Russian settlement on the N.W. Coast."
*Notes:* Captain A. W. Williams, son of Captain Israel Williams, died at sea at age 19 two years after donating this model. He has not yet been identified with a Northwest Coast voyage, though he may have been at Bodega, the Russian settlement on the California coast. See numbers 21, 22, 23, and 36 above, and especially number 50 below.

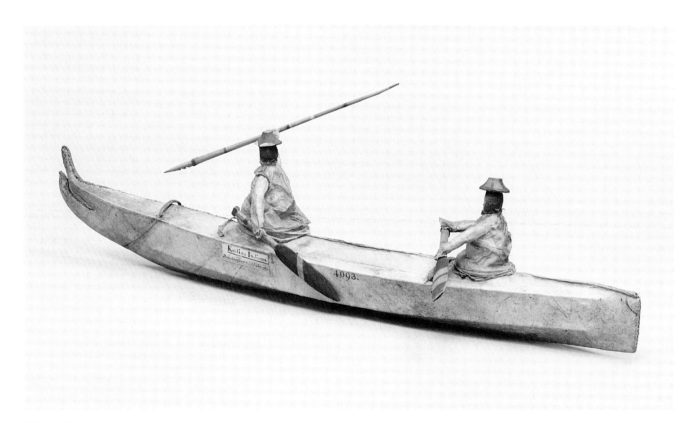

**Object 49**
Canoe model with "Kodiac Indians." PEM E3630.  Length overall: 68.5 cm.

**50. "4126. Cammerlink, or cloak from the N.W. Coast"**

*Donor:* "Capt. A. W. Williams, 1829."

*Provenance:* East India Marine Society 1831 catalogue; E-file.

*Current Status:* E7347. This kamleika or "cammerlink" is described in the E-file as: "Seal Intestine Dress: Jumper with edging of varied-colored stripes around cuffs and neck. Also long parka decorated with small tufts of orange and black and three patterned tabs with fringes."

*Notes:* See previous entry.

**51. "4209. The Head Chief's cap at Norfolk or Norton Sound"**

*Donor:* Unknown.

*Provenance:* MS addition to East India Marine Society 1821 catalogue; 1831 catalogue; E-file.

*Current Status:* Identified in the 1831 catalogue as "4209, Cap of a Principal Chief at Norfolk, or Norton's Sound" and in the E-file as E3646, "Hat from Norfolk Sound near Sitka." (See the color plate on p. 82.)

*Notes:* It is extremely unfortunate that there is no information about this very fine painted basketry hat other than the date of acquisition in 1829. The origin is almost certainly Norfolk Sound, where the Russian center at Sitka was within the territory of the Tlingit, rather than Norton Sound, significantly farther north on the Bering Strait coast of Alaska. Few American ships made it as far north as Norton Sound during the era of the maritime fur trade, and the confusion of the place of origin was certainly on the part of the cataloguer rather than the collector. It may be that this hat, like the next one, was collected by Captain Thomas Meek and presented for him to the EIMS by Captain William Osgood.

**52. "4210. Cap of the Principal Chief at Oonalaska—the work done with a knife ornamented with the whiskers of the Sea Lion—Presented by Capt. Thos. Meek of Marblehead at the Sandwich Islands to Captain Osgood & by him to this Society"**

*Donor:* "Thomas Meek."

*Provenance:* MS addition to East India Marine Society 1821 catalogue; 1831 catalogue; E-file.

*Current Status:* Identified in the 1831 catalogue as: "4210. Cap of a Chief at Oonalaska, carved from a block of wood—ornamented with the whiskers of the Sea Lion, *Capt. Wm. Osgood.*" Currently E3486 and attributed only to "Capt. William Osgood, 1829." (See color plate on p. 82.)

*Notes:* Captain Thomas Meek had ample opportunity to collect this extraordinary long-visored cap. As captain of the *Amethyst* in 1812, he traveled to Sitka, where he was contracted by Governor Aleksandr Baranov of the Russian-American Company to transport Aleut hunters and their 52 skin boats (or baidarkas) to California for a season of hunting. When he returned to Sitka, the *Amethyst* was purchased by the Russians. Captain Meek returned to the Alaska coast on the *Brutus* in 1817 and made a round-trip voyage from Sitka to Kamchatka, carrying cargo and men for the Russian-American Company. In 1818 he was at Sitka again in command of the *Eagle.*

**53. "4239. Skin of a Musk-rat *(Fiber Zibethecus,)* from the N.W. Coast"**

*Donor:* "Capt. Wm. Osgood."

*Provenance:* MS addition to East India Marine Society 1821 catalogue; 1831 catalogue.

*Current Status:* Unknown. This horn was probably discarded in 1942 when the museum cleaned house to create a more focused collection of zoological specimens. See number 41 above.

*Notes:* Osgood is not known to have been on the Northwest Coast himself, but he did command voyages to Hawaii and was a courier for souvenirs from Captain Thomas Meek. In at least one instance (number 52 above), a cap clearly described in the 1821 catalogue as "presented by Capt. Thos. Meek of Marblehead at the Sandwich Islands to Captain Osgood & by him to this Society" was, by the 1831 catalogue, attributed solely to Osgood.

**54. "4240. Skin of a young Sea Otter, *(Lutra Marina,)* from the N.W. Coast"**

*Donor:* "Capt. Wm. Osgood."

*Provenance:* MS addition to East India Marine Society 1821 catalogue; 1831 catalogue.

*Current Status:* Unknown; see number 41 above for a possible explanation.

*Notes:* See number 53 above.

**55. "4264. Stone Pipe from N.W. coast of America"**
*Donor:* "Mr. John C. Jones."
*Provenance:* MS addition to East India Marine Society 1821 catalogue; 1831 catalogue.
*Current Status:* E3498 (see illustration on this page).
*Notes:* This is an extraordinary pipe in the shape of an American ship. John Coffin Jones worked as the Hawaiian agent for the Boston firm of Marshall and Wildes (ca. 1827) and later became the U.S. Consular agent in Hawaii (ca. 1836–1837). In this capacity he encountered almost every vessel involved in the Northwest Coast trade, and he had ample opportunity to collect artifacts from the region and to send them back to New England. Museum records indicate that this pipe was received between July and September of 1830. At Santa Barbara in 1838 Jones was married to Manuela Maria Antonia Carrillo, daughter of the Spanish governor of California. The wedding is described by Richard Henry Dana, Jr., in *Two Years Before the Mast*, where he refers to Jones as "our agent," implying that Jones represented the firm of Bryant and Sturgis as well as Marshall and Wildes.

**56. "4265. [A Pipe] surrounded with Grotesque figures. The mineral a peculiar kind of slate or indurated clay"**
*Donor:* "John C. Jones."
*Provenance:* MS addition to East India Marine Society 1821 catalogue; 1831 catalogue.
*Current Status:* Described in the 1831 catalogue as "another [Stone Pipe] curiously carved with grotesque figures, the mineral is slate or indurated clay." Currently number E3499 (see illustration on this page).
*Notes:* See number 55.

**57. "4284. A full dress for a lady from Behrings Straits"**
*Donor:* "Capt. W. Osgood, 1830."
*Provenance:* MS addition to East India Marine Society 1821 catalogue; 1831 catalogue.
*Current Status:* This may be one of two early Aleutian kamleikas, known to be East India Marine Society pieces but currently unattributed. Numbered E982 and E1123, they are of similar size and decoration. There is also an Aleutian bag or purse made of intestines, which might have been part of this donation; it is currently E3638.
*Notes:* See number 53.

**58. "4285. A dagger used by the natives of the N.W. coast. The copper came from Cook's Inlet. 1830"**
*Donor:* "W. Osgood, 1831."
*Provenance:* MS addition to East India Marine Society 1821 catalogue; 1831 catalogue; E-file.
*Current Status:* E3560. This is a Tlingit-style dagger and sheath, double ended with long and short blades attached at the butt-ends. It is described in the E-file as "Steel blades set in copper or bronze handle. Handle is wrapped with tanned skin, native fiber and braided human hair string."
*Notes:* See number 53 for information about Captain Osgood.

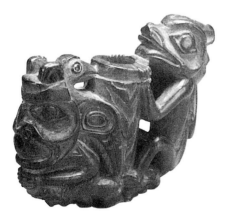

**Object 55**
Haida argillite pipe. PEM E3498.
12.4 cm x 6.4 cm x 2.8 cm.

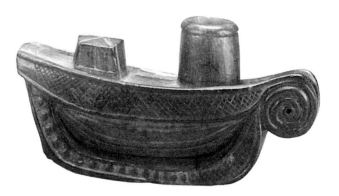

**Object 56**
Haida argillite pipe. PEM E3499. 9.2 cm x 5.8 cm.

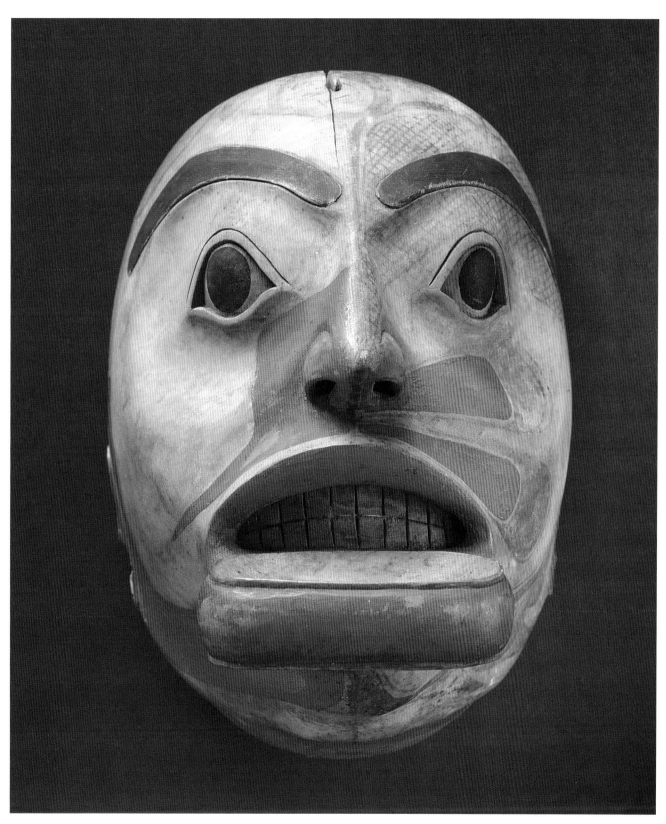

**Object 235**
Haida mask. PMH 98-04-10/51671. 20.5 cm x 15 cm.

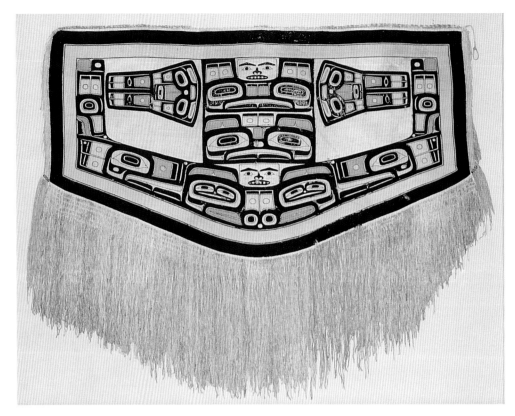

**Object 70**
Chilkat weaving known as the Coppers Blanket. PEM E3648. 162 cm x 120 cm.

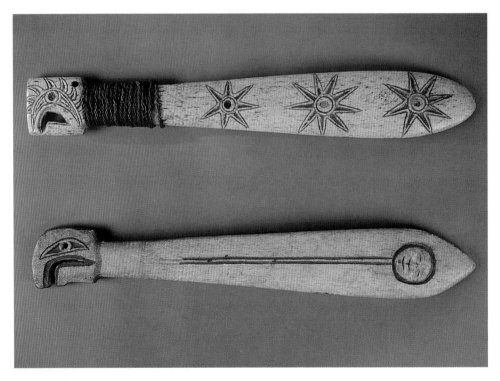

**Object 83b**
Nootkan whalebone clubs. *Top*, PMH 67-10-10/255; *bottom*, PMH 67-10-10/256, 50.8 cm x 7.62 cm.

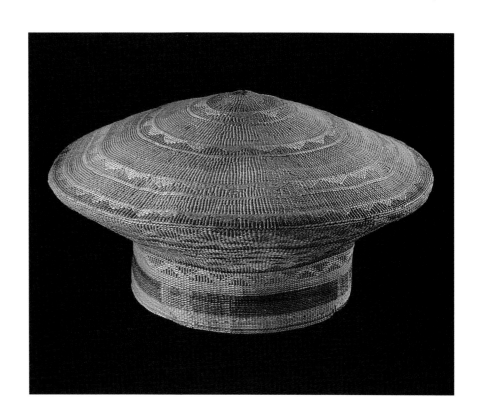

**Object 215**
Tlingit-made sailor cap.
PMH 99-12-10/53083.
29.85 cm x 29.85 cm.

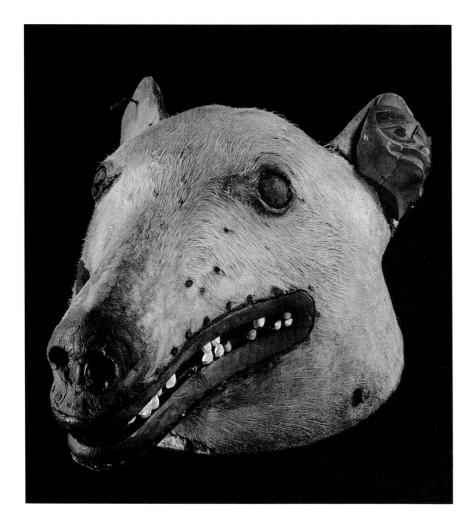

**Object 89e**
Grizzly-bear head ornament.
PMH 67-10-10/275.
36.83 cm x 25.4 cm.

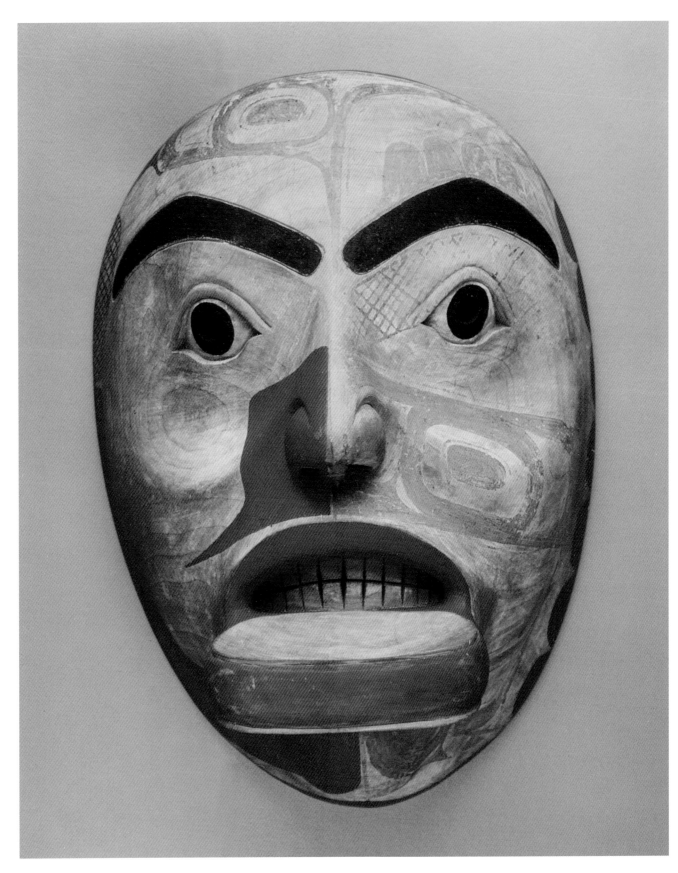

**Object 46**
Haida mask of a distinguished chieftainess. PEM E3483. Length overall: 26 cm.

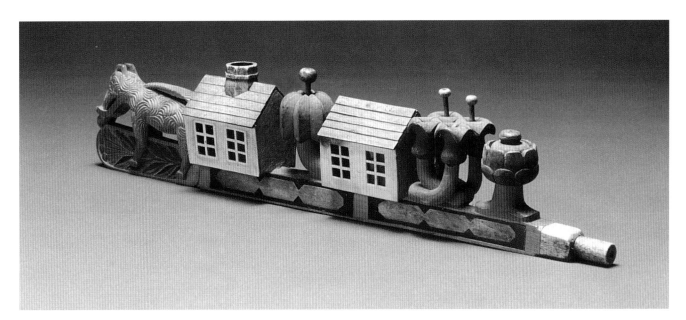

**Object 73**
Wooden pipe. PEM E3492. Length overall: 46.4 cm.

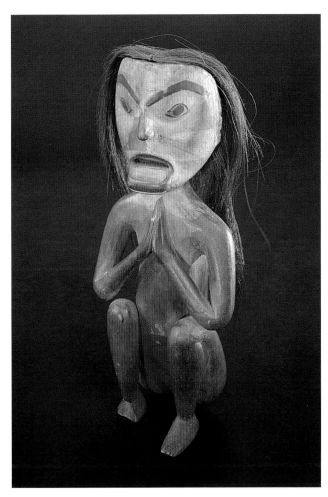

**Object 226**
Haida carved figure. PMH 99-12-10/53093. 19 cm x 8 cm.

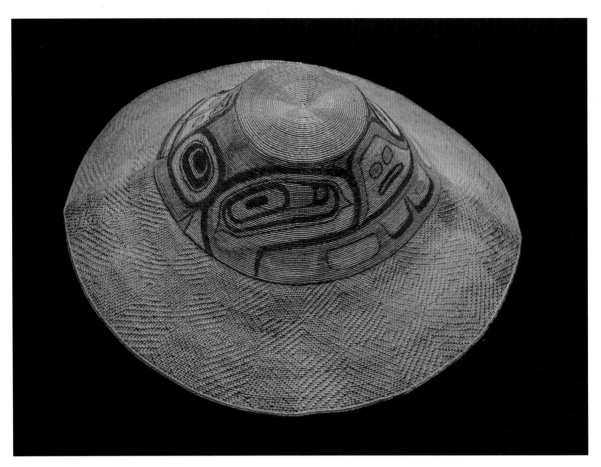

**Object 51**
Painted basketry hat. PEM E3646. 39 cm x 13 cm.

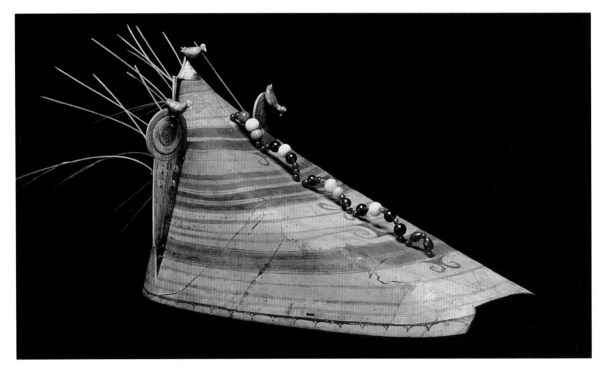

**Object 52**
Chief's cap, carved from wood and ornamented with sea lion whiskers. PEM E3486. 46 cm x 25.5 cm.

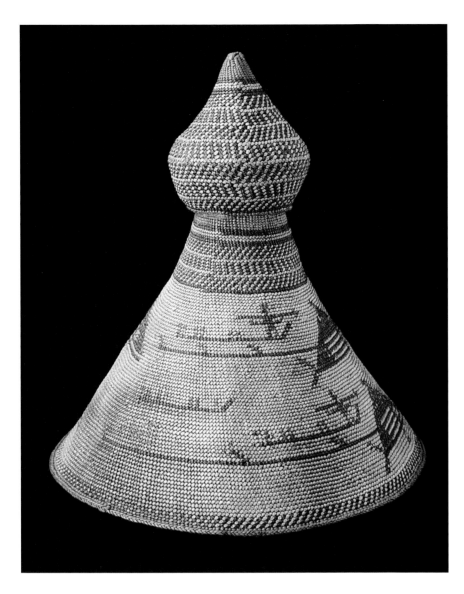

**Object 211**
Nootkan whaleman's hat.
PMH 99-12-10/53079. 27 cm x 22.5 cm.

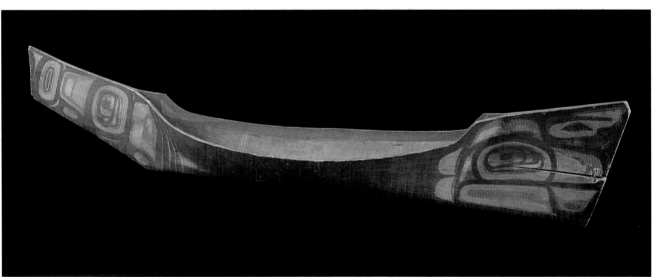

**Object 195**
Wooden canoe model. PMH 69-20-10/1246. 111.76 cm x 21.59 cm.

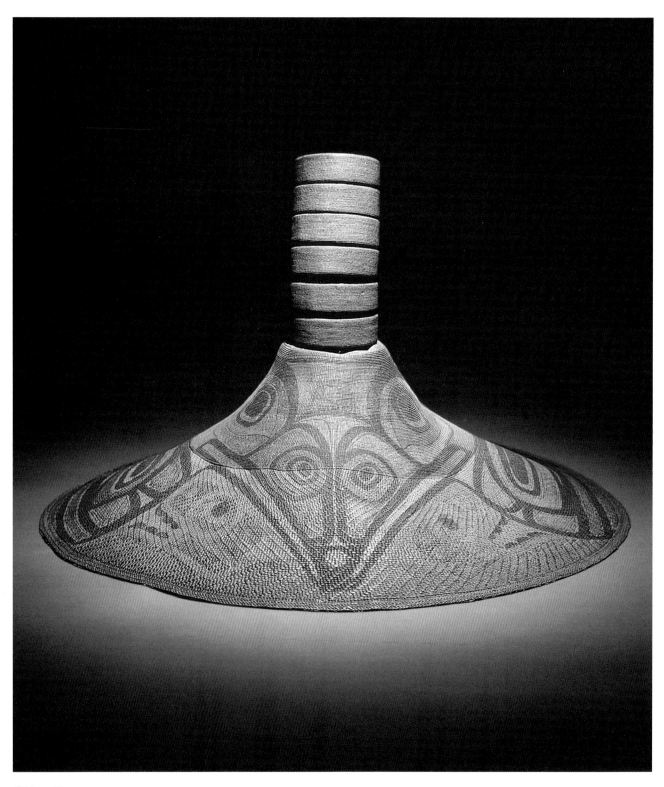

**Object 67**
Tlingit basketry hat with six "potlatch rings." PEM E3647. 63.5 cm x 33 cm.

**59. "4286, Bayonets bound together & used as a dagger by the natives of Nootka Sound, supposed to be a remnant of the arms of the ship *Boston* which was taken by surprise & the crew murdered in [blank]"**

*Donor:* "W. Osgood, 1831."

*Provenance:* MS addition to East India Marine Society 1821 catalogue; 1831 catalogue; E-file.

*Current Status:* The 1831 catalogue adds: "by the celebrated chief Maquinna. See Jewett's Narrative." The current number is E3559 (see illustration on this page).

*Notes:* The famous ship *Boston,* from the city of the same name, arrived on the Northwest Coast in March 1803 and was soon after captured and destroyed by the Mowachaht people of Nootka Sound under the leadership of their chief, Maquinna. Captain John Salter and most of the crew were killed in the attack. Two survivors, John Jewitt and John Thompson, lived in captivity at Nootka Sound until July 1805, when they were rescued by the Boston brig *Lydia.* Jewitt kept a journal of his experience, which was published as *A Journal Kept at Nootka Sound* (1807); a later expanded version appeared as *A Narrative of the Adventures and*

*Sufferings of John R. Jewitt* (1815). Jewitt was the *Boston's* armorer and made a number of daggers for Maquinna, as he describes in his journal. For a full description of the possibilities surrounding the collecting of this dagger, see pages 51–53; for another dagger with a possible Jewitt attribution, see number 25. For information on Captain Osgood, see number 53.

**60. "462–464. Arrows, with barbed heads, of very hard wood"**

*Donor:* None given.

*Provenance:* East India Marine Society 1831 catalogue.

*Current Status:* One arrow of a group of four now attributed to the Northwest Coast still bears the number 463. All four share the current number E3578.

**61. "3459–3463. Five Arrows with Iron Heads"**

*Donor:* None given.

*Provenance:* East India Marine Society 1831 catalogue.

*Current Status:* These five arrows now bear the number E7335.

**62. "3471–3472. Arrows with Bone heads"**

*Donor:* None given.

*Provenance:* East India Marine Society 1831 catalogue.

*Current Status:* Number 3471 currently bears the number E7337; 3472 is now E7338. As these are identified in the catalogue as "fish gigs" they may possibly be part of number 25 above, which lost their association to Captain Richardson between the time of their donation and the publication of the 1831 catalogue.

**63. "4333. Dress of the Natives of the N.W. Coast, made of the intestines of the Ursine Seal, *(Otaria ursina)*"**

*Donor:* "A. Trask of Danvers."

*Provenance:* 1837 MS supplement to East India Marine Society 1831 catalogue.

*Current Status:* This is almost certainly the current E3650. The garment is unequivocally listed in the 1837 supplement as number 4333; but the object itself is marked with the East India Marine Society number 4335 in a style consistent with a circa 1830s accession date; and the description corresponding to number 4335 in the 1837 supplement

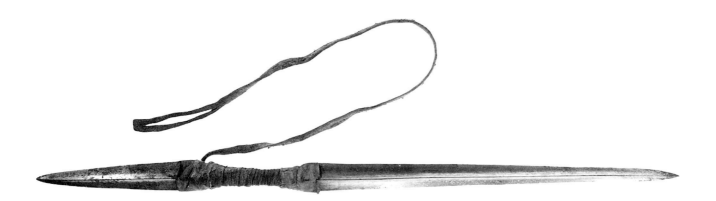

**Object 59**
Dagger made by John Jewitt of the ship *Boston* from bayonets bound together. PEM E3559. Length overall: 66 cm.

is "Horn of the American Elk, from California, Capt. Bradshaw of Beverly," which could not refer to the Northwest Coast garment. Evidently, the names and descriptions were confused in the 1837 supplement, and this eventually resulted in a mistaken attribution in the E-file, which credits the gift to a David Pulsifer, circa 1860. Clearly, 4333 is the correct number for the garment, and either "A. Trask" (not identified) or Captain Bradshaw is the probable donor.

*Notes:* Captain Bradshaw also donated a horn from the coast of California, an extraordinary potlatch hat, and an argillite pipe (see numbers 67 and 68 below). This kamleika may have been collected by him in California around 1824, where he could have obtained it from one of the many Aleut men then hunting there from American ships. For additional details on his career, see number 41 above.

**64. "4343. Garment as used by men of distinction on the N.W. Coast, made of the intestines of the Ursine Seal"**
*Donor:* "John C. Jones, Esq., 1835."
*Provenance:* 1837 MS supplement to East India Marine Society 1831 catalogue.
*Current Status:* Currently E7346, this shirt, now much deteriorated, is still labeled with an East India Marine Society label that attributes the gift to Jones.
*Notes:* See number 55.

**65. "4344. Skin of a Seal, (Phoca sp.) from Aleutian Islands"**
*Donor:* John C. Jones.
*Provenance:* 1837 MS supplement to East India Marine Society 1831 catalogue.

*Current Status:* Probably discarded in 1941. For details see number 41 above.
*Notes:* See number 55.

**66. "4362. Model of a Canoe of the Kodiac Indians, with the natives seated in it, from the N.W. Coast"**
*Donor:* "J. S.[sic] Jones [John Coffin Jones], Boston."
*Provenance:* 1837 MS supplement to East India Marine Society 1831 catalogue.
*Current Status:* An old label affixed to this kayak model reads, "4362: Kodiar [sic] Indians, Presented by J. S. Jones Esqr—Boston." This extraordinary piece is staffed with three carved figures having arms fashioned from iron nails or thick wire, with gut shirts, two with carved wooden hats and the other with a wooden visor. It is complete with hunting gear and is decorated with beads. Current number: E7351.
*Notes:* See number 55.

**67. "4385. A Cap from Nootka Sound"**
*Donor:* "Capt. Bradshaw, 1832."
*Provenance:* 1837 MS supplement to East India Marine Society 1831 catalogue; E-file.
*Current Status:* E3647 (see color plate on p. 84).
*Notes:* Like numbers 41 and 68, this Tlingit basketry hat with six "potlatch rings" was probably collected around 1825 on the coast of California, far from its place of origin. Not having been to the Northwest Coast, either Bradshaw or the curator of the society's cabinet presumed it to be from Nootka Sound, the principal locale of the early maritime fur trade as described by Captain Cook and others; however, it is almost certainly of Tlingit origin from

the Alaska coast. This hat is pictured on the cover of *American Indian Art* (Fall 1986).[17]

**68. "4386. Stone Pipe [from Nootka Sound]"**
*Donor:* "Capt. Bradshaw."
*Provenance:* 1837 MS supplement to East India Marine Society 1831 catalogue; E-file.
*Current Status:* E3496. Described in the E-file as a "stylized argillite pipe, illustrated in Marius Barbeau's *Haida Myths,* p. 94."
*Notes:* Like the previous entry, probably collected on the California coast circa 1824.

**69. "4387. War Club, from North West Coast"**
*Donor:* "R. B. Forbes of Milton, Mass."
*Provenance:* 1837 MS supplement to East India Marine Society 1831 catalogue.
*Current Status:* Unknown. This could be a Nootkan club of skeletal whale bone, but it cannot be located in the present collection.
*Notes:* Robert Bennet Forbes was among the most active and successful young captains involved in Boston's China trade. Though he did not make a voyage to the Northwest Coast proper, he was on the coast of California (at San Francisco and Bodega Bay) and in the Hawaiian Islands commanding the brig *Nile* in 1825. This vessel was owned by his kinsmen James and Thomas Handasyd Perkins. As described on pages 47–50, it was not uncommon to find artifacts from the Northwest Coast at either of Forbes's Pacific landfalls at this time.

**70. "4389. Two Military Parade Cloths, used on the North West Coast"**
*Donor:* "R. B. Forbes of Milton, Mass."
*Provenance:* 1837 MS supplement to East India Marine Society 1831 catalogue; E-file.
*Current Status:* E3648. (See color plate on p. 78.) One of these is the very famous and fine example of Chilkat weaving known as the Coppers Blanket because of the two design fields that are woven in the shape of the traditional coppers that were important symbols of wealth and status on the Northwest Coast.[18] The whereabouts of the second "parade cloth" is unknown.
*Notes:* Captain Robert Bennet Forbes (see the previous entry) almost certainly collected these examples of Tlingit weaving at Bodega Bay, the Russian settlement and trading post on the California coast, in 1825. The Russians commonly transported both Aleut and Tlingit hunters to Bodega Bay from Sitka, the epicenter of the Russian-American Company's activities in Alaska (often on American ships); and Sitka is not far from Chilkat, where these blankets originated. This dancing blanket was probably transported to California by one of the Americans then plying the route and subsequently traded there to Forbes.

**71. "4390. Utensil of Mat Work, used as a Water Vessel on the North West Coast"**
*Donor:* "R. B. Forbes of Milton, Mass., 1832."
*Provenance:* 1837 MS supplement to East India Marine Society 1831 catalogue; E-file.
*Current Status:* E3624 (see illustration on this page). This is an example of fine Chinook weaving.
*Notes:* As with numbers 69 and 70 above, this was probably collected in

1825 by Robert Bennet Forbes on the coast of California or in the Hawaiian Islands, both of which had frequent connections to the Northwest Coast.

**72. "4630. Cloak, from North West Coast of America"**
*Donor:* "Seth Barker, 1835."
*Provenance:* 1837 MS supplement to East India Marine Society 1831 catalogue.
*Current Status:* E7344 (see illustration on next page).
*Notes:* Captain Seth Barker commanded a Northwest Coast voyage in the bark *Volunteer* of Boston from 1823 to 1825, on which this object must have been collected. This Aleut gut garment is described and illustrated in Lydia Black's book *Aleut Art*.[19]

**73. "5064. Pipe carved from wood. Carving and decorative designs show Russian influence. Stylized animal, two houses and six figures of plant life. Length 18 1/4."**

*Donor:* "Received: September 17, 1849—Capt. I. N. Chapman."
*Provenance:* 1837 MS supplement to East India Marine Society 1831 catalogue.
*Current Status:* E3492. (See color plate on p. 81.) This imaginative pipe has two small square houses, exotic plants, and an animal that Victoria Wyatt describes as "a cross between an elephant and a horse."[20] Wyatt and others believe it to be Haida, but it was almost certainly collected at the Columbia River in 1842, possibly transported there from the Queen Charlotte Islands by one of the American ships then frequenting that route.
*Notes:* In 1842 Isaac Chapman was master of the Salem brig *Nereus* on a Pacific Ocean voyage, calling at the Hawaiian Islands, the Columbia River, Hawaii again, New Zealand, Australia, Tahiti, and back to Salem. The trade had changed so radically by this time that Chapman was primarily transporting supplies and stores from one location to the next. At the Columbia River he encountered William Cushing

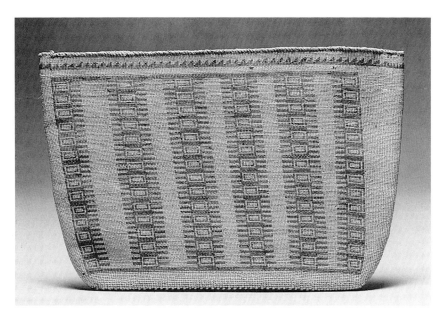

Object 71
Chinook basketry. PEM E3624. 35.2 cm x 21.8 cm.

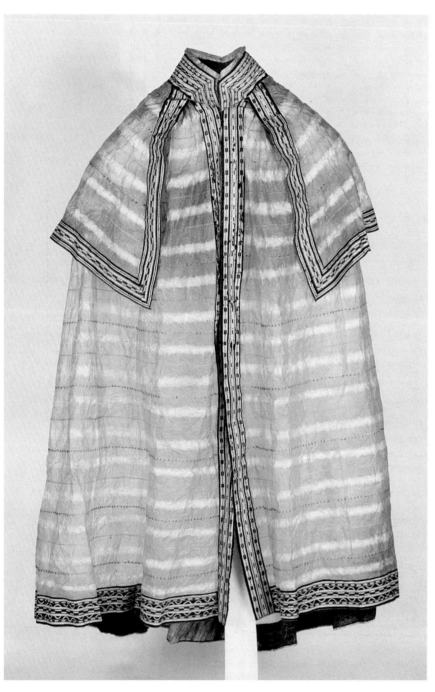

aboard the *Chenamus* of Newburyport, who also returned to New England with souvenirs from the northern part of the coast without actually having ventured north of the Columbia River. See the description in the section about Newburyport collections on page 142.

**74. "Model Kayak, Aleutian, before 1821, E.I. 321"**
*Donor:* Unknown.
*Provenance:* E-file (from the collection of the Essex Institute).
*Current Status:* E7352.

**75. "Model canoe"**
*Donor:* "Edw. Griffin? 1825."
*Provenance:* E-file.
*Current Status:* This carved wooden canoe model is described in the E-file as "Columbia R., N.W. Coast, E.I.M.S.?" (in the "E" accession book there are also the pencil notations "Chinook" and "Edw. Griffin? 1825." It is currently number E939 (see illustration on next page).
*Notes:* This may be one of the canoe models described in number 27 above whose current whereabouts is unknown.

**Object 72**
Aleut gut cape. PEM E7344. Length overall: 122 cm.

**76. "Model of an Indian Whaling canoe & gear from Vancouver Island 'Nootka Tribe' L. 51.30 N 129° W. N.W. Coast of America"**
*Donor:* "Captain Nathaniel Silsbee, 1800."
*Provenance:* Label pasted on canoe (from the Essex Institute).
*Current Status:* E7349, with associated gear E3563 (see illustration on this page). The E-file calls this "E.I., 423, Capt. N. Silsbee, 1800"; the "E" accession book calls it a "Model of canoe, Nootka Sound North End Vancouver." It also says "O.C. 117," which would associate it with the "old catalogue" numbering system and consequently with the Silsbee fish gig described as number 6 above.

*Notes:* This extraordinary carved model of a dugout whaling canoe was separated for about a century and a half from the carved model gear that accompanies it—five carved effigies of sealskin floats and lines with harpoon heads—but the numbers still legible on the artifacts make the association clear. For information on Captain Silsbee's career, see number 4 above.

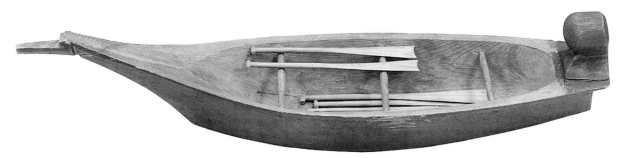

**Object 75**
Canoe model. PEM E939. Length overall: 60 cm.

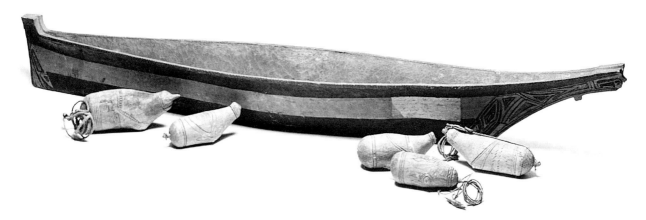

**Object 76**
Model of a dugout whaling canoe and gear. PEM E7349 and E3563. Length overall: 107 cm.

# Massachusetts Historical Society
# 1791

As Boston boomed after the Revolutionary War, the movement to establish an association of "persons of historical tastes" began to be discussed with some fervor. In 1789 John M. Pintard, a young New York merchant and one of the original owners of the *Columbia* and *Washington*, approached Jeremy Belknap about forming "a Society of Antiquarians."[21] Belknap, a Boston minister and historian, became devoted to the idea and sketched out the following plan in August 1790:

> A society to be formed . . . for the purpose of collecting, preserving, and communicating the antiquities of America. . . . Each member, on his admission, shall engage to use his utmost endeavors to collect and communicate to the Society manuscripts, printed books and pamphlets, historical facts, biographical anecdotes, observations in natural history, specimens of natural and artificial curiosities, and any other matters which may elucidate the natural and political history of America from the earliest times to the present day . . .[22]

The result of Belknap's efforts was the Massachusetts Historical Society (MHS), officially founded on 24 January 1791.[23] Among the very first donations made to the society were a number of Northwest Coast Indian items brought back to Boston on the ship *Columbia* and given to the society by Captain Robert Gray and by the principal owner, Joseph Barrell. At the very time that Jeremy Belknap was putting his plan for the society on paper, the *Columbia* was entering Boston harbor after her landmark voyage—the first American ship to travel around Cape Horn, the first to reach the Northwest Coast, and the first to circumnavigate the globe. Once the society was established, several captains seem to have collected with donation to the museum specifically in mind. For example,

James Magee departed Boston as master of the ship *Margaret* in October 1791, and when he returned more than two years later he immediately presented the society with a large assortment of "curiosities."

The society reassessed its collections several times during the nineteenth century, each time moving farther from a museum identity and becoming more of a library. In 1833, when it moved to Tremont Street, most of its natural history specimens were deposited at the Boston Society of Natural History. In 1867, the bulk of the ethnological collection was sold for $20,000 to the newly formed Peabody Museum of American Archaeology and Ethnology at Harvard University.[24]

In addition to logbooks, journals, and papers associated with some of the voyages on which specific artifacts were collected, the MHS acknowledged donations in their published *Proceedings of the Massachusetts Historical Society.* A manuscript "Cabinet Log Book, 1791–1952" provides some more detailed information about groups of objects given in the early years.

In the case of one donor, Captain Ebenezer Dorr, Jr., the record in the *Proceedings* was given without any details as "A Valuable collection of Curiosities from the North-west Coast of America." Fortunately, a list of artifacts collected by Dorr has been found in his journal of a 1790–1792 voyage as a mate aboard the Boston brig *Hope.*

Not all of the objects described in the early catalogues survived to be transferred to Harvard. Some, like the scalps donated by Captain James Rowan, were probably not in suitable condition, but other important Native American artifacts were apparently stolen by one of the society's members, Samuel Turell. The society loaned a portion of its collection to Turell in 1802 "to be deposited in a Cabinet of Natural History, which he proposes to establish in the town of Boston."[25] Five years later Turell apparently refused to return the collection. On 25 August 1807 the society voted "that Dr. Eliot, Judge Davis, Dr. Webster, and Mr. Shaw be a committee to demand of Mr. Turell, Cabinet-Keeper, the various articles belonging to the Society which have been in his possession, and to see that they are returned to the Cabinet."[26] Several subsequent requests for the return of the articles having failed, the society voted on 27 August 1811 that

> Whereas a Committee has been instructed to demand of Samuel Turell the several articles intrusted to him as Cabinet-Keeper, which he has not returned, and whereas he has otherwise acted unworthily as a member; therefore,
>
> *Voted,* That he be expelled from the Society.[27]

Turell was the third and last person ever to be expelled from the MHS. (The other two had been politicians at the national level—a U.S. senator and a secretary of state, who were forced out of their positions because of political scandals, and the MHS felt obliged to follow suit.) The circumstances of Turell's expulsion are important because he had in his possession at that time a number of unspecified objects from the society's collection. Among the artifacts exhibited in his private museum in Boston were "many Indian Curiosities," which were seen there in 1802 by the Reverend William Bentley of Salem.[28] Some of the MHS collection of Northwest Coast Indian artifacts that cannot be located today were probably included in Turell's theft.

At the Peabody Museum, Harvard (PMH), the society's collection received catalogue numbers from 226 to 431, with some nonsequential numbers making up the total of 231 "specimens."[29] They were later given a group accession number of 67-10, identifying the group as the tenth accession acquired in 1867. All of the Northwest Coast material received the further designation of being of North American origin, which was indicated by the number 10. Each of the MHS collections from the Northwest Coast is thus identified by the prefix "67-10-10" followed by the individual catalogue number.[30]

It is not always possible to reconcile the original records of the MHS with the list of material transferred to Harvard because in the transfer process a number of artifacts were surely mislabeled. In some cases, names were altered and known characters, like John Boit, a mate on the *Columbia* and master of the *Union*, became the mysterious "Capt. Boyd." In other cases, donors known to have been associated with large collections were identified with miscellaneous objects that had no other attribution. In this way Captain James Magee became known as the collector of many more objects than he actually gave to the MHS, and some of the artifacts attributed to him by the PMH for more than a century are reunited here with the names of the actual donors, Captain Ebenezer Dorr, Captain Stephen Hills, and others.

# OBJECT LIST

## 77. "Cloak, and mantle, pieces of Cloth, etc. from Nootka Sound"

*Donor:* "Joseph Barrell, Esq., for himself and associates."

*Provenance:* MS "Cabinet Log Book, 1791–1952" (p. 1) and *Proceedings of the Massachusetts Historical Society,* 21 December 1791.

*Current Status:* Unknown. These were cedar-bark garments, further described in the *Proceedings* as "manufactured there from the bark of trees"; none survived to be transferred to the PMH in 1867.

*Notes:* Barrell was the principal owner of the *Columbia* and *Washington,* and his associates were the other owners, Samuel Brown, Charles Bulfinch, John Derby, Crowell Hatch, and John M. Pintard (who had also influenced Jeremy Belknap in founding the society). From the early date of this donation, these objects certainly came to Boston when the *Columbia* returned from her first voyage under the command of Robert Gray.

## 78. "Hat. A straw hat from Nootka Sound"

*Donor:* "Joseph Barrell, Esq., and his associates, 21 December 1791."

*Provenance:* MS "Cabinet Log Book, 1791–1952" (p. 1) and printed *Catalogue of the Cabinet,* 1885, page 111.

*Current Status:* This is somewhat mysterious, as the MHS record would indicate that this hat had been retained after other ethnological collections were transferred to the PMH, but the accession list at the PMH is unequivocal: there is only one hat attributed to Barrell by the MHS, and it entered the PMH as number 67-10-10/329, described as a "Hat, North west Coast, J. Barrell."

*Notes:* See previous entry.

## 79. "Sundary [sic] Curiosities from the . . . N.W. Coast"

*Donor:* "Mr. L. Haigt."

*Provenance:* MS "Cabinet Log Book, 1791–1952" (p. 1) and *Proceedings of the Massachusetts Historical Society,* 29 January 1793.

*Current Status:* Unfortunately, the collection remains unspecified.

*Notes:* Lewis Hayt was a supplier to the *Columbia,* who may have engaged in private trade with the owners, officers, or members of the crew, resulting in this collection of souvenirs of the voyage.[31]

## 80. "A Fish hook, from Nootka Sound"

*Donor:* "The President."

*Provenance:* MS "Cabinet Log Book, 1791–1952" (p. 2) and *Proceedings of the Massachusetts Historical Society,* 26 November 1793.

*Current Status:* All of the fishhooks transferred from the MHS to the PMH became attributed to James Magee (see number 82 below).

*Notes:* The Honorable James Sullivan, LL.D., was president of the Massachusetts Historical Society from 1791 to 1806. A founding member of both the MHS and the American Academy of Arts and Sciences, Sullivan had a passionate and patriotic interest in history and published a number of works on a wide range of legal and historical topics. He was appointed to the Supreme Judicial Court of Massachusetts in 1776, was elected to Congress in 1783, became attorney general of Massachusetts in 1790, and was elected governor in 1807. No direct link has been found between Sullivan and any Northwest Coast voyage, but like Rev. William Bentley of Salem (see pp. 37–38, Sullivan is a perfect example of the amateur scientist and historian at the turn of the nineteenth century, for

whom acquiring collections (and in turn donating them to one of the scientific societies) was a way of life.

## 81. "A Bow and Arrow & c. from the N.W. Coast of America"

*Donor:* "Captain R. Gray."

*Provenance:* MS "Cabinet Log Book, 1791–1952" (p. 2) and *Proceedings of the Massachusetts Historical Society,* 26 November 1793.

*Current Status:* Numerous unattributed bows and arrows were transferred from the MHS to the PMH in 1867, including a Chinook bow from the Columbia River (67-10-10/386). A Kwakiutl "bow with hair attached" is number 67-10-10/297; a Tlingit bow is number 67-10-10/298. An unidentified bow from the Northwest Coast described as a "worthless specimen" was destroyed in 1884; it was number 67-10-10/296. An additional nineteen unattributed bows and arrows are included as numbers 67-10-10/387–390.

*Notes:* Robert Gray left Boston in September 1787 as master of the *Lady Washington,* traveling in company with John Kendrick, master of the *Columbia.* On the Northwest Coast, at Kendrick's insistence, the two exchanged vessels; thus, when Gray returned to Boston in August 1790 it was in command of the *Columbia,* the first American ship to circumnavigate the globe. He departed for the Northwest Coast in the *Columbia* again in September 1790, entered the Columbia River and named it after the ship on 12 May 1792, and after a second trading venture on the Coast and a second circumnavigation, returned to Boston on 25 July 1793, just a few months before this donation was made to the MHS.

**82. "Three Indian Habits, a Model of a Cano [sic], a Sea Otter Skin, an Elks Horn, Two Water Baskets, Three Caps, one Combe [sic], A Stone Axe, a Ladys Work Bag and Thread, Two Lip ornaments, Bracelets, Bows & Arrows, a Decoy Bird, Several Harpoons, Lances and Buoys, a variety of Fish Hooks, Samples of Cordage, Skin of the Glutton, Skin of the Silver Seal."**

*Donor:* "Capt. James Magee, collected by him in a late voyage around the World."

*Provenance:* MS "Cabinet Log Book, 1791–1952" (pp. 3–4), and *Proceedings of the Massachusetts Historical Society,* 28 October 1794.

*Current Status:*

A. *Three Indian habits:* These garments might have been cedar bark or sea mammal gut, but they were never transferred to the PMH and have subsequently been lost.

B. *Model of a canoe:* In the PMH records, 67-10-10/290 is a "Model of a canoe, North west Coast, Capt. James Magee, 1794."

C. *Sea otter skin:* Never transferred and subsequently lost.

D. *An elk's horn:* This object may have stayed for a time in the collection of the MHS; it appears in a published *Catalogue of the Cabinet* (1885), but all record of it has since been lost.

E. *Two water baskets:* Unknown.

F. *Three caps:* In total, Magee is associated in the PMH accession record with seven Nootkan basketry hats, numbers 67-10-10/268 (five hats), and 67-10-10/269 (see illustration on this page) and 270. Three of the four additional hats listed in the catalogue and credited to Magee were in fact probably donated by Ebenezer Dorr (see number 92 below). Over the years, the PMH exchanged three of the seven hats

with other institutions, and today they can be found in the Heye collection,[32] the Denver Art Museum,[33] and the American Museum of Natural History in New York City,[34] all still attributed to Magee.

G. *One comb:* Though Magee's original collection clearly included only a single comb, two are attributed to him in the PMH record: a "Comb of horn" is 67-10-10/265, and a "Comb made of bone" is 67-10-10/266 (see illustration on next page).

H. *Stone axe:* Unless this is a Nootkan whalebone club wrongly described (see the Hills and Dorr donations below, numbers 83 and 92), there is no mention of it in any subsequent record.

I. *Lady's workbag and thread:* Unless this is 67-10-10/428, an otherwise unidentified "bag," it was evidently never transferred to the PMH.

J. *Two ornaments for the lips:* A single labret was transferred to the PMH and given the number 67-10-10/277.

K. *Several bracelets:* No record.

L. *Bows and arrows:* No bows or arrows are specifically connected with Magee in the PMH record, although there are a number unattributed in the collection (see number 81 above). There are seven "spear points" on the PMH list that are attributed to Magee, numbers 67-10-10/257 (3), 258 (3) and 260.

M. *A decoy bird:* No record.

N. *Several harpoons:* These may be the "spear points" described above; otherwise they appear to be lost.

O. *Lances and buoys:* Nothing fitting this description and specifically attributed to Magee survives at the PMH. However, a "spear with float of bladder" from the Northwest Coast, with no collector credited, entered the collection as 67-10-10/354.

**Object 82f**
Nootkan basketry hat. PMH 67-10-10/269. 27 cm x 27 cm x 25 cm.

P. *Fishhooks:* In all, fourteen fishhooks from the Northwest Coast are attributed to Magee in the accession records at the PMH; eleven of these are grouped together as number 67-10-10/250 (notes in the record from Lt. George Emmons indicate that "the small ones are for cod, the larger are for halibut"). Number 67-10-10/251 is a Nootkan fishhook, and numbers 67-10-10/253 and 254 are Tlingit hooks. (See illustrations on next two pages.) It seems reasonable to presume that some of these were the ones donated by Bentley and Dorr (see numbers 89 and 92 below).

Q. *Samples of cordage:* Though lacking any collector information, there is a sample of "leather cordage" from the Northwest Coast, number 67-10-10/407.

R. *Skin of the glutton:* No subsequent record found.

S. *Skin of the silver seal:* No subsequent record found.

*Notes:* James Magee was master of the Boston ship *Margaret*, which departed for the Northwest Coast in October 1791. He became seriously ill on the voyage, and for most of the time his ship was on the Northwest Coast, Magee himself was a guest of the Spanish magistrate ashore at Nootka Sound. Eventually he turned over command of his ship to the first mate, David Lamb, and returned to Boston via Canton on the brigantine *Hope* (of which he was a part owner) under Captain Joseph Ingraham, arriving home in the summer of 1793. On the *Hope* Magee traveled with the young mate, Ebenezer Dorr, whose collection of souvenirs is described below. In the PMH record Magee is also credited with donating a "knife made of bone," number 67-10-10/267, which cannot be reconciled with any of the objects in his list or any of the missing objects from other known donors.

**83. "A Paddle from Nootka, a Weapon used by the natives in killing deer, Specimens of White and Green earth, from N.W. Coast . . . A Pair of Boots, from Kamchatka"**
*Donor:* "Mr. S. Hills."
*Provenance:* MS "Cabinet Log Book, 1791–1952" (p. 5) and *Proceedings of the Massachusetts Historical Society,* 20 December 1794.

*Current Status:*

A. *Paddle:* No paddles are attributed to Stephen Hills in the PMH record, but eight are credited to a "Thomas Hills" in 1794—one of which must be part of Stephen Hills's original gift (there is no Thomas Hills in the original MHS record, and the date of 1794 is clear). The other paddles are probably the gifts of Captains John Boit and Ebenezer Dorr, noted below; they are 67-10-10/337-344.

B. *Weapon used by the natives in killing deer:* Two "clubs for killing deer" and a model of the same are listed in the PMH accession records, but there the Nootkan whalebone clubs are erroneously attributed to Captain James Magee. This error in the 1867 list has been extensively repeated in the literature on early Northwest Coast collections. (As noted above, Magee did not give any such clubs to the MHS.) At least one of the "clubs for killing deer" must have been the one collected by Hills; the others are probably the gift of Ebenezer Dorr (see number 92 below). The two clubs bear the numbers 67-10-10/255 and 256 (see color plate on p. 78), the "model of a club like 256" is 67-10-10/259.

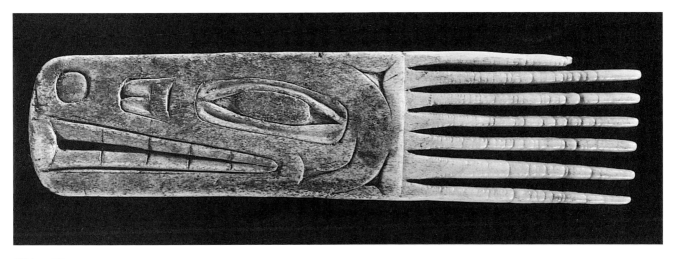

**Object 82g**
Comb made of bone. PMH 67-10-10/266. 12.7 cm x 3.18 cm.

C. *Pair of boots from Kamchatka:* 67-10-10/294, in the record clearly attributed to "Stephen Hills, 1794." *Notes:* Stephen Hills was Captain James Magee's third mate on the *Margaret,* and these objects were evidently acquired on the same 1791–1794 voyage as Magee's extensive collection, described above in number 82. Hills returned to the Northwest Coast in the fall of 1795 as captain of the Boston brig *Sea Otter,* which he owned with Magee, Russell Sturgis, and J. and Th. Lamb. Hills was killed (along with his purser and steward) by the natives of Cumshewa in 1796, and the *Sea Otter* returned to Boston under the command of James Rowan, arriving in July 1798. Rowan would later donate a scalp to the MHS, which was presumably that of Hills or one of the other casualties from the *Sea Otter* (see number 90 below).

## 84. "Paddle"

*Donor:* "Capt. J. Roberts."
*Provenance:* MS "Cabinet Log Book, 1791–1952" (p. 6) and *Proceedings of the Massachusetts Historical Society,* 27 October 1795.
*Current Status:* This paddle was included in an assortment of objects representing the major stops on a China trade voyage: the Northwest Coast, Hawaii, and Canton. The whole donation, described in both the "Cabinet Log Book" and the *Proceedings,* included "A Cap or Helmet, ornamented with feathers, A Specimen of very fine Cotton, an ornamental Collar, A War Club, a Paddle, Arrows, a Mandarines Tobacco Pouch." Only the paddle can be attributed to the Northwest Coast with any certainty. It was transferred to the PMH with the Roberts association intact and is currently 67-10-10/336.
*Notes:* Josiah Roberts was captain of the Boston ship *Jefferson,* which cleared

Boston in November 1791 and returned in 1794. This paddle must have been collected on that voyage.

## 85. "Apron, Paddle, Fishing Lines, from the N.W. Coast"

*Donor:* "Capt. Boit."
*Provenance:* MS "Cabinet Log Book, 1791–1952" (p. 9), and *Proceedings of the Massachusetts Historical Society,* 30 January 1798.
*Current Status:*
A. *Apron:* Probably a cedar-bark garment, none of which survives.
B. *Paddle:* If it survives, this paddle must be either 67-10-10/335, which has no donor cited, or one of the paddles attributed in PMH records to "Thomas Hills" (see number 83 above).

C. *Fishing lines from the Northwest Coast:* Unknown.
*Notes:* John Boit was the fifth mate under Captain Robert Gray on the *Columbia's* second voyage to the Northwest Coast, from 1790 to 1793. After gaining additional experience on a coastal and a transatlantic voyage, Boit became, at the age of nineteen, the captain of the sloop *Union* of Newport, R.I., and made a successful Northwest Coast voyage, 1794–1796. It was on this voyage that he probably collected the artifacts mentioned here. Additionally, there is a spoon in MHS credited to "Capt. Boyd," 67-10-10/ 422.

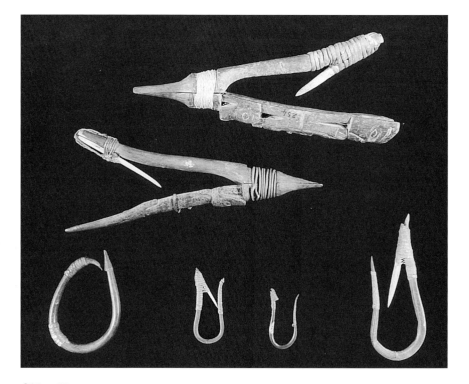

**Object 82p**
Fishhooks at Peabody Museum, Harvard. Left photo: *top,* 67-10-10/254, 33.02 cm x 13.97 cm; *middle,* 67-10-10/253, 34.29 cm x 12.7 cm; *bottom,* 67-10-10/250, 17.78 cm x 8.89 cm. Right photo: *left,* closer view of 67-10-10/253; *right,* closer view of 67-10-10/254.

**86. "Several Articles of Dress and Weapons from the S. Sea I. & N.W. Coast"**

*Donor:* "Mr. J. Boit, Jr."

*Provenance:* MS "Cabinet Log Book, 1791–1952" (p. 9), and *Proceedings of the Massachusetts Historical Society,* 30 January 1798.

*Current Status:* Unknown.

*Notes:* Unfortunately, the lack of specificity here and the absence of a mention in the PMH records make it impossible to attribute any specific weapons to

Boit. In *Soft Gold: The Fur Trade & Cultural Exchange on the Northwest Coast of America,* Bill Holm speculates that Boit might have collected the two whalebone clubs erroneously attributed to James Magee,[35] but it seems clear that one of them was donated by Samuel Hills and more likely that the other was the gift of Ebenezer Dorr, who mentioned collecting two of them in his journal and later also made an unspecified but "valuable" donation to the MHS (see numbers 83 and 92 for

details). It is possible, as Holm suggests, that the wooden sheath described below as number 93 was the gift of Boit.

**87. "An artificial Toad cut in Stone, Bow and Arrows, A small Birch Canoe, from Nootka Sound"**

*Donor:* "Mr. J. Tucker of York."

*Provenance:* MS "Cabinet Log Book, 1791–1952" (p. 10), and *Proceedings of the Massachusetts Historical Society,* 30 January 1798.

*Current Status:*

A. *An artificial toad cut in stone:* This may have been an argillite carving. If so, it would be the earliest example collected. Unfortunately, there is no subsequent record.

B. *Bow and arrows:* See the unattributed bows and arrows described in the Gray collection (number 81) above.

C. *A small birch canoe from Nootka Sound:* The record is obviously confused here. Tucker was from Maine and could very well have donated a birch-bark canoe model, but no such item would have originated on the Northwest Coast. There is only one unattributed "model of canoe in wood" from the Northwest Coast in the PMH record (67-10-10/278), and that was more likely collected by Ebenezer Dorr (see number 92 below).

*Notes:* Captain Joseph Tucker served as an officer in the Continental Army during the Revolution (the title "captain" is a military rather than maritime designation). His wife, Mary Stone, was a member of a prominent family of York (then Massachusetts, now Maine); her mother was a descendant of Governor Bradstreet. Tucker purchased a wharf and other property from his father-in-law and became an influential citizen of York, serving as collector of customs for the port from 1793 to 1804 and as town treasurer for a number of years until his death around 1812.

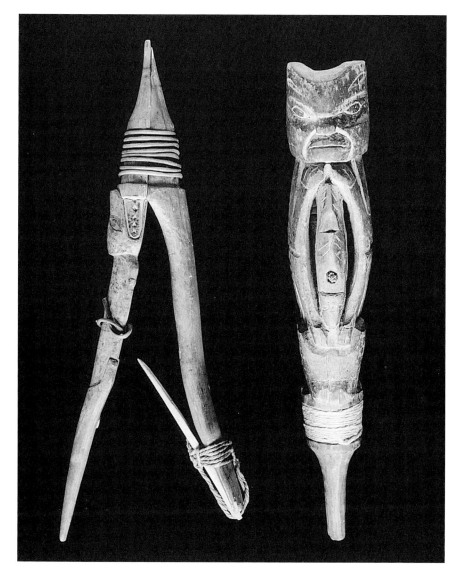

Although his position as a customs officer and prominent citizen would certainly have put him in circles where he might have obtained Northwest Coast articles, Captain Tucker never went to the Pacific Ocean himself. The vague nature of this entry may indicate a confusion on the part of either Tucker or the MHS as to the actual origin of these artifacts.

## 88. "Heads of Indian Arrows"

*Donor:* "David Nye, Esq., of Falmouth."
*Provenance:* MS "Cabinet Log Book, 1791–1952" (pp. 11–12) and *Proceedings of the Massachusetts Historical Society,* 27 January 1801.
*Current Status:* Two separate entries, one as "Heads of Indian Arrows" and a later one as "Four Heads of Indian Arrows" are listed in the MHS "Cabinet Log Book," one dated 28 January 1800, the other 27 January 1801. It is not clear if these are two gifts, or one that has been repeated in error. In any case, Nye's name does not appear in the PMH catalogue ledger, and there are no arrowheads listed. There are a number of unattributed spearpoints that may include those donated by Nye. Numbers 67-10-10/261, 262, 264, and 283 are "spear points of bone," and number 67-10-10/263 is a "spear point of bone & iron."
*Notes:* David Nye made at least three voyages to the Northwest Coast; unfortunately the earliest, on which he collected these arrowheads, has not been identified. Later, when the Boston brig *Lydia* was already on the Northwest Coast during her voyage of 1804–1807, Nye was promoted to fill the berth of a troublesome first mate, probably transferring from the *Pearl.* He later commanded the Salem brig *New Hazard* on a voyage of 1810–1813. In 1818 on the

coast of Chile, he succeeded Captain Thomas Meek as commander of the *Brutus* and spent at least two seasons on the Northwest Coast, where the *Brutus* was sold to the Russians in late 1819.

## 89. "From the Northwest Coast and Sandwich Islands, Two Lady's Work Bags, a Fishing Net, Three Fish Hooks, Two Lip pieces, an ornament for the head, Two pieces of Cloth, A Pair of Kamstchatka Boots, Three Bills of the Albatross, Skin of a Young Penguin, Three Sea Shells, and Several Articles . . ."

*Donor:* "Rev. W. Bentley."
*Provenance:* MS "Cabinet Log Book, 1791–1952" (pp. 12–13), and *Proceedings of the Massachusetts Historical Society,* 27 January 1801.
*Current Status:*

A. *Two lady's workbags:* An unattributed "bag" in the PMH, number 67-10-10/428, may either be one of those donated by Bentley or the one described in the Magee collection (number 82) above. There is also an unattributed "Young lady's cap," number 67-10-10/271, which is noted in the PMH catalogue ledger as having been identified by Franz Boas as a Chinook cap from the mouth of the Columbia River. In the collection of the East India Marine Society there was some confusion among women's workbags and the smaller basketry caps worn by girls, and that may have occurred here as well.

B. *A fishing net:* Unknown.

C. *Three fishhooks:* All of the Northwest Coast fishhooks on the PMH list are attributed to James Magee (see number 82).

D. *Two lip pieces:* Unknown.

E. *An ornament for the head:* An unattributed wooden helmet in the PMH list, number 67-10-10/275, seems to fit

this description (see color plate on p. 79); PMH exhibit labels describe it as having been "Collected in the 1790's." This is an extraordinary grizzly-bear head, which is associated with Chief Shakes of Wrangell, Alaska, in a note in the PMH catalogue book signed "A.S. 83[1?]."[36]

F. *Two pieces of cloth:* Unknown.

G. *A pair of Kamchatka boots:* Although not attributed, these must be 67-10-10/295, listed as "Boots, Kamstchatka."

*Notes:* Reverend William Bentley of Salem was the recipient of the first Northwest Coast Indian artifacts sent back to New England. He received several gifts from Captain John Kendrick, sent via two Salem ship masters who met up with Kendrick at Canton and returned to New England before the *Columbia* completed its historic circumnavigation and returned to Boston in August 1790. Kendrick first wrote to Bentley from the Northwest Coast, delivering his letter via one of the British ships to Canton; the letter was received by Bentley in March 1790. Three months later Bentley noted in his diary the receipt of sundry curiosities from the Northwest Coast, writing on 31 May: "My good friend Capt Hodges [of the ship *William and Henry*] presented to me a Pike or Spear of Wood, with a Bow & two Arrows brought by the American Ship *Columbia* from Nootka Sound to Canton, & Specimens of Cloth from Sandwich Islands." A week later he reported on "Curiosities delivered to me by Capt H. Elkins [of the ship *Atlantic*] . . . Specimens of Cloth from the *Columbia.* Hooks of Bone & Mother of Pearl from the Natives of America, with Lines."[37] Bentley also had "A War Club from N.W. Coast," which cannot be located today but was listed in the catalogue of his cabinet.[38]

Chief Shakes is mentioned by name by a number of traders. For example, the anonymous keeper of a journal aboard the *Rob Roy,* in an entry dated 13 March 1822 at Cocklanes: "This day the Chief of the Stickene Tribe was on board named Shakes and a number of others. Shakes appears to be a pretty crafty fellow and it is said he intends taking the first vessel he possibly can to revenge the death of his wives father who was killed by Capt. Hill[s] of Brig *Otter* some time since." (The death of Captain Hills, who gave the objects listed in the entry for number 83 above, and the retribution taken for his death by his mate James Rowan, are described in the next entry.)

### 90. "An European Scalp, received from an Indian on the North West Coast of America"

*Donor:* "Capt. T. Roan [sic]."
*Provenance:* MS "Cabinet Log Book, 1791–1952" (p. 13) and *Proceedings of the Massachusetts Historical Society,* 27 January 1801.
*Current Status:* Not transferred to PMH and currently lost.
*Notes:* Captain James Rowan, whose name was misspelled in the MHS *Proceedings,* was captain of the Boston vessel *Eliza,* which made a 1798–1800 voyage to the Northwest Coast. Earlier, as a mate on the *Sea Otter,* Rowan had witnessed the murder of Captain Stephen Hills and two crew members near the Haida village of Cumshewa in the Queen Charlotte Islands. On the *Eliza* voyage he was offered the scalps of his former shipmates and an opportunity to arrange for the execution of their murderers. William Sturgis, then a young man making his first voyage on the *Eliza,* witnessed the events and described them later in a public lecture in Boston. According to Sturgis, two high-ranking brothers, one named

Scotsi, came aboard the ship, carrying "the scalps of the white men killed at Cumshawas":

Capt. Rowan succeeded in enticing these people on board the *Eliza,* where they were seized and confined; but subsequently all except Scotsi and his brother were released upon surrendering the scalps in their possession. These scalps were brought on board in a box, which being opened, they were found carefully enveloped in several folds of blue cloth, with the long hair—the fashion of that day—powdered with the down of sea fowl, just as they had been used, a short time before, in a war dance.[39]

The scalp or scalps donated by Rowan to the MHS a few months after his return are certainly those of his former shipmates, one of whom, Captain Stephen Hills, had earlier donated his own collection to the society (see number 83 above).

### 91. "A Bow, from the Northwest Coast . . . Curious Pipes from different parts of the World"

*Donor:* "Rev. Dr. John Eliot."
*Provenance:* MS "Cabinet Log Book, 1791–1952" (p. 15), and *Proceedings of the Massachusetts Historical Society,* 26 January 1802.
*Current Status:* See the list of unattributed bows and arrows in number 81 above.

### 92. "A valuable Collection of Curiosities from the N.W. Coast"

*Donor:* "Mr. E. Dorr, Jr."
*Provenance:* MS "Cabinet Log Book, 1791–1952" (p. 15) and *Proceedings of the Massachusetts Historical Society,* 25 January 1803.
*Current Status:* There are no further details of Dorr's collection in the records of the MHS, but there is a list

of artifacts collected in the Sandwich Islands, Friendly Islands, and on the Northwest Coast written in the back of his journal of the brig *Hope* during a voyage of 1790–1792; and this is almost certainly the collection in question.[40] Dorr's list includes:

A. *"7 Nootka paddles":* Dorr must have been the collector of some of the paddles credited to "Thomas" Hills (see Stephen Hills, number 83 above) and/or 67-10-10/335, an unattributed paddle.

B. *"2 Bows with Arrows":* Some of the unattributed bows and arrows described above in number 81 are probably part of Dorr's donation.

C. *"2 Small Canoes":* One of these is probably 67-10-10/278, a "Model of a canoe in wood, North west Coast," which is unattributed.

D. *"3 Hats":* Three of the four extra hats attributed to James Magee and described above in number 82 are probably actually part of this collection.

E. *"1 Bark Cutsarck":* Like other pieces of cedar-bark clothing, this did not survive to be transferred to the PMH.

F. *"2 F[ishing?] Pole":* Unknown.

G. *"4 Whale & 1 Sea Otter Gigs":* These are unknown, unless one of them is the "spear with float of bladder" that entered the collection as 67-10-10/354 and remains unattributed. (See also Magee's "Lances and Buoys" above in number 82.)

H. *"10 Fish hooks":* See the description of fishhooks in the Magee collection, above in number 82.

I. *"2 Bone Clubs":* As noted above, two Nootkan whalebone clubs described as weapons "for killing deer" and a model of the same are in the PMH catalogue ledger, erroneously credited as gifts of Captain James Magee. At least one of these clubs must have been collected by Samuel Hills, the other club and the model are probably part of this collection made by

Ebenezer Dorr. The two clubs bear the numbers 67-10-10/255 and 256, the "model of a club like 256" is 67-10-10/259.

*Notes:* Ebenezer Dorr was second mate on the Boston brig *Hope* on a Northwest Coast voyage of 1790–1792 and later commanded the Boston ship *Otter* to the Northwest Coast, 1795–1797. His family was extensively involved in the maritime fur trade, and he had ample opportunities for collecting ethnological souvenirs. The list that he compiled of his collection in the back of his *Hope* journal is the only document of its kind located in an American source.

*The following artifacts are acknowledged as transfers from the MHS in the PMH accession list but appear nowhere in the records of the former institution:*

### 93. "Wooden knife sheathes, N.W. Coast"

*Donor:* None given.
*Provenance:* PMH list of artifacts transferred from the MHS.
*Current Status:* 67-10-10/378-81 (a total of 6 knife sheathes).
*Notes:* While the record does not associate any of these sheathes with any particular donor, Bill Holm speculates in *Soft Gold* that at least one of them might have been collected by James Magee or

John Boit.[41] In the latter case, it would be one of the undifferentiated "weapons" donated to the MHS in 1798 and described above in number 86.

### 94. "Gambling Sticks, North west Coast"

*Donor:* None given.
*Provenance:* PMH list of artifacts transferred from the MHS.
*Current Status:* 67-10-10/430.

# Dartmouth College Museum
# 1772

The Dartmouth College Museum was founded in 1772, one of only three museums founded on the North American continent during the colonial period. (Benjamin Franklin's American Philosophical Society in Philadelphia preceded it by two years, and the museum of the Library Society of Charleston, South Carolina, was founded in January 1773.) Though it is the oldest museum in America still maintained by the same organization and under the same name, most of the early collections have not survived—the unfortunate victims of institutional politics, changing philosophies, moves from one location to another, and student shenanigans over many decades. (At one point in 1811, students fired a cannon at the museum, destroying much of the building and its contents.)

There was a catalogue list of the collection made in 1810, the manuscript original of which was transcribed in 1920 and has since disappeared. The typescript transcription includes a number of early Northwest Coast Indian pieces, all of them apparently donated in the eighteenth century when the maritime fur trade was thriving. Although a 1958 history of the museum describes a surviving "group of Northwest-coast Indian fish hooks" from the early period, none of the artifacts listed here can be identified in the Dartmouth College Museum today.[42] A small assemblage of artifacts from the Northwest Coast was given to the Deerfield Academy Museum around 1797 by Elijah Williams, and some of those are consistent with the Dartmouth catalogue (see page 104).

# OBJECT LIST

## 95. "224. A Horn Comb, from Nootka Sound; by A. Holden"

*Donor:* A later manuscript notation identifies the donor as "Capt. Asa Holden."

*Provenance:* 1920 typescript transcription of 1810 Dartmouth College Museum catalogue.

*Current Status:* Unknown.

*Notes:* A Northwest Coast Indian comb was transferred from Dartmouth to the Deerfield Academy Museum, and this or the next item may be the one, but no further information is available and the object does not survive. See number 111 below.

## 96. "225. A Indian Comb from the N. Western Coast"

*Donor:* Unknown.

*Provenance:* 1920 typescript transcription of 1810 Dartmouth College Museum catalogue.

*Current Status:* Unknown.

*Notes:* A Northwest Coast Indian comb was transferred from Dartmouth to the Deerfield Academy Museum, and this or the previous item may be the one, but no further information is available and the object does not survive. See number 111 below.

## 97. "226. A Squaw's fan"

*Donor:* "Capt Kendric [sic]."

*Provenance:* 1920 typescript transcription of 1810 Dartmouth College Museum catalogue.

*Current Status:* Unknown.

*Notes:* This is a very interesting item because John Kendrick did not return from the Pacific Ocean, where he commanded the *Columbia* on the first American expedition around Cape Horn and to the Northwest Coast. He did, however, send a number of Northwest Coast Indian objects back from Canton (see next entry and number 89 in the MHS collection described above). Fans are not generally associated with the Northwest Coast; only one other is mentioned in the early collections and that was given to the Deerfield Museum. Though the Deerfield records indicate that "Mr. John Theyser of Boston" was the donor, it was very probably this same piece, which unfortunately does not survive. See number 121 below.

## 98. "229. Indian Bow and Quiver of arrows"

*Donor:* "Lem. Hedge."

*Provenance:* 1920 typescript transcription of 1810 Dartmouth College Museum catalogue.

*Current Status:* Unknown.

*Notes:* The name "Lem. Hedge" here is probably an error in the transcription. Captain Hodges of the Salem vessel *William and Henry* brought Northwest Coast Indian items received from Captain John Kendrick at Canton to the Reverend William Bentley of Salem in March 1790, as Bentley noted in his diary. (See MHS entry number 89.) As other entries here note "Mr. Derby of Salem" as the donor, one might conjecture that some of the material sent back by Kendrick via Hodges came into the hands of John Derby of Salem, who was one of the owners of the *Columbia* and its consort, the *Washington,* and that he subsequently donated them to Dartmouth. "Arrows and spikes" from the Northwest Coast were transferred to the Deerfield Museum, though none survive. See number 110 below.

## 99. "230. The points of 4 Arrows"

*Donor:* Unknown.

*Provenance:* 1920 typescript transcription of 1810 Dartmouth College Museum catalogue.

*Current Status:* Unknown.

*Notes:* Though these are not specifically identified as Northwest Coast, the placement of this entry would indicate that it was part of the collection identified with John Kendrick, Captain Hodges, and John Derby.

## 100. "231. Indian fish Hooks 15 different kinds, with lines"

*Donor:* Unknown.

*Provenance:* 1920 typescript transcription of 1810 Dartmouth College Museum catalogue.

*Current Status:* Unknown.

*Notes:* Though these are not specifically identified as Northwest Coast, the placement of this entry would indicate that it was part of the collection identified with John Kendrick, Captain Hodges, and John Derby. These were probably transferred to Deerfield, where the early catalogue indicates "Fish Hooks and Lines from N. West Coast of America" having been donated from the Dartmouth museum. See number 108 below.

## 101. "232. An Indian's Spear from the N. West Coast"

*Donor:* "Mr. Derby, Salem."

*Provenance:* 1920 typescript transcription of 1810 Dartmouth College Museum catalogue.

*Current Status:* Unknown.

*Notes:* A manuscript notation to the typescript identifies the donor here as Elias Hasket Derby of Salem, from an article published in the *Worcester Spy* on 7 September 1796:

We are happy to inform the publick that Elias Hasket Derby, Esq. of Salem, has lately made a liberal donation to the Museum of the College. Among other valuable and rare curiosities he has presented the zebra, an African animal, a valuable acquisition to the curious in natural history; besides many other rarities from Asia and the Northwest-coast of America. It is a happy circumstance that commerce may become the road to philosophy, as well as to wealth; and that those who are increasing the respectability of this country by enlarging its commercial interest, have inclination and taste to increase the interest of science at home.

At the time this article was written, Elias Hasket Derby was one of the most prominent merchants of the age, and it is possible that his greater fame obscured the fact that at least the Northwest Coast pieces included in this gift were much more likely the gift of his less famous brother. John Derby was one of the owners of the *Columbia* and *Washington,* the vessels that made the first American voyage to the Northwest Coast. John Derby donated Northwest Coast Indian artifacts to the East India Marine Society Museum and, through Joseph Barrell (one of his partners in the venture) to the Massachusetts Historical Society (described above in entry number 89). Derby, like the Reverend William Bentley of Salem, may have received these objects from Kendrick via one of the Salem vessels he encountered in Canton. This spear may have been among the "Arrows and Spikes" donated to the Deerfield Museum.

**102. "233. Indian Sachem's Cap"**
*Donor:* "Capt. Kendric [sic]."
*Provenance:* 1920 typescript transcription of 1810 Dartmouth College Museum catalogue.
*Current Status:* Unknown.
*Notes:* Another artifact from the first American voyage to the Northwest Coast, this cap was probably transferred to the Deerfield Academy collection as "a Hat from the north west coast of America" though it is there identified with Elihu Hoyt (see number 119 below). Unfortunately, the hat does not survive. See previous entries for information on Captain John Kendrick.

**103. "237. A Piece of Cloth from the N. West Coast, made of the Bark of Trees"**
*Donor:* "Mr. Derby."
*Provenance:* 1920 typescript transcription of 1810 Dartmouth College Museum catalogue.
*Current Status:* Unknown.
*Notes:* See number 101 above for information on John or Elias Hasket Derby. This apparent cedar-bark piece and the next three items were almost certainly given to the Deerfield Academy Museum as "Seven samples of Cloth" from the Northwest Coast. None survive today. See number 112 below.

**104. "238. A piece of Ditto"**
*Donor:* Unknown.
*Provenance:* 1920 typescript transcription of 1810 Dartmouth College Museum catalogue.
*Current Status:* Unknown.
*Notes:* See previous entry.

**105. "239. A piece of Ditto"**
*Donor:* Unknown.
*Provenance:* 1920 typescript transcription of 1810 Dartmouth College Museum catalogue
*Current Status:* Unknown.
*Notes:* See number 103.

**106. "240. Ditto"**
*Donor:* "Mr. Derby."
*Provenance:* 1920 typescript transcription of 1810 Dartmouth College Museum catalogue.
*Current Status:* Unknown.
*Notes:* See number 103.

# Deerfield Academy Museum
# 1797

*(Now Memorial Hall Museum*
*of Pocumtuck Valley Memorial Association)*

An educational "cabinet," apparently begun in June 1797, became part of the Deerfield Academy in Deerfield, Massachusetts, when that school opened in 1799, and the collection grew quickly thereafter. Donations were made by a number of persons and institutions, some with connections to the Northwest Coast trade, including the Massachusetts Historical Society. Several of the most significant objects came as a gift through Deerfield native Elijah Williams, who facilitated the transfer from the Dartmouth College Museum of a collection of Northwest Coast Indian artifacts. This important collection originated with Captain John Kendrick when he was in command first of the *Columbia* and later the *Washington* on the first American voyage to the North Pacific.

The Pocumtuck Valley Memorial Association (PVMA) was founded in 1870 to memorialize settlers killed by local Indians in 1704. In 1877 the association acquired the Deerfield Academy Museum along with the building in which it was housed, and in 1880 it was reopened as Memorial Hall.[43] Along with the collection, the PVMA received a manuscript catalogue entitled "An historical Index for the Museum of Deerfield Academy which collection began June 1797." The index was not a chronological list, beginning at that time. Rather, it may have been conceived several years retrospectively when the collection had grown to some size. Consequently, the order in which artifacts appear in the following list cannot be considered a guide to the date of their acquisition, and some of the donor information is worth questioning. Additional cataloguing efforts in 1886, 1908, and 1920, changed the numbers of some objects and obscured the provenance of many. Approximately one hundred of the items listed in the original manuscript catalogue survive at the PVMA, among which are five from the Northwest Coast.

# OBJECT LIST

**107. "52 | Fish hooks made by the natives of the North West Coast of America. Also a Bow & Arrow Made by the Same"**
*Donor:* "Mr. Sam¹ Turall of Boston."
*Provenance:* MS "Historical Index for the Museum of Deerfield Academy."
*Current Status:* Unknown.
*Notes:* Samuel Turell founded a "Cabinet of Natural History" in Boston in 1802, apparently comprised mostly of artifacts borrowed from the Massachusetts Historical Society (of which he was a member). Over the next decade the society tried without success to get Turell to return its property. He was finally ejected as a member, and the objects were never returned. Turell is known to have had in his possession "many Indian Curiosities" from the MHS at around the time this donation was made to Deerfield, and these may be among them. Unfortunately, they have not survived. (See pp. 90–92.)

**108. "68 | Fish Hooks and Lines from N. West Coast of America"**
*Donor:* "Museum of Dart. College by Mr. Elijah Williams, Springfield."
*Provenance:* MS "Historical Index for the Museum of Deerfield Academy."
*Current Status:* Unknown.
*Notes:* Elijah Williams was born in Deerfield in 1745. He received a bachelor's degree from Harvard in 1764 and an honorary master's degree from Dartmouth College in 1773 (one of the first awarded). He practiced law in New Hampshire for a time, but his Tory politics forced his removal to Nova Scotia at the time of the American Revolution. He died in Deerfield on a visit there in 1793. How he became the agent for the transfer of material from the Dartmouth

College Museum to the Deerfield Academy Museum is a mystery, as he does not seem to have served in any official or professional capacity at the former institution. The artifacts included in his gift were collected primarily by Captain John Kendrick on the first American voyage to the Northwest Coast and sent by him via Canton back to Salem. These fishhooks were certainly among the collection described in the Dartmouth catalogue as "Indian fish Hooks 15 different kinds, with lines." See number 100 above.

**109. "69 | Spoon from same place"**
*Donor:* "Museum of Dart. College by Mr. Elijah Williams, Springfield."
*Provenance:* MS "Historical Index for the Museum of Deerfield Academy."
*Current Status:* Probably one of three spoons identified by PVMA location descriptions as MH C-60, MH C-79, or Case C.
*Notes:* No spoon is described in the records of the Dartmouth College Museum, but there are three horn spoons from the Northwest Coast currently in the collection of the PVMA that originated in the Deerfield Academy collection. (See also numbers 114 and 118 below.)

**110. "70 | Arrows and Spikes from same place"**
*Donor:* "Museum of Dart. College by Mr. Elijah Williams, Springfield."
*Provenance:* MS "Historical Index for the Museum of Deerfield Academy."
*Current Status:* Unknown.
*Notes:* These may have included either or both of the "Indian Bow and Quiver of arrows" and "Indian's Spear" described in the Dartmouth College entry above as numbers 98 and 101. None survive.

**111. "71 | Comb from same place"**
*Donor:* "Museum of Dart. College by Mr. Elijah Williams, Springfield."
*Provenance:* MS "Historical Index for the Museum of Deerfield Academy."
*Current Status:* Unknown.
*Notes:* Two mountain-sheep or mountain-goat horn combs were in the collection of the Dartmouth College Museum and are described above as numbers 95 and 96. Neither survive.

**112. "72 | Seven samples of Cloth from same place"**
*Donor:* "Museum of Dart. College by Mr. Elijah Williams, Springfield."
*Provenance:* MS "Historical Index for the Museum of Deerfield Academy."
*Current Status:* Unknown.
*Notes:* These were apparently pieces of woven cedar bark—possibly mats, capes, or portions of same. Among the seven were almost certainly the four described in the Dartmouth College list as a "Piece of Cloth from the N. West Coast, made of the Bark of Trees" and three subsequent entries of "ditto." See the Dartmouth entries above for numbers 103 through 106.

**113. "113 | An Indian Basket from N. West Coast"**
*Donor:* "Mr. James Green, Boston."
*Provenance:* MS "Historical Index for the Museum of Deerfield Academy."
*Current Status:* Possibly identified by PVMA location descriptions as MH C-40 or 42.
*Notes:* There is a small basket in the PVMA collection that was transferred from Deerfield Academy, but whether it is the one described here or number 122 below is not clear. A nineteenth-century label on the object refers to it as a "Grass cup from Alaska." The identity of James Green is unknown, but he

may have been related to Jonathan Green, a missionary who traveled to the Northwest Coast on the Boston ship *Volunteer* in 1829.[44]

### 114. "122 | A Spoon from Nootka Sound"

*Donor:* "Nath[l] Paine Esq[r], Worcester."
*Provenance:* MS "Historical Index for the Museum of Deerfield Academy."
*Current Status:* Probably one of three spoons identified by PVMA location descriptions as MH C-60, MH C-79, or Case C.
*Notes:* There are three horn spoons from the Northwest Coast currently in the collection of the PVMA that originated in the Deerfield Academy collection. (See also numbers 109 above and 118 below.) Nathaniel Paine had strong connections to the two most influential Boston firms managing Northwest voyages. His sister was married to James Perkins who, with his brother Thomas Handasyd Perkins, had a hand in numerous early ventures. His nephew married Ann Cushing Sturgis, thus bringing Paine into the circle of William Sturgis through two different marital connections. At a lecture in 1848 Sturgis exhibited two labrets from the Northwest Coast, which he identified as having been obtained through "the kindness of my friend Mr. Paine, of Worcester."[45] It may be that Sturgis was actually borrowing items that he himself had given to Paine.

### 115. "153 | Indian war club"

*Donor:* "Hon. Thomas Dwight esq. Spring[d]."
*Provenance:* MS "Historical Index for the Museum of Deerfield Academy."
*Current Status:* Identified by PVMA location description as MH C-7.

*Notes:* Though this entry appears to be crossed out in the index, this very fine Nootkan whalebone club survives in the collection of the PVMA. The strike out may have occurred during one of the subsequent cataloguing efforts when the club was renumbered as 168. Thomas Dwight was a Harvard graduate who practiced law in Springfield before serving in the Massachusetts and later the U.S. legislatures. He was said to be a man whose "ample means enabled him to gratify his desires,"[46] including, presumably, the collecting of artifacts like this one from a Boston mariner.

### 116. "185 | An instrument made up by some tribes, in the North West coast of America, to form a 2[d] mouth—the under lip is opened parallel with the mouth and this instrument placed in it."

*Donor:* "Mr. Newel."
*Provenance:* MS "Historical Index for the Museum of Deerfield Academy."
*Current Status:* Unknown.
*Notes:* The labret described here can no longer be located. The procedure by which labrets were first introduced into the lower lip was much misunderstood by sailors in the late eighteenth and early nineteenth centuries, and consequently by the people back in New England for whom the sailors were the primary cultural informants. William Sturgis, who had actually attended a potlatch where an adolescent girl first had her lip pierced, was one of the few to describe it accurately. See the quotation from his 1848 lecture on page 9 and Malloy, ed., *"Most Remarkable Enterprise,"* 35.

### 117. "214 | A Robe from Nootka Sound"

*Donor:* Unknown.
*Provenance:* MS "Historical Index for the Museum of Deerfield Academy."
*Current Status:* Unknown.
*Notes:* This may possibly refer to one of the cedar-bark pieces received from the Dartmouth College Museum. See numbers 103 to 106 (Dartmouth) and 112 (Deerfield) above.

### 118. "215 | Spoon from D°—" ["Ditto" meaning Nootka Sound]

*Donor:* Unknown.
*Provenance:* MS "Historical Index for the Museum of Deerfield Academy."
*Current Status:* Probably one of three spoons identified by PVMA location descriptions as MH C-60, MH C-79, or Case C.
*Notes:* There are three horn spoons from the Northwest Coast currently in the collection of the PVMA that originated in the Deerfield Academy collection. (See also numbers 109 and 114 above.)

### 119. "227 | A Hat from the north west coast of America"

*Donor:* "Capt. Elihu Hoyt."
*Provenance:* MS "Historical Index for the Museum of Deerfield Academy."
*Current Status:* Unknown.
*Notes:* Elihu Hoyt represented Deerfield in the Massachusetts Legislature in Boston and consequently had access to "Boston men" returning from the Northwest Coast in the late eighteenth century. (He was not a mariner, the designation "captain" referring in his case to military rank rather than command of a ship.) This hat may, however, be the "Indian Sachem's Cap" collected by John Kendrick and

donated originally to the Dartmouth College Museum (see number 102 above). The "Historical Index" of the Deerfield Academy Museum may have misidentified some of the early donors. Regardless of whether the hat was collected by Hoyt or Kendrick, it unfortunately does not survive.

**120. "249 | Three Darts from the north west Coast"**
*Donor:* "Mr. John Theyser of Boston."
*Provenance:* MS "Historical Index for the Muscum of Deerfield Academy."
*Current Status:* Unknown.
*Notes:* For the same reasons given in the next entry, these "darts" may actually have been part of the collection transferred from Dartmouth; perhaps they are the "points of 4 Arrows" described above as number 99.

**121. "250 | A Fan, from Dᵒ"** ["Ditto" meaning "north west Coast"]
*Donor:* "Mr. John Theyser of Boston."
*Provenance:* MS "Historical Index for the Museum of Deerfield Academy."
*Current Status:* Unknown.
*Notes:* Only one other "fan" is mentioned in early New England collections as having originated on the Northwest Coast, and that is the Kendrick gift to the Dartmouth College Museum described above in number 97 as "A Squaw's fan." Even if that attribution is in error and the fan originated in Polynesia, the possibility that the fan described in the Deerfield collection is the same one, acquired from the Dartmouth Museum and then the donor later misidentified in the index, must be considered. John Theyser is not known to have been associated with the Northwest Coast trade.

**122. "315 | A basket from N.W. coast"**
*Donor:* "Adam Williams."
*Provenance:* MS "Historical Index for the Museum of Deerfield Academy."
*Current Status:* Possibly identified by PVMA location descriptions as MH C-40 or 42.
*Notes:* There is a small basket in the PVMA collection that was transferred from Deerfield Academy, but whether it is the one described here or number 113 above is not clear. A nineteenth-century label on the object refers to it as a "Grass cup from Alaska." Adam Williams may have been related to Elijah Williams (see the description of his donation in numbers 108–112 above), or he may have been associated with the Salem seafaring family of that name. Both Captain Israel Porter Williams and his son, A. W. Williams (who died at sea at age 19 in 1831), donated Northwest Coast materials to the museum of the East India Marine Society in Salem, though neither can be identified as ever having made a Northwest voyage. See, for instance, number 21 above.

# Boston Athenaeum
## 1807

The Boston Athenaeum, a private library founded in 1807, was first conceived by the Anthology Society, a group of well-educated and socially prominent young Bostonians who produced a magazine called the *Monthly Anthology and Boston Review* and a pamphlet entitled "On Manners and Literature, on the Improvement of Taste, and the Encouragement of Genius."[47] In 1805, the members created a library for their own use, and this was incorporated two years later as the Boston Athenaeum.[48] From its inception, the Athenaeum sold a limited number of membership shares to provide the funds needed for its operation.

When they opened on Tremont Street in Boston the founders declared their intentions to operate "a Reading-Room, a Library, a Museum, and a Laboratory":[49]

> The Reading-room and Library being considered the lead objects and chief departments of the Athenaeum, it is proposed, as far as can be done without detriment to them, to join to the foundation a MUSEUM or CABINET, which shall contain specimens from the three kingdoms of nature, scientifically arranged; natural and artificial curiosities, antiques, coins, medals, vases, gems and intaglios . . .[50]

> The *Museum,* by its collection of natural objects scientifically arranged, will both excite and gratify that disposition to study nature, which is always safe and sometimes profitable and important, by means of the discoveries and improvements to which it leads. This department of the institution will preserve, for constant inspection, a multitude of productions, natural and artificial, either curious or useful, brought from

different countries, which are not now obtained; or, being obtained, are lost through want of a proper receptacle, in which they may be placed."[51]

In 1822 the organization moved into a mansion donated by James Perkins, Esq. Four years later it received $16,000 from James and Thomas Handasyd Perkins, the son and brother of James Perkins, Esq., and the greatest benefactors of the Athenaeum in its founding decades. In the 30 years between 1791 and 1821, as partners in the firm of J. and T. H. Perkins, these men owned or managed some fourteen vessels involved in at least twenty-four voyages to the Northwest Coast.[52] It is highly likely that they influenced the men who worked for them to collect artifacts for the Athenaeum collection.

In 1849 the Athenaeum moved into a new building on Beacon Street, which had been designed for them by architect Edward C. Cabot and which still houses the library today. To cover the costs of the new building, new shares were offered between 1854 and 1858. William Sturgis purchased a share at that time and became a vigorous supporter and benefactor of the institution.

In 1867 the Athenaeum transferred its museum collection of 130 specimens to the Peabody Museum at Harvard (PMH). There, along with the collections of the Massachusetts Historical Society, the Athenaeum gift was acknowledged as having been among the first donations to the new museum:

> The next important additions to our collections were made by the Trustees of the Boston Athenaeum and by the Trustees of the Massachusetts Historical Society,—both of these bodies having formally voted to place on deposit with us the ethnological specimens belonging to them, such objects no longer coming within the scope and design of these institutions. The collections . . . both contain valuable objects from various parts of the world, especially from the North-west Coast of America, where they were mostly obtained during the latter part of the last and the beginning of the present century, and from the islands of the Pacific Ocean.[53]

No original accession records or catalogues of the museum remain in the collection of the Boston Athenaeum, but artifacts that were transferred to the PMH in 1867 can be identified through the accession lists at the latter institution, where the entire group was retrospectively given the number "67-9," identifying it as the ninth accession acquired in 1867, along with the suffix "10" indicating North American origin.

The following list is taken directly from the manuscript catalogue ledger at the PMH; I have enclosed all of the original entries in quotation marks. In subsequent years a number of additions and emendations were made to the ledger, including several that strike out the "Northwest Coast" attribution. All those changes are represented here, with subsequent notations included in brackets.

# OBJECT LIST

**123. 67-9-10/77: "Stone Pipe with two bowls, North west Coast"** [A later note reads "Possibly Haida or Tlingit RBD 2/12/34 J.R."]

**124. 67-9-10/84: "Model of a canoe, North west Coast"** [A later note reads "Aleutian Islands."]

**125. 67-9-10/85: "Model of a canoe, North west Coast, Josiah Sturgis, 1819"** [A later note reads "Kadiak Island," and still another reads "Alaska Nigluk Eskimos Inland fr. Point Barrow, presented to B.A. by {Josiah Sturgis}."]
*Notes:* This charming kayak model has three figures in it all wearing gut kamleikas and wooden hats, the middle one a top hat. The original label is still attached to the model and reads: "Presented to the Boston Athenaeum By Josiah Sturgis April 1819." Josiah Sturgis was the brother of Russell Sturgis and the uncle of William Sturgis, two of the most prominent merchants in the Northwest Coast trade. In addition, Josiah and Russell Sturgis each married a sister of James and Thomas Handasyd Perkins, imparting to the family circle around Josiah Sturgis a dynastic power in the trade. Sturgis served for over a decade on the *Levant,* a ship belonging to his in-laws, eventually becoming captain of the vessel at Canton and commanding a voyage to the Columbia River in 1818, when the Perkins Company contracted with the North West Company to carry furs to Canton. Josiah Sturgis

later worked extensively in the local waters around Boston as an agent for the U.S. Revenue Service and as a lightship captain.[54] He was a popular enough old sailor that a poem about him was published in the mariners' newspaper, the *Sheet Anchor* in 1845:

ACROSTIC

Josiah Sturgis, ever kind
and true,
On terra firma or the ocean
blue,
Sought fame and fortune
on the changing sea
In early life, and passed
through each degree;
Ascending surely, with a
steady hand,
He soon obtained distinc-
tion and command.
Sure, fortune rarely smiled
on one more kind,
Truer of heart, or of a
gentler mind.
Unfold to him a case of
want or woe,
Relief and soothing tries to
heal the blow.
Good as he is— "beloved
both far and near,"
Such now we wish him,
and "a good new year."
OLD SALT[55]

**126. 67-9-10/86: "Model of a canoe, North west Coast"**
*Notes:* This kayak model is by the same hand as the one donated by Josiah Sturgis and described above as number 125. Like the previous entry, it is an Aleut kayak model with three figures, the middle one wearing a top hat.

**127. 67-9-10/130: "Bracelet made of horn, Southern Vancouver or lower Fraser (Salish)"**
*Notes:* This mountain-goat horn bracelet is described and illustrated as number 130 on page 156 in *Soft Gold.*[56] (See the illustration on next page.)

**128. 67-9-10/138: "Pipe made of Walrus tusk, ~~North-west Coast~~"** [The original cultural attribution to "North-west Coast" was overwritten with "Alaska, Western Eskimo" in a note dated 2/12/34, and signed "JR" for Jean Read.]

**129. 67-9-10/139: "Ornament of bone work"** [A later annotation reads: "Emmons thinks this is an adze handle;" another identifies it as "Chinook," and notes that one could "see two views of similar carving in E. S. Curtis's work, Vol. VIII, oppo. page 104." Peter Corey, who examined the piece in 1975, identified it as an adze of Wasco origin.]

**130. 67-9-10/140: "Implement made of walrus tusk"** ["Northwest America" was added later over a now-obscured original cultural attribution, and the piece was further identified as a "drill-bow" in a note signed "CCW/MC 10/14/33."]

**131. 67-9-10/141: "~~Fork, North west Coast~~"** [Replaced by: "Comb for shredding sinew in cord making." Another notation in a different hand added "or for combing hair on skin garments, Alaska, western Eskimo 2/12/34 JR." The later note also identifies the piece as "Walrus tusk."]

**132. 67-9-10/142: "Wooden Spoon, North-west Coast"** [A later note reads "Haida, SFG/JR/2/12/34."]

**133. 67-9-10/143: "Fish hook, Pugets Sound"**
*Notes:* This piece was exchanged with the National Museum, Mexico City, in June 1964.

**134. 67-9-10/144: "Drill bow, ~~North-west Coast~~"** [The original cultural attribution to "North-west Coast" was overwritten with "Alaska, Western Eskimo 2/12/34 JR."]

**135. 67-9-10/145: "Implement of walrus tusk, ~~North-west Coast~~"** [A later note reads "Seam creaser, Alaska, Western Eskimo 2/12/34 JR."]

**136. 67-9-10/146: "Ornament of ~~bone~~ North-west Coast"** [Additional notations identify it as a "Needle case," "Walrus Ivory," and "Eskimo of Alaska." A later insertion further identified the Alaska Eskimos as "Western."]

**137. 67-9-10/147: "Knife made of bone, ~~North-west Coast~~"** [A later note reads "Dagger with bone blade, Alaska, Western Eskimo 2/12/34 JR."]

**138. 67-9-10/148: "Ornament of bone, North-west Coast"**
*Notes:* This object was stolen in 1974.

**139. 67-9-10/149: "Ornament representing a bear, ~~North-west Coast~~"** [Two later handwritteen notes identify this as "Eskimo" and "Alaska."]

**140. 67-9-10/150: "Ornaments, ~~North-west Coast~~"** [Two later hand-written notes identify these as "Eskimo" and "Alaska."]
*Notes:* There are fifteen specimens identified with this number.

**141. 67-9-10/151: "Box & chain for trinkets, North west Coast"** [A later note reads "Alaska, Western Eskimo, 2/12/34 JR."]

**142. 67-9-10/152: "Lip ornament, North west Coast"**

**143. 67-9-10/153: "Human figure carved in bone, North west Coast"** [Two later handwritten notes identify this as "Eskimo" and depicting a woman.]

**144. 67-9-10/154: "Human figure carved in bone, North west Coast"** [A later note reads "Eskimo."]

**145. 67-9-10/155: "Fish carved in bone, North west Coast"** [A later note reads "Eskimo."]

**146. 67-9-10/158: "Implement of bone, North west Coast"** [A later note reads "Belt hook for needle case, Alaska, Eskimo, 2/12/34 JR."]

**147. 67-9-10/159: "Reel for making nets, Northwest Coast"** [A later note reads "Large wooden netting needle."]

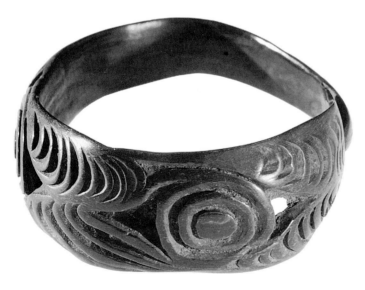

Object 127
Bracelet made of mountain-goat horn. PMH 67-9-10/130. 7.62 cm x 5.02 cm.

**148. 67-9-10/163: "Jointed image of wood"** [The original cultural attribution was overwritten with "Northwest Coast" by Jean Read on 2/13/34, and a note was added two days later identifying it as "Haida, but strongly influenced by scrimshaw," signed by "SJG."]
*Notes:* This interesting and perhaps unique artifact is very poorly described in the PMH catalogue ledger. Carved from a single piece of wood, it consists of two interlocking links. (See the illustration on this page.) The top link is in the form of two arms coming up to clasp a face; the bottom has the representation of two legs, with a disk separating the feet. Between them, and attached to the top link, is a thick ring of wood, which resembles the iron ring that forms a part of a ship's block. This may be what led "SJG" to make the reference to scrimshaw, though the lack of marine mammal products or any etched surface design makes the comparison inappropriate.[57] This item may, in fact, have been made to suspend or lift heavy items, in imitation of shipboard use, as a line could be rigged through each of the links.

**149. 67-9-10/164: "Carved wood with rings"** [Later notes read "Northwest Coast—2/13/34 JR" and "Bag-handle, SJG/JR/2/15/34."]

**150. 67-9-10/172: "Bow"** [The original cultural attribution is overwritten with "Probably Point Barrow," and the bow is further identified as "sinew-corded." Jean Read also added "Alaska, Western Eskimo, 2/12/34."]

**151. 67-9-10/174: "Arrow points of bone, North-west Coast"**
*Notes:* There are six specimens identified with this number.

**152. 67-9-10/175: "Spear point of bone, ~~North-west Coast~~"** [A later note reads "Alaska, Western Eskimo 2/12/34 JR."]

**153. 67-9-10/176: "Spear point of bone, North-west Coast"** [A later note reads "Alaska, Western Eskimo, 2/13/34 JR."]

**154. 67-9-10/178: "Implement of bone, North-west Coast"** [Later additions read "Hair pin? (long bone point)," "Eskimo," and "about 13 in. long."]

**155. 67-9-10/188: "Spear point of bone, North-west Coast"** [A later note reads "Alaska Western Eskimo 2/12/34/JR."]

**156. 67-9-10/203: "Cylindrical basket"** [The original cultural attribution is overwritten with "Northwest Coast Indians." Additional notations note that there were once "Parts of 4 sets gambling sticks, a, b, c, d" and later that "The record of these sticks is lost. They may or may not belong with this basket."]

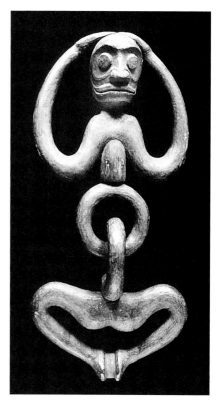

**Object 148**
Jointed image of wood. PMH 67-9-10/163. 27.31 cm x 12.7 cm.

# American Antiquarian Society
# 1812

The American Antiquarian Society (AAS), a private library and cabinet, was organized by Isaiah Thomas in Worcester, Massachusetts, in November 1812 with a membership drawn from across the United States, Canada, and abroad. The mission was clearly stated in the society's first publication, which set the organization in the context of European scientific societies going all the way back to Charlemagne:

> The utility of Publick Institutions, formed for the express purpose of preserving valuable remains of ancient time, and of affording a safe repository for the discoveries which have resulted from the researches of scientifick and inquisitive men, has been fully tested by the experience of the old world.
>
> That persuasion that a National Institution of a similar nature would be promotive of the interests of science, literature, and the arts, in the United Sates, gave rise to the AMERICAN ANTIQUARIAN SOCIETY.[58]

While the other major New England institutions had been founded in the seaports, with easy access to returning ships and the treasures they carried, the AAS specifically removed itself from both the large cities and the waterfront:

> For the better preservation from the destruction so often experienced in large towns and cities by fire, as well as from the ravages of an enemy, to which seaports in particular are so much exposed in times of war, it is universally agreed, that for a place of deposit for articles intended to be preserved for ages, and of which many, if destroyed, or carried away, could never be replaced by others of the like kind, an inland situation is

to be preserved; this consideration alone was judged sufficient for plac-
ing the Library and Museum of this Society forty miles distant from the
nearest branch of the sea, in the town of Worcester, Massachusetts.[59]

The society received a collection of forty "Articles from the North
West, Pacific Ocean & c." from Roderic McKenzie of the North West
Company in February 1818. As a chief trader for the North West Company,
McKenzie had connections to fur traders and trading posts throughout the
west, including Fort George at the mouth of the Columbia River, which
had been founded as Astoria by the American Pacific Fur Company in
1811. The North West Company also had a direct link to the Boston firm
of James and Thomas Handasyd Perkins, who from 1817 to 1821 shipped
their furs from the Columbia River to Canton, thereby allowing the North
West Company to bypass the monopolies of the British East India and
South Seas Companies.

A letter from McKenzie, written at company headquarters in
Terrebonne, Quebec, accompanied the gift and inventoried the contents,
though unfortunately not in sufficient detail to be able to confidently iden-
tify the origin of all of the objects. While several are actually described as
being from the "North west," "Western Coast," "New Caledonia," or "New
California," others are less specific (i.e., "from beyond the Rocky
Mountains"). A pair of whalebone combs from the Northwest Coast, now
in the collection of the Peabody Museum at Harvard (PMH), are
described as "Two Indian Combs from Rocky Mountains." The objects on
McKenzie's list were numbered from 1 through 40; the gift was acknowl-
edged the following year in an *Address to the Members of the American
Antiquarian Society*,[60] where the list was reproduced without the numbers.

In 1890 and 1895 the ethnological collections of the AAS, including
some sixty Northwest Coast Indian items, were transferred to the Peabody
Museum of American Archaeology and Ethnology at Harvard, with a
notation that "Most of these objects from the Northwest Coast were
obtained by the AAS from Roderic McKenzie, Esq., Terrebonne, Lower
Canada, and acknowledged in the AAS Report for 1819." Though the
total Northwest Coast collection was half again the size of the McKenzie
gift, the objects within the entire group have at different times been asso-
ciated with McKenzie. Each individual object was assigned a five-digit cat-
alogue number; many decades later a group accession number was also
added to more completely identify each object—either "90-17" or "95-20,"
depending upon the year of transfer. As with all North American collec-
tions, the suffix "10" was added to the accession number; consequently each

of the early AAS artifacts from the Northwest Coast is identified by the prefix "90-17-10" or "95-20-10," followed by the individual catalogue number. In 1910, another collection of artifacts was received at the PMH in an exchange with the American Antiquarian Society; this group retrospectively received the number "10-47-10."

The society has a manuscript account book of "Donors and Donations to the American Antiquarian Society," which was begun in May 1813 and which includes both books and artifacts. A typed transcription, listing just the artifacts, was made by Katherine Reid in 1948. Additional references to artifacts in the collection appear in the AAS correspondence file, where undated descriptions can be found written on the backs of small pieces of society stationery. In the AAS object list below, the first group is presented in the numerical order adopted by McKenzie in his 1818 letter to the society, and I have attempted to match these descriptions to the corresponding objects in the PMH accession list. The next group consists of those Northwest Coast Indian objects that were definitely *not* part of McKenzie's gift, but which appear in the manuscript accounts of the collections of the AAS. The third group consists of the objects not documented in AAS records; they are described as they appear in the catalogue ledger of the PMH.

# OBJECT LIST

**157. "1. Wood to make fire by friction"**
*Donor:* Roderic McKenzie.
*Provenance:* MS letter from McKenzie to American Antiquarian Society, 1818.
*Current Status:* One of the items received from the AAS is described in the PMH catalogue as a "Fire stick and hearth, North West Coast" (95-20-10/48398), which must certainly be a part of McKenzie's donation. There are also four Tlingit "throwing sticks" with no other identification that are also part of the AAS gift. These "elaborately carved" sticks could easily have been misinterpreted by McKenzie when they arrived in Montreal from Alaska, and it seems possible that they might also be part of the "wood" described above. They are described in the PMH catalogue as:
 A. 95-20-10/48389: "Throwing stick, Probably Southern Alaska." [A later notation adds "Kadiak I. See Lisiansky Plate III, probably Tlingit."]
 B. 95-20-10/48390: "Throwing stick, elaborately carved, Southern Alaska, Tlingit Indians."
 C. 95-20-10/48391: "Throwing stick, elaborately carved, Southern Alaska, Tlingit Indians."

 D. 95-20-10/48392: "Throwing stick, elaborately carved, Southern Alaska, Tlingit Indians."
*Notes:* These are illustrated as "Tlingit throwing sticks" in *Soft Gold*, numbers 40–42 (pp. 76–79).

**158. "4. Two Indian Combs from Rocky Mountains"**
*Donor:* Roderic McKenzie.
*Provenance:* MS letter from McKenzie to American Antiquarian Society, 1818.
*Current Status:* Two combs were transferred from the AAS:
 A. 95-20-10/48393: "Wooden comb, North West Coast." [Later notations add: "Southern Vancouver or Lower Frazer," "(Roderick McKenzie)," and "Probably ~~Tlingit~~."]
*Notes:* This comb is described and illustrated in *Soft Gold*, number 131 (p. 157). See the illustration on this page.
 B. 95-20-10/48394: "Wooden comb, North West Coast." [Later notations add: "Southern Vancouver or Lower Frazer," "(Roderick McKenzie)," "Representing Mythical being: Xoaexoe," and "Probably ~~Tlingit~~."]
*Notes:* This object was lost by a borrowing institution in 1972.

**159. "5. A Dish made of Watap"**
*Donor:* Roderic McKenzie.
*Provenance:* MS letter from McKenzie to American Antiquarian Society, 1818.
*Current Status:* Watap, a root material used in subarctic basketry, is not generally associated with the Northwest Coast proper. McKenzie, who was probably familiar with the term from his experience at Fort Chippewayan on Lake Athabasca in 1789, seems to have confused cedar bark or some other Northwest Coast product for watap. Though the "dish" description is somewhat puzzling, there seem to be two likely candidates in the PMH record:
 A. 95-20-10/48408: "A bag of net work-twined weaving, Probably Fraser region ('New Caledonia')." [The original cultural attribution has been overwritten here and a later note adds: "Sagebrush? bark bag."]
 B. 90-17-10/48427: "Pouch of woven grass, Probably Aleut—Alaska." [A note adds that this is "An excellent example of the ancient twined weaving."]

**160. "6. A Miguow or Spoon from Rocky Mountains"**
*Donor:* Roderic McKenzie.
*Provenance:* MS letter from McKenzie to American Antiquarian Society, 1818.
*Current Status:* 95-20-10/48400: "Horn Spoon, North West Coast." [A later handwritten note says "Not Tlingit."]

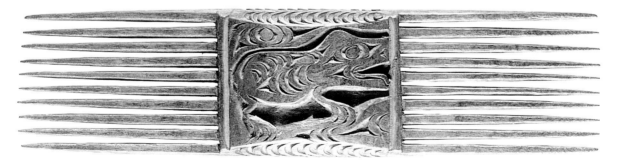

**Object 158a**
Wooden comb. PMH 95-20-10/48393. 21.59 cm x 5.08 cm.

**161. "8. Wristband from the Western Coast"**

*Donor:* Roderic McKenzie.

*Provenance:* MS letter from McKenzie to American Antiquarian Society, 1818.

*Current Status:* This is probably 95-20-10/48405: "Carved bracelet of horn, North West Coast." [The original cultural attribution has been overwritten here, and a later note adds: "Southern Vancouver or lower Fraser Coast Salish."]

*Notes:* Number 95-20-10/48405, a mountain-goat horn bracelet that was acquired from the AAS is described and illustrated as number 129 in *Soft Gold* (p. 156). See the illustration on this page and number 173 below.

**162. "10. A Bracelet of Shells from Fraser's River"**

*Donor:* Roderic McKenzie.

*Provenance:* MS letter from McKenzie to American Antiquarian Society, 1818.

*Current Status:* There is no "bracelet" that can be said to fit this description, but there are two hoop rattles that might have been mistaken for bracelets by McKenzie, especially with the cross-piece handle missing. They are described in the PMH catalogue ledger as:

A. 95-20-10/48399: "Ancient form of rattle, North West Coast, With Crested Puffin beak pendents." [A later note adds "Old & Rare."]

B. 95-20-10/48401: "Rattle, Handle missing, North West Coast." [Added later: "Dr. Boas has seen these used at delta of the Fraser River. Probably made in the interior."]

**163. "11. An Indian Cap from Columbia beyond Rocky Mountains"**

*Donor:* Roderic McKenzie.

*Provenance:* MS letter from McKenzie to American Antiquarian Society, 1818.

*Current Status:* There are two possible matches for this entry in the PMH accession book:

A. 90-17-10/48415: "Hat of seal intestines, Eskimo—Probably Alaska."

B. 90-17-10/48428 "Wooden hat, Probably Aleut—Alaska."

**164. "12. A Bag of Rushes to Carry water from beyond Rocky Mountains"**

*Donor:* Roderic McKenzie.

*Provenance:* MS letter from McKenzie to American Antiquarian Society, 1818.

*Current Status:* 95-20-10/48407: "Bag for 'carrying water,' Probably Shahaptian," and "From the Columbia R." [The original cultural attribution has been overwritten.]

**165. "14. A Striped Blanket of Dog Hair from the Western Coast"**

*Donor:* Roderic McKenzie.

*Provenance:* MS letter from McKenzie to American Antiquarian Society, 1818.

*Current Status:* 90-17-10/48410: "'Blanket of dog's hair,' Salishan." [A later note adds: "(Puget Sound Region Probably)," "Roderick McKenzie," and "Obtained previous to 1810. See Proceedings Am. Ant. Soc. for 1819— p. 32." Previous notes or cultural attribution were overwritten or erased.] See the illustration on next page.

**166. "15. A Mat of rushes from the western Coast"**

*Donor:* Roderic McKenzie.

*Provenance:* MS letter from McKenzie to American Antiquarian Society, 1818.

*Current Status:* Unknown.

**Object 161**
Bracelet made of mountain-goat horn. PMH 95-20-10/48405. 7.9 cm x 5 cm.

**167. "16. A Bag of Net Work (bark)"**
*Donor:* Roderic McKenzie.
*Provenance:* MS letter from McKenzie to American Antiquarian Society, 1818.
*Current Status:* This is probably 95-20-10/48409: "Purse of cedar bark." ["N.W.C." was added later.]
*Notes:* See also the artifacts described under number 159 above.

**168. "17. An Indian Shield from New Caledonia"**
*Donor:* Roderic McKenzie.
*Provenance:* MS letter from McKenzie to American Antiquarian Society, 1818.
*Current Status:* Unknown.

**169. "18. A Quiver of Bow and Arrows from New Caledonia"**
*Donor:* Roderic McKenzie.
*Provenance:* MS letter from McKenzie to American Antiquarian Society, 1818.
*Current Status:* While there is no "quiver" in the PMH list (unless it is one of the various "bags" described elsewhere), there is one bow, one "sea otter arrow," and several "portions of harpoon heads," some or all of which may have made up this entry in McKenzie's letter. While all of the arrow and harpoon heads are evidently Alaskan Eskimo, the bow has been re-attributed in a later handwritten note to California. The relevant objects are:
A. 95-20-10/48412: "Sinew-backed bow, ~~Northwest Coast~~." [A later attribution says "California."]
B. 90-17-10/48421: "Portions of harpoon heads, Eskimo—Probably Alaska (4 specimens)."
C. 90-17-10/48422: "Portions of harpoon heads, Eskimo—Probably Alaska (2 specimens)."
D. 90-17-10/48425: "Sea otter arrow (point missing), Cook's Inlet Type."

**170. "19. A Net of bark or nettles from MKenzies River"**
*Donor:* Roderic McKenzie.
*Provenance:* MS letter from McKenzie to American Antiquarian Society, 1818.
*Current Status:* Unknown.

**171. "20. A Net of Whalebone from MKenzies River"**
*Donor:* Roderic McKenzie.
*Provenance:* MS letter from McKenzie to American Antiquarian Society, 1818.
*Current Status:* Nothing made of baleen survived to be transferred to the PMH.

**172. "24. An Indian Shot Bag"**
*Donor:* Roderic McKenzie.
*Provenance:* MS letter from McKenzie to American Antiquarian Society, 1818.

*Current Status:* This would seem to be 90-17-10/48418, "Leather pouch, Eskimo—Probably Alaska"; however, there are four other possibilities listed under two numbers in the PMH catalogue ledger:
A. 90-17-10/48419: "Bag, Eskimo—Probably Alaska."
B. 90-17-10/48414: "Bags of seal intestines, Eskimo—Probably Alaska (3 specimens)."

**173. "25. A pair of Indian Bracelets"**
*Donor:* Roderic McKenzie.
*Provenance:* MS letter from McKenzie to American Antiquarian Society, 1818.
*Current Status:* See numbers 161 and 162 above.

**Object 165**
Blanket of dog's hair. PMH 90-17-10/48410. 109.22 cm x 93.98 cm.

**174. "26. An Indian War dress ornamented with Human Hair from the North west"**
*Donor:* Roderic McKenzie.
*Provenance:* MS letter from McKenzie to American Antiquarian Society, 1818.
*Current Status:* This must be one of three kamleikas entered into the PMH catalogue ledger as number 90-17-10/48416, "Coat of seal intestines, Eskimo—Probably Alaska, 3 specimens."

**175. "30. A Pair of North West Indian Shoes ornamented"**
*Donor:* Roderic McKenzie.
*Provenance:* MS letter from McKenzie to American Antiquarian Society, 1818.
*Current Status:* 90-17-10/48420: "Pair boots, Eskimo—Probably Alaska." [A later note reads "(Aleutian probably)."]

**176. "33. Rocky Mountain Sheep Wool"**
*Donor:* Roderic McKenzie.
*Provenance:* MS letter from McKenzie to American Antiquarian Society, 1818.
*Current Status:* This may be number 90-17-10/48411, described in the PMH record as: "Blanket made of wool of mountain goat," with later notations adding "Twined Weaving" and "Fraser R. (Prob. Thomson Inds)."
*Notes:* There is some confusion between this entry, the only one that specifically mentions mountain-sheep wool (possibly in confusion with "wool of mountain goat"), and two blankets specifically entered into the PMH collection as made of dog hair. See numbers 165 and 179.

**177. "37. Plain Indian Dress from New Caledonia beyond Rocky Mountains"**
*Donor:* Roderic McKenzie.
*Provenance:* MS letter from McKenzie to American Antiquarian Society, 1818.
*Current Status:* Unknown.

**178. "39. An Indian ornamented Garter"**
*Donor:* Roderic McKenzie.
*Provenance:* MS letter from McKenzie to American Antiquarian Society, 1818.
*Current Status:* Unknown.

**179. "40. A Blanket of Dog hair from Fraser's River beyond Rocky Mountains"**
*Donor:* Roderic McKenzie.
*Provenance:* MS letter from McKenzie to American Antiquarian Society, 1818.
*Current Status:* See numbers 165 and 176 above.

*The following objects appeared in the manuscript account of "Donors and Donations to the American Antiquarian Society."*

**180. "Several heads of Indian arrows; Bone and pearl fish hook from North West Coast; Stone axe from the Sandwich Islands"**
*Donor:* Horatio G. Locke, Boston.
*Provenance:* MS list of "Donors and Donations to the American Antiquarian Society," Vol. I, entry for 30 October 1816; typescript list of artifacts in the AAS cabinet, 1948.
*Current Status:* There are a number of objects listed in the PMH catalogue list that may be part of this donation, including:
  A. *Several heads of Indian arrows:*
90-17-10/48421: "Portions of harpoon heads, Eskimo—Probably Alaska (4 specimens)."
90-17-10/48422: "Portions of harpoon heads, Eskimo—Probably Alaska (2 specimens)."
90-17-10/48425: "Sea otter arrow (point missing), Cook's Inlet Type."
  B. *Bone and pearl fishhook from North West Coast:*
95-20-10/48413: "Fish hook (for Cod), Cape Flattery, Washington, Type Makah Indians" ["Wakashan"].
  C. *Stone axe from the Sandwich Islands:*
95-20-10/48397: "War Club or Slave Killer, North West Coast." [Additional notes add "(Athapascan)" and "of antler."]

**181. 90-17-10/48423: The original ledger description for this artifact was left blank, but a notation probably made in the middle of the twentieth century identifies it as a "Small wood fish (lure?)," later further described as "Eskimo—Probably Alaska."**

**182. "A very curious stone pipe highly sculptured, brought from the Northwest Coast. Supposed to be manufactured in the East Indies or China"**
*Donor:* Samuel Brazer, Esq., Worcester.
*Provenance:* MS list of "Donors and Donations to the American Antiquarian Society," Vol. I, entry for 25 April 1820; typescript list of artifacts in the AAS cabinet, 1948. [In the typescript, "pipe" is mistakenly transcribed as "pike."]
*Current Status:* This is one of two argillite pipes transferred from the AAS to the PMH; the other is described in the next entry. These two pipes, among the earliest argillite carvings documented, are currently numbered 95-20-10/48403 (see illustration on next page) and 48404.[61]

*Notes:* This pipe and the one that follows have been erroneously associated with Roderic McKenzie. The AAS records are clear that this pipe was donated by Samuel Brazer, one of the most enigmatic donors of Northwest Coast Indian material. A baker from Worcester, he was eulogized as "of a kindly temper, but of abrupt manner;— of a blunt humor of which he was proud, and a saucy wit in which he too frequently indulged." He rose from poverty to wealth through investments in an unnamed industry, and then "suddenly, with no fault or folly of his own, by the loss of title to a large and valuable estate in Boston . . . he was cast back again to poverty and a debtor's prison."[62] It may be that his investments included a voyage to the Northwest Coast and Canton and that this pipe was a souvenir of the venture.

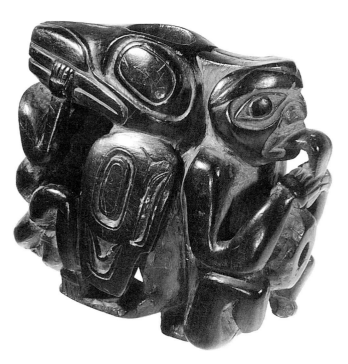

Object 182
Argillite pipe. PMH 95-20-10/48403. 8.5 cm x 4.5 cm.

**183. "Curious stone pipe from the North West Coast"**

*Donor:* Unknown.

*Provenance:* This description appears on a loose piece of paper inserted between pages 12 and 13 of Volume I of the MS list of "Donors and Donations to the American Antiquarian Society" and in the 1948 typescript list of artifacts (where it is mistakenly identified as a "pike" rather than a "pipe").

*Current Status:* This is one of two argillite pipes transferred from the AAS to the PMH; the other is described in the previous entry. Sometimes erroneously attributed to Roderic McKenzie, this pipe is clearly *not* among the items listed in the McKenzie donation documents. These two pipes, among the earliest argillite carvings documented, are currently numbered 95-20-10/48403 and 48404 (see illustration on this page).

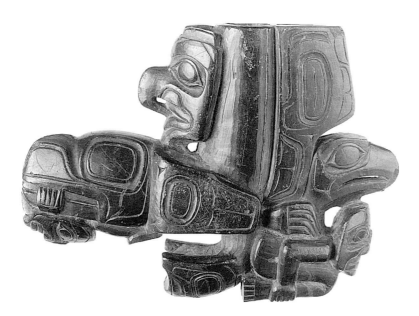

Object 183
Argillite pipe. PMH 95-20-10/48404. 8.26 cm x 1.27 cm.

**184. "A carved representation of the face of a high chief, female, on the Northwest Coast. Carved and painted by a native of that coast."**
*Donor:* J.[or I.] Goodwin, Esq. of Worcester.
*Provenance:* MS list of "Donors and Donations to the American Antiquarian Society," Vol. I, entry for 1 November 1826; typescript list of artifacts in the AAS cabinet, 1948.
*Current Status:* This is one of the most famous and often-reproduced artifacts from the early trade on the Northwest Coast, especially because of the enigmatic inscription on the back: "A cor-

rect likeness of Jenny Cass, a  high chief woman of the North west Coast[.] J. [or I.] Goodwin Esq."[63] Today it bears the PMH number 10-47-10/ 76826 (see illustration on this page).
*Notes:* It has generally been supposed that J. Goodwin was a trader on the Northwest Coast who collected the mask. The only person who seems even remotely to fit that description is Daniel Goodwin, who traveled to the Northwest Coast on two voyages of the Boston ship *Atahualpa* during 1800–1803 and 1803–1806. Like other mariners in the trade, Goodwin had ample opportunity to trade on his own

account for souvenirs. The financial records of his first voyage disclose numerous debits for articles received from the ship's store while on the Northwest Coast, and these can only have been used to barter for souvenirs or sexual favors. In 1802 his purchases included numerous items of clothing (which may have been either for his own use or for trade), two dozen buttons, multiple knives and combs, and a pound-and-a-half of white beads.[64] Goodwin died on the second voyage, along with Captain David Porter and seven shipmates, when their vessel was attacked at Milbanke Sound in June 1805. An account of the incident was published in Salem and reprinted in April 1806 in the *Connecticut Courant,* where Goodwin—whose first name is consistently given as Daniel in the ship's records—is referred to as "John W. Goodwin." A similar story in the *Annual Register* of London, England, a month later also refers to him as "John Goodwin,"[65] and these news articles may have been the source of the confusion of his given name. More likely, however, the inscription on this mask was not made by the collector at all, but by Israel Goodwin, an active member of the American Antiquarian Society, where this mask resided for eighty-five years before being transferred to the PMH. Israel Goodwin was appointed keeper of the cabinet in July 1831,[66] and in that capacity he would have had ample opportunity to examine and describe the mask and perhaps to inscribe what information was known about it right onto the mask itself (which, at the time, would not have been regarded as a violation of the integrity of the object). The initial that has been deciphered for years as a *J* could, in fact, just as easily be an *I.* Apart from the ambiguity of its specific provenance, this mask is notable as one of eleven masks and at least three dolls

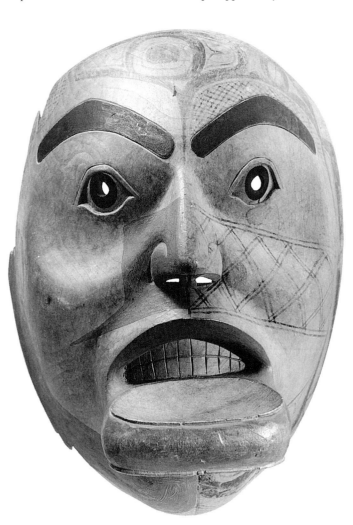

**Object 184**
Carved mask representing a female high chief. PMH 10-47-10/76826. 25 cm x 19 cm.

by the same carver. For other masks by the same hand, see numbers 46 and 235. For a description of the possible circumstances of the collecting of this mask, see chapter one, pages 12 to 16.

**185. "Wooden stirrups from the N.W. Coast of America"**
*Donor:* Dr. Usher Parsons of Providence, R.I.
*Provenance:* MS list of "Donors and Donations to the American Antiquarian Society," Vol. III, entry for May 1840; typescript list of artifacts in the AAS cabinet, 1948.
*Current Status:* It is impossible to know exactly what Northwest Coast article might have been meant by the description "stirrups." Perhaps they were large halibut hooks misunderstood by the cataloguer at the AAS. Several such hooks entered the PMH as part of the AAS collection, including: 95-20-10/48387, "Fish Hook, Southern Alaska" [later "or QCIs," "Haida Indians," and "Skittegatan"]; and 95-20-10/48388, "Fish Hook, Tlingit Indians, Alaska" [later "Koluschan"].
*Notes:* Dr. Usher Parsons served as a surgeon in the U.S. Navy during the War of 1812. (He died in 1868, the last survivor of Commodore Perry's flagship *Lawrence.*) Parsons was the author of the standard reference work on shipboard medicine, and at various times in his career he was associated with the Charlestown, Massachusetts, Navy Yard and with Harvard and Brown Universities. A keen antiquarian with extensive seafaring connections, Dr. Parsons had ample opportunity to encounter mariners who had traveled to the Northwest Coast, though the circumstances under which he acquired these mysterious "stirrups" is not known.

*The following artifacts, listed in the PMH accession book as originating at the AAS, do not have any counterpart in AAS manuscripts. They are reproduced here as they appear in the PMH record.*

**186. 95-20-10/48395: "Set of gambling sticks and bag, North West Coast, Probably Kitsan (Chimmesham)** [sp?] **or Athapascan"** [The cultural attribution here may be in a different hand.]

**187. 95-20-10/48396: "Ornament made from part of lower jaw of bear, North West Coast, inlaid with Haliotis shell"**

**188. 90-17-10/48402: "Fish skin thread, Probably Alaska"**

**189. 95-20-10/48406: "Wooden dish, North West Coast"** [A later notation adds "carved & painted at ends in red, black & blue. Shell inlay around rim."]

*Notes:* This very fine example of a carved square bowl is illustrated as number 18 in *Soft Gold* (pp. 48–49; see also the illustration on this page). Bill Holm says that "museum records suggest a collection date of before 1819," referring to old labels in the PMH archives, but that date would indicate that this object was, at that time, mistakenly associated with the Roderic McKenzie gift described above.

**190. 90-17-10/48424: "Model of Kaiak"** [The original cultural attribution is overwritten with "Aleutian Type (2 specimens)."]

**191. 90-17-10/48429: "Pair mittens, Eskimo"**

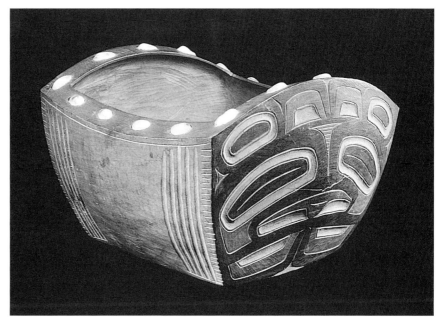

Object 189
Carved square bowl. PMH 95-20-10/48406. 17.78 cm x 19.05 cm.

# Boston Marine Society, 1742
# (Collection, 1832)

The Boston Marine Society was founded in 1742 as a "loving and friendly Society called The Fellowship Club." Limited to master mariners, members pledged

> to promote the Interest of each other in all Things in their Power, and
> to consult and resolve upon such Matters and Things from Time to
> Time, as may be serviceable to the Society, and to encourage suitable
> Persons to become Members thereof, as well as to relieve such Members
> of this Society, who by Misfortunes and Losses shall become proper
> Objects, according to the Ability of the Box.[67]

The first person to benefit from the charity of the club was Sarah Salter, the widow and "relict of Jona. Salter" and mother of the future captain of the ill-fated ship *Boston.* Mrs. Salter received twenty pounds in 1753.[68]

In 1754 the organization was incorporated as the Boston Marine Society, but membership was not limited to the captains of that port. As the collecting of observations, the building of lighthouses, and the sharing of navigational information quickly became the society's priorities, the participation of master mariners from Newport, Providence, Salem, Marblehead, and other New England ports was welcomed.

It was not until 1832 that the BMS began to talk about establishing a museum of its own, probably inspired by the high profile and success of the Salem East India Marine Society's cabinet. A committee was appointed to "take into consideration, the expediency of forming a collection of rare and valuable curiosities, that may be formed into a museum."[69] A year later there was a sizeable collection on exhibition in the society's room over the Tremont Bank on State Street. Within a decade the museum had outgrown the available space, and the entire collection was deposited with the Mer-

cantile Library Association, an organization dedicated to the education of men employed by the Boston merchant firms, most of which were well represented in the membership roster of the Marine Society.[70]

The relationship between the Boston Marine Society and the Mercantile Library Association was something like that between a captain and his crew, the former informing the latter that it would place

> the articles of curiosity belonging to that society, and now in your possession, on loan, for your Association to hold them in trust until the Boston Marine Society should call for them, and then your Association [shall] deliver them back to the Boston Marine Society, without any charge for storage or other expense—your compensation for keeping them [being] the gratification and benefit that you and your visitors [have] had from the sight of them.[71]

At some point the collection was transferred to the Boston Society of Natural History, probably when the latter institution opened its elegant new building on Berkeley Street in Boston's Back Bay in 1864. (The Society of Natural History evolved into the Boston Science Museum, but records of ethnographic collections are lost.) In 1869 the Boston Society of Natural History transferred its own ethnographic collections to the new Peabody Museum at Harvard and suggested that the Boston Marine Society do the same. It did, gaining with the decision the satisfaction of knowing that it had aided "the furtherance of so valuable a science as that of ethnology."[72]

This collection was acknowledged in the *Third Annual Report of the Peabody Museum* as being "chiefly from the northwest coast of America, and the islands of the Pacific," amounting to one hundred and fifty-one pieces and consisting of "an excellent series of clubs, spears, paddles, bows and arrows, models of canoes, badges of office, many of these elaborately carved, different kinds of musical instruments, personal ornaments, carvings, hats, articles of clothing, etc."[73]

Unfortunately, no original records of the Boston Marine Society's museum survive at the current BMS headquarters in Charlestown. At Harvard, the collection retrospectively received the number "69-20-10," and the following list is taken directly from the Peabody Museum's catalogue ledger.

# OBJECT LIST

**192. 69-20-10/1243: "Model of War Canoe, N.W. Coast, Samuel Topliff, about 1849"**
*Notes:* Captain Samuel Topliff was master and owner of the schooner *Nancy* of Boston (built at Newburyport, 1788; registered at Boston, 18 Jan. 1792; John Coffin Jones and Giles Alexander of Boston were the previous owners). Vancouver met a ship *Nancy* of New York at the Hawaiian Islands in March 1794, about which little else is known.[74]

**193. 69-20-10/1244: "Model of War canoe in wood, N.W. Coast"** [A later note added "Haida."]
*Notes:* Bill Holm says this model (see illustration on this page) was made by the same hand as number 236 below. See *Soft Gold*, number 14 (p. 44).

**194. 69-20-10/1245: "Model of War canoe in wood, N.W. Coast"**

**195. 69-20-10/1246: "Model of canoe in wood, N.W. Coast"**
*Notes:* This canoe model is described and illustrated as number 15 in *Soft Gold* (p. 45). (See color plate on p. 83 of this volume.)

**196. 69-20-10/1247: "Model of canoe in wood, N.W. Coast "**

**197. 69-20-10/1248: "Model of War canoe, made of intestine, N.W. Coast"** [A later notation reads "Aleutian Islands."]

**198. 69-20-10/1250: "Paddles belonging with 1243, N.W. Coast, (11 specimens)"**

**199. 69-20-10/1251: "Miniature paddles, Northwest Coast, (6 specimens)"**
[The number of specimens was later changed to 5.]
*Notes:* See illustration on next page.

**200. 69-20-10/1252: "Miniature paddles, Northwest Coast, (3 specimens)"**
[The number of specimens was later changed to 4.]

**201. 69-20-10/1255: "Paddle, N.West Coast"**

**202. 69-20-10/1260: "Pipe carved in slate, North west Coast"**

**203. 69-20-10/1261: "Pipe carved in slate, broken, North west Coast"**

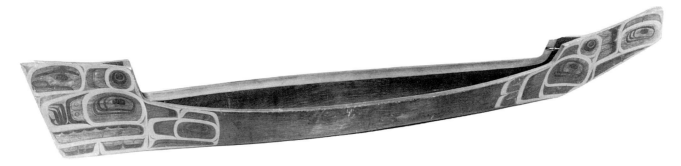

Object 193
Model of war canoe. PMH 69-20-10/1244. 182.88 cm x 24.13 cm.

**204. 69-20-10/1264: "Bow also a hat, North west Coast"** [A later notation reads: "Bow Probably Southern Tlingit."]

**205. 69-20-10/1265: "Bow, North west Coast"** [A later notation reads: "Probably Southern Tlingit."]
*Notes:* This bow has a notation that it was collected by "Capt. Sutter." Captain John Suter had extensive experience on the Northwest Coast. He was mate on the *Pearl* in 1805 and later became master of that vessel (1807–1810). He commanded the *Atahualpa* and *Mentor* to the Northwest Coast, the latter for an exceptionally long voyage between 1816 and 1819.

**206. 69-20-10/1274: "Robe made of intestines, North west Coast"**

**207. 69-20-10/1278: "Cup made of skin, North west Coast"**

**208. 69-20-10/1330: "Dagger made of Copper, North west Coast?"** [Later the question mark was struck.]
*Notes:* This very fine dagger is described and illustrated in *Soft Gold* as number 31 (p. 64). See the illustration on this page.

**209. 69-20-10/1393: "Spear point, of walrus tusk"** [A later hand added "North West Coast."]

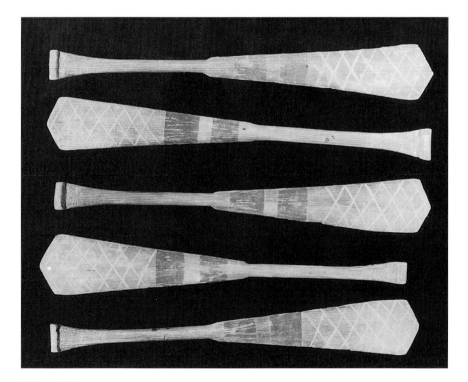

Object 199
Miniature paddles. PMH 69-20-10/1251. 33.02 cm x 5.08 cm.

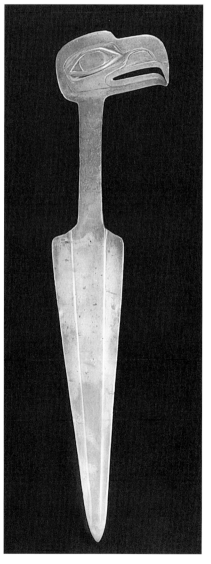

Object 208
Copper dagger. PMH 69-20-10/1330. 38.1 cm x 8.89 cm.

# Boston Museum
# 1841

*(Including collections from the former Peale Museum
and the former New England Museum)*

## THE PEALE MUSEUM, 1785

Of the museum collections founded in the late eighteenth century, the most influential at the time was the Peale Museum, founded in Philadelphia in 1785 by the painter Charles Willson Peale.[75] Included in the large Peale collection were artifacts collected by Meriwether Lewis and William Clark on their epic trek across the North American continent between 1804 and 1806. When they returned to St. Louis in 1806, one "Clatsop hat" was forwarded to Washington (presumably to Thomas Jefferson) by Lewis, and another was sent by Clark to Louisville "in the care of Mr. Wolpards."[76] Some portion of the material collected by Lewis and Clark was donated to the Peale Museum in 1810, and the acquisition was announced on March first in the Philadelphia newspaper, *Poulson's American Daily Advertiser.*

> Addition and Donations, To Peale's Museum, In the State House, March 1st 1810.
>
> Part of the articles collected by Messrs. Lewis and Clark, viz . . . Hat, made by a Clatsop woman, near the Pacific Ocean. . . . Cap, such as are worn by the women on the plains of Columbia. . . . Two ornaments worn round the neck, by the natives of the plains of Columbia. . . . A Bag made of grass, by the Pishquilpahs's on the Columbia River—another used as a Water Cup, of the same material. A Cap of the same. . . .
>
> All the above presented by George Meriwether Lewis, and Gen. William Clark.

Lewis and Clark commissioned hats made by Clatsop women for use by the expeditionary party, as Meriwether Lewis described in a journal entry dated 22 February 1806:

We were visited today by two Clatsop women and two boys who
brought a parsel of excellent hats made of Cedar bark and ornamented
with beargrass. Two of these hats had been made by measures which
Capt. Clark and myself had given one of the women sometimes since
with the request to make each of us a hat; they fit us very well, and are
in the form we desired them. we purchased all their hats and distributed
them among the party. the woodwork and sculpture of these people as
well as these hats and their waterproof baskets evince an ingenuity by
no means common among the aborigenes of America.[77]

The explorers also described and collected hats that were made fur-
ther north on the coast (from Nootka Sound north to the coast of Alaska)
and probably transported to the Columbia River on one of the American
ships then regularly sailing between the two regions. The hats from the
Peale collection were eventually transferred to the Boston Museum and
from there to the Peabody Museum at Harvard. Unfortunately, none of
the hats that survive at the PMH actually originated among the Clatsop
or Chinook—possibly because Lewis and Clark purchased local hats for
their own use and not as part of a souvenir collection. It is not likely that
either the American explorers or Peale discerned the specific tribal origin
of any of the hats they collected, and the hats referred to in the article
quoted above as originating at the Columbia River are probably the same
Nootkan and Tlingit hats now in the PMH collection and described
below.

Peale received additional Northwest Coast material from other
sources, although the means by which he acquired them is not clear. His
connections were certainly widespread, and the fame of his museum would
have drawn donations from persons not acquainted with him personally or
connected to Philadelphia. Among the contributors was Captain Edward
Fanning, whose voyages were described in his book, *Voyages to the South
Seas, Indian and Pacific Oceans, China Sea, North West Coast, Feejee Islands,
South Shetlands . . . 1830–1837.*

The sons of museum founder Charles Willson Peale (all named for
great painters) included Titian Peale, who served as a naturalist on the
Wilkes Expedition, and Rubens Peale, who for a time had his own theater,
called the Parthenon, in New York, an institution that exhibited scientific
specimens in a setting devoted primarily to theatrical entertainments.
(Following the collapse of the venture in the hands of Rubens Peale, it was,
for a time, owned by a comedian and actor named Yankee Hill whose
father, Captain Samuel Hill, had commanded a number of voyages to the
Northwest Coast.)

The Peale Museum collections were sold in 1848, and the ethno-graphic and natural history materials were divided a year later between the famous showman P. T. Barnum and Moses Kimball, who ran a museum-theater complex in Boston called "The Boston Museum." A catalogue of the "sheriff's sale" of 1848 lists undifferentiated "Articles of Bark Clothing" and "Dresses made from the Intestines of a Whale, & c." which must have been obtained on voyages to the Northwest Coast. Also mentioned but not described in detail are "Curiosities, Stone Pipes, Idols, & c.," "Indian arti-cles of dress," "18 spears and hats, 30 arrows, 23 war clubs, 16 bows, arrows and bats," and the frustrating entry "Canoes, various."[78]

## THE NEW ENGLAND MUSEUM AND GALLERY OF FINE ARTS, 1818, AND THE BOSTON MUSEUM, 1841

In addition to the "learned societies," which founded museum collections as a scientific adjunct to their libraries, several commercial institutions sprang up in the first quarter of the nineteenth century in which objects were exhibited as part of a larger complex of entertainment for the masses. The motive for these institutions was profit making, and consequently, they lacked the zealous support of interested members with a personal connec-tion to the organization (as was the case for the marine societies) and the benefaction of wealthy philanthropists who made projects of institutions like the MHS and Boston Athenaeum.

One such commercial institution was the New England Museum and Gallery of Fine Arts, which was founded in 1818 by Dr. John Dwight, Peter B. Barzin, and Ethan A. Greenwood, who "formed themselves into an association for the purpose of collecting and establishing a Museum of Natural History and miscellaneous curiosities."[79] The nucleus of the col-lection was Ethan Greenwood's statuary, paintings, and prints, which had been exhibited at "Greenwood's Painting Room, No. 1 Tremont St.," prior to the founding of the New England Museum. Greenwood was compen-sated for the donation of his collection with $2,000 worth of shares in the new company.

In April 1818 the new museum opened on Market Street in Boston. It quickly acquired other collections from the New York Museum and from Nix's Museum of New Haven, Connecticut. In 1825 the "curiosities and monstrosities" of another Boston institution, the Columbian Museum, which had been founded by Daniel Bowen before 1797, were added to the

growing New England Museum.[80] Over the next two decades, the New England Museum survived several financial crises, but the core management remained consistent. Dr. Dwight was the president of the organization for twenty-one years.

In February 1840 Moses Kimball was elected to the position of agent and superintendent of the organization, and when the museum lost its lease a few months later, Kimball moved the collection to Lowell. Whether Moses Kimball and his brother, David Kimball, joined the organization with the intention of taking it over is not clear, but that was certainly the result. David Kimball was chosen to form and lead a committee to consider the future of the museum in November 1840. Within a few months the New England Museum was defunct, and on 14 June 1841 the new Boston Museum and Gallery of Fine Arts opened on Tremont Street in Boston. The new institution was owned and operated entirely by the Kimball brothers, and the collections of the former New England Museum provided the foundation.

Although Moses and David Kimball were committed to the collections, they considered them to be secondary to the theatricals that were featured at the Boston Museum. (Yankee Hill, the comedian son of the Northwest trader, Captain Samuel Hill, was a headliner in the early years.) A catalogue printed in 1844 describes cases filled with exotic artifacts from the Polynesian islands and China, which would indicate that merchants or mariners involved in the Pacific trade were providing some of the collections. There were also a number of Indian "curiosities," including bows and arrows, ornaments, pipes, bracelets, fishing and sporting implements, caps, helmets, relics, dresses, pouches, etc., none of which are described in detail.[81]

In 1847 the Boston Museum moved to a new building and published a broadside promising "Amusement for the Million!"

Strangers visiting Boston, should by no means omit examining the vast MAGAZINE OF WONDERS, comprising all that is curious and beautiful in Art and strange in nature, of the productions of Earth, Sea and Air; to be found in the immense collection of the BOSTON MUSEUM . . .[82]

The art, animals, bugs, birds, freaks, shells, and skeletons on exhibit were then enumerated in the broadside, including "collections of Costumes, Impelements & c. of the North American Indians, and South Sea Islands; and of Heathen Idols . . . undoubtedly the best in America."

A catalogue published in 1847 includes descriptions similar to those of three years earlier, with the addition of "Chinese and North Western Hats, Caps, Dresses, etc."[83] It is not surprising that materials from the Northwest Coast would end up in a museum in Boston, the port at the center of the Northwest trade, but unfortunately no specific details survive to illuminate them. In 1849 Moses Kimball doubled the size of the museum with the acquisition of ethnographic material from the Peale Museum, including the Lewis and Clark hats described above.

In 1893 the Kimballs gave their natural history collection to the Boston Society of Natural History. When Moses Kimball died two years later, the Boston Museum was dissolved. At that time it was said to have included "upward of half a million articles."[84] In 1899 the ethnographic material was given to the PMH by the heirs of David Kimball. The following list is culled from the PMH catalogue ledger, where the collection retrospectively received the number "99-12."[85]

# OBJECT LIST

## 210. "Sinew backed Bow, Chinook River, a branch of the Columbia River near Astoria, Undoubtedly Clatsop Indians"

*Donor:* "Presented by Capt. Bishop, 1800."
*Provenance:* PMH catalogue ledger.
*Current Status:* 99-12-10/52951.
*Notes:* This artifact is one of very few for which the collecting is specifically described in a shipboard journal. When Captain Charles Bishop visited the Columbia River in 1795 as master of the American-built but British-registered ship *Ruby,* he referred to the estuary as the Chinook River and, on 8 December, described the collecting of this bow:

> In the Evening, Concomally returned and came along side the Ship, having left Shelathwell with one of his Wives, at her Fathers house up the River Chinnook. In their Passage from thence an heavy sea upset the Cannoe and he lost two Guns, two Leathr dresses and a Moose Deer intended for us. He had another in his canoe, which he offered to give us but we soon found to our Mortification that it was only fitt for the 'DELICATE' venison Eaters in England. Disaponted at our refusal of this Present he offered one of his Leathr War Dresses, and Several Bows & Arrows. The latter articles I accepted: and bought from him the Former: For I was too well Pleased with his Generosity to take the other without bestowing an Equevilent Article. . . .[86]

Just after this incident he wrote that "Shelathwells Wife Gave me a curious wrought Hatt, made by herself."[87] In the course of his voyage, which lasted from 1794 to 1799, Bishop had many opportunities to trade or give this bow to one of the Boston captains on the coast. For example, he met the *Washington* in Hawaii in February 1796, soon after the death of Captain John Kendrick, and assisted Kendrick's successor, Captain Roger Simpson:

> The *Washington* having broke an anchor Stock, Capt. Simpson requested the Assistance of our Carpenters in replacing it which was readily complyed with. He is an Englishman, and appears to be a Gentleman, and having given me a good deal of information together with Several Letters of introduction to his Friends at Canton and Macao, I yielded to his Solicitations and spared him a few necessarys which I am ashured of replacing there, taking his Bill on the owners of the Washington for the Same. . . .[88]

## 211. "Woman's hat, Nootka Sound Indians"

*Donor:* "Gift of the heirs of David Kimball . . . (Boston Museum Collection)."
*Provenance:* PMH catalogue ledger.
*Current Status:* 99-12-10/53079. See the color plate on page 83.
*Notes:* This fine Nootkan whaleman's hat was probably collected by Lewis and Clark at the mouth of the Columbia River and accessioned by the Peale Museum in 1805. See next entry for details.

## 212. "Woman's hat, Nootka Sound"

[Later notes add: "Probably the one purchased by L&C of a Clatsop Ind for a fish-hook" and "This is probably the one referred to in Peale M. accession book as cap worn by natives of Columbia R. and Pacific O. and given by L&C."]
*Donor:* "Gift of the heirs of David Kimball . . . (Boston Museum Collection)."

*Provenance:* PMH catalogue ledger.
*Current Status:* 99-12-10/53080.
*Notes:* Like number 211 above, this is a Nootkan hat probably collected by Lewis and Clark.

Such hats, with "faint representations of the whales, the Canoes, and the harpooners Strikeing them," were mentioned by both Lewis and Clark in personal journal entries so similar that they must have been either written together or shared. These knob-topped hats, made by women artisans at Nootka Sound, would have been recognizable to members of the expedition from illustrations in the narrative of Cook's third voyage. Each of the American explorers fully described them and drew two sketches, rough cartoons in their journals and more finished depictions for the final reports.[89] The PMH entry referring to this hat as purchased "for a fish-hook" is almost certainly an error. See number 216 below.

American ships, making a regular transit from Nootka Sound to the Columbia River after 1792 (when the river was first visited by Captain Robert Gray and named for his ship), probably conveyed this hat into the hands of the Clatsop or Chinook, along with others made by northern tribes on the Northwest Coast.

## 213. "Hat of spruce root and cedar bark" [Later ditto marks indicating "Nootka Sound Indians" were overwritten with "Kwakiutl Inds Probably," and a clarifying note was added in 1910: "This is the old form. Spruce roots hats are sometimes now (1910) made and the cedar bark type used to cover them when not in use, Boas, 452. See Boas (The Kwakiutl) page 453."]

*Donor:* "Gift of the heirs of David Kimball . . . (Boston Museum Collection)."
*Provenance:* PMH catalogue ledger.

*Current Status:* 99-12-10/53081 (see the illustration on this page).
*Notes:* This is another of the hats thought to have been collected by Lewis and Clark and subsequently given to the Peale Museum. It is described as number 3 in *Soft Gold* (p. 34), where Bill Holm says it is "probably Nootkan."

### 214. "Cedar bark Hat Cover, Kwakiutl Indians"

*Donor:* "Gift of the heirs of David Kimball . . . (Boston Museum Collection)."
*Provenance:* PMH catalogue ledger.
*Current Status:* 99-12-10/53082.

### 215. "Cap of Spruce roote embroidered with Grass, Tlingit Indians—Form made in imitation of Sailor's caps"

*Donor:* "Gift of the heirs of David Kimball . . . (Boston Museum Collection)."
*Provenance:* PMH catalogue ledger.
*Current Status:* 99-12-10/53083. See the color plate on page 79.

*Notes:* Bill Holm says this hat is "typical Tlingit basketry" (see *Soft Gold*, number 11 on p. 40). The hats worn by American sailors were copied by Northwest Coast Indians in their native materials. Holm says that the Tlingit, who made this hat, "adopted a similar sailor's cap style for their social dancing regalia." Similar style hats were also made by the Aleuts of sea mammal intestines.[90]

### 216. "Hat of Cedar Bark & split twigs, Indians of the Northwest Coast"

*Donor:* "Gift of the heirs of David Kimball . . . (Boston Museum Collection)."
*Provenance:* PMH catalogue ledger.
*Current Status:* 99-12-10/53176 (see the illustration on next page).
*Notes:* This hat was collected by Lewis and Clark and described by Lewis in his journal:

> We also purchased a small quantity of train oil for a pair of Brass armbands and a hat for some fishinghooks. These hats are of their own manufactory and are composed of Cedar bark and bear grass interwoven with the fingers and ornimented with various colours and figures, they are nearly waterproof, light, and I am convinced are much more durable than either chip or straw. These hats form a small article of traffic with the Clatsops and Chinnooks who dispose of them to the whites. The form of the hat is that which was in vogue in the U^ed States and great Britain in the years 1800 & 1801 with a high crown rather larger at the top than where it joins the brim; the brim narrow or about 2 or 2 1/2 inches.[91]

This spruce root hat is woven to resemble a top hat and, according to Bill Holm, may be a unique example of the form (see *Soft Gold*, number 10 on p. 39). Like the other hats surviving from the Lewis and Clark collection, it was produced far north of the Columbia River where it was collected. Holm says "the style of decoration in weft-dyed bands suggests Haida work, but the twining direction is more characteristic of Tlingit basketry."

### 217. "Model of Canoe, Northwest Coast Southern Type" [A later note indicates that Franz Boas identified it as "probably Nootka;" that note is struck out and another note says "Emmons says this is Tlingit."]

*Donor:* "Gift of the heirs of David Kimball . . . (Boston Museum Collection)."
*Provenance:* PMH catalogue ledger.
*Current Status:* 99-12-10/53084.
*Notes:* The catalogue of the "sheriff's sale" that dissolved the collection of the Peale Museum in 1848 notes the sale of a case full of "Canoes, various," and this must be one of the models described in that enigmatic entry.

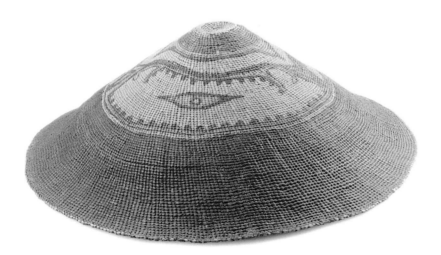

**Object 213**
Hat of spruce root and cedar bark. PMH 99-12-10/53081. 28.5 cm x 26 cm.

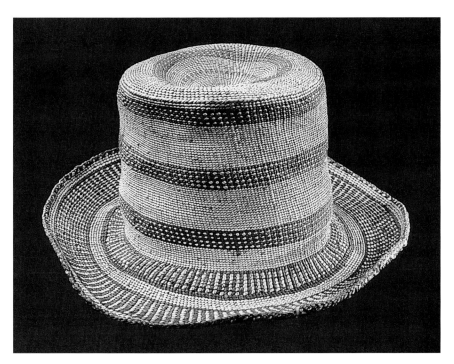

**218. "Slave killer or Club, Indians of the Northwest Coast"** [Further described as "Wooden handle. Stone head."]

*Donor:* "Gift of the heirs of David Kimball . . . (Boston Museum Collection)."

*Provenance:* PMH catalogue ledger.

*Current Status:* 99-12-10/53085.

*Notes:* F. Thompson is said to have donated this club to the Peale Museum in 1812. This may be Francis A. Thompson of Boston, who was active in the Pacific trade and eventually relocated to Hawaii around 1830, where he managed Boston interests and invested in the *Crusader* with a number of active Northwest captains.

Object 216
Hat of cedar bark and split twigs. PMH 99-12-10/53176. 30.48 cm x 35.56 cm.

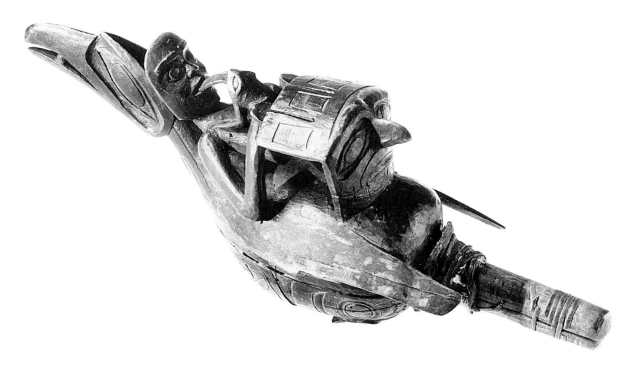

Object 220
Dance rattle. PMH 99-12-10/53087. Approximately 30 cm x 10 cm x 10 cm.

**219. "Ancient form of Dance Rattle, Indians of the Northwest Coast"** [Further described as "Wood with beak of the Puffin attached."]
*Donor:* "Gift of the heirs of David Kimball . . . (Boston Museum Collection)."
*Provenance:* PMH catalogue ledger.
*Current Status:* 99-12-10/53086.

**220. "Dance Rattle, Indians of the Northwest Coast"** [Further described as "Bird form."]
*Donor:* "Gift of the heirs of David Kimball . . . (Boston Museum Collection)."
*Provenance:* PMH catalogue ledger.
*Current Status:* 99-12-10/53087 (see illustration on previous page).

**221. "Wooden Spoon, Indians of the Northwest Coast"**
*Donor:* "Gift of the heirs of David Kimball . . . (Boston Museum Collection)."
*Provenance:* PMH catalogue ledger.
*Current Status:* 99-12-10/53088.

**222. "Horn Spoon Indians of the Northwest Coast"**
*Donor:* "Gift of the heirs of David Kimball . . . (Boston Museum Collection)."
*Provenance:* PMH catalogue ledger.
*Current Status:* 99-12-10/53089.

**223. "Set of Gambling Sticks, Indians of the Northwest Coast"** [A later note added "probably Haida."]
*Donor:* "Gift of the heirs of David Kimball . . . (Boston Museum Collection)."
*Provenance:* PMH catalogue ledger.
*Current Status:* 99-12-10/53090.

**224. "Wooden Food Dish, Indians of the Northwest Coast"**
*Donor:* "Gift of the heirs of David Kimball . . . (Boston Museum Collection)."
*Provenance:* PMH catalogue ledger.
*Current Status:* 99-12-10/53091 (see illustration on next page).
*Notes:* This carved Tlingit bowl is attributed in Peale Museum records to George Campbell, who became the treasurer and manager of the museum in the 1840s. The date of donation of this very fine carved bowl is given as 1820, so Campbell may have been on a voyage earlier in his career, or he may have just had strong antiquarian instincts as a young man and collected it from a returning "Boston man." It is illustrated as number 22 in *Soft Gold* (p. 52).

**225. "Throwing Stick, Indians of the Northwest Coast"**
*Donor:* "Gift of the heirs of David Kimball . . . (Boston Museum Collection)."
*Provenance:* PMH catalogue ledger.
*Current Status:* 99-12-10/53092 (see illustration on next page).
*Notes:* This Tlingit artifact was donated to the Peale Museum by Captain Thomas Robinson of Boston. Robinson became a member of the Boston Marine Society in 1792, already having achieved the rank of master mariner. His other donations to the Peale Museum were from China and Hawaii, indicating that he may have made a Northwest Coast voyage, although one cannot be identified. He would, at any rate, have been well known among Northwest Coast traders. In later years he commanded the U.S. Navy frigates *John Adams* and *New York*. See *Soft Gold,* number 43 (pp. 78–79). Robinson also donated the canoe model described in entry number 229.

There was another Thomas Robinson, who traveled to the Pacific Ocean at the age of twenty-one aboard the Boston brig *Otter* in 1809. Though the ship continued on to the Northwest Coast under the command of Captain Samuel Hill, it is not known for sure if Robinson remained aboard. Nor is he known to have risen to the rank of captain.

**226. "Wooden effigy of Woman with labret, Indians of the Northwest Coast"**
*Donor:* "Gift of the heirs of David Kimball . . . (Boston Museum Collection)."
*Provenance:* PMH catalogue ledger.
*Current Status:* 99-12-10/53093. See the color plate on page 81.
*Notes:* This carved wooden figure and the one that follows were made by the artist who created the "Jenny Cass" series of masks and two other dolls similar to this one. This carving appears in *Soft Gold* as number 136 (p. 161). According to Bill Holm "there is no doubt that they were carved for sale to white visitors—there is no real precedent for them in traditional native art." For three masks and another doll by the same carver, see numbers 46, 184, 227, and 235.

**227. "Wooden effigy of Woman with labret, Indians of the Northwest Coast"** [This entry is included as ditto marks from the above, with the additional note "Probably Tsimshian."]
*Donor:* "Gift of the heirs of David Kimball . . . (Boston Museum Collection)."
*Provenance:* PMH catalogue ledger.
*Current Status:* 99-12-10/53094 (see illustration on next page).
*Notes:* See above.

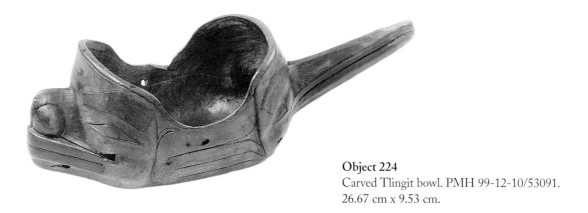

**Object 224**
Carved Tlingit bowl. PMH 99-12-10/53091.
26.67 cm x 9.53 cm.

**Object 225**
Tlingit throwing stick.
PMH 99-12-10/53092.
38.74 cm x 5.08 cm.

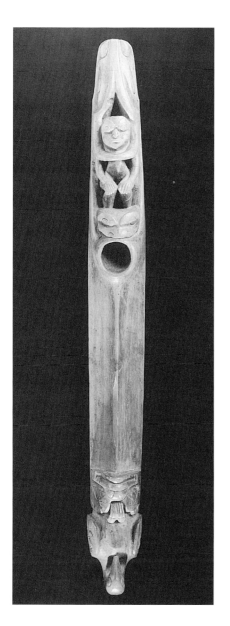

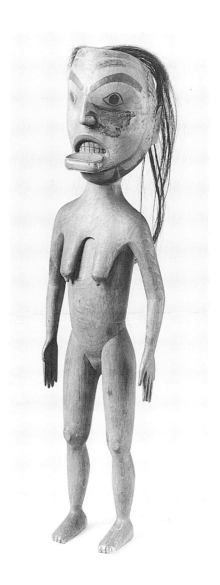

**Object 227**
Effigy of a woman with a labret.
PMH 99-12-10/53094.
45.72 cm x 13.97 cm.

**228. "Model of a Canoe (War), Indians of the Northwest Coast"** [A later note adds "Probably Tsimshian."]
*Donor:* "Gift of the heirs of David Kimball . . . (Boston Museum Collection)."
*Provenance:* PMH catalogue ledger.
*Current Status:* 99-12-10/53095.
*Notes:* The catalogue of the "sheriff's sale" that dissolved the collection of the Peale Museum in 1848 notes the sale of a case full of "Canoes, various," and this must be one of the models described in that enigmatic entry.

**229. "Model of a Canoe (War), Indians of the Northwest Coast"**
*Donor:* "Gift of the heirs of David Kimball . . . (Boston Museum Collection)."
*Provenance:* PMH catalogue ledger.
*Current Status:* 99-12-10/53096.
*Notes:* This canoe model was donated to the Peale Museum by Captain Thomas Robinson of Boston in 1813. For details of his career see the note to number 225 above.

**230. "Black Slate Pipe, Haida Indian Queen Charlotte Islands"** [A later note adds "Kadiak I. See Lisiansky Plate III."]
*Donor:* "Gift of the heirs of David Kimball . . . (Boston Museum Collection)."
*Provenance:* PMH catalogue ledger.
*Current Status:* 99-12-10/53097.

**231. "Throwing Stick (Roger's type), Northwest Coast"** [The "Northwest Coast" cultural attribution was later struck and replaced by "Alaska."]
*Donor:* "Gift of the heirs of David Kimball . . . (Boston Museum Collection)."
*Provenance:* PMH catalogue ledger.
*Current Status:* 99-12-10/53098.

**232. "Model of a Kaiak"** [Later notes add "shitkin" and "(Sitkin I) one of the Aleutian Is.," "Previous to 1812," and "Presented by Mr. F. Thompson [to the Peale Museum] Aug. 15, 1812."]
*Donor:* "Gift of the heirs of David Kimball . . . (Boston Museum Collection)."
*Provenance:* PMH catalogue ledger.
*Current Status:* 99-12-10/53136 (see illustration on this page).
*Notes:* This Aleutian kayak model must be one of the "Canoes, various" described in the catalogue of the "sheriff's sale" that dissolved the collection of the Peale Museum in 1848. Records indicate that it was donated by F. Thompson in 1812. This may be Francis A. Thompson of Boston, an active trader in the Pacific. Thompson moved to Hawaii around 1830, where he managed Boston interests and invested in the *Crusader* with a number of other Northwest captains.

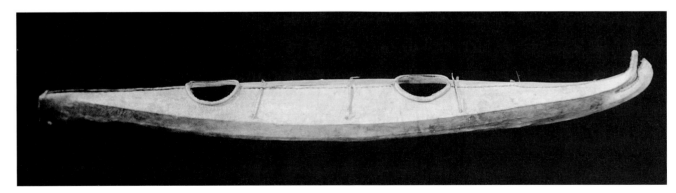

**Object 232**
Aleutian kayak model. PMH 99-12-10/53136. 85.09 cm x 13.97 cm.

# Peabody Museum of American Archaeology and Ethnology 1867

*(Now known as the Peabody Museum of Archaeology and Ethnology)*

In 1866 George Peabody, a Massachusetts native who had moved to London and made a fortune in banking, pledged $150,000 to establish a new museum at Harvard. (He had given a similar amount to the East India Marine Society in Salem, which subsequently changed its name, in his honor, to the Peabody Academy of Science.) The Peabody Museum of American Archaeology and Ethnology (PMH) opened at Harvard in 1867.

In addition to the collections acquired from other institutions as described above, the museum appealed through printed circulars to other donors, and five objects were acquired for which a clear provenance to the maritime fur trade can be established.

# OBJECT LIST

### 233. "Model of a Canoe, Northwest Coast"

*Donor:* Peabody Academy of Science.
*Provenance:* PMH catalogue ledger.
*Current Status:* 69-9-10/1203.
*Notes:* This Aleut kayak model was one of a pair given to the museum of the East India Marine Society in May 1802 by Captains Clifford Crowninshield and M. Folger. It was transferred to the Peabody Museum at Harvard in 1869, still bearing its EIMS number. See number 8 above.

### 234. "Model of a Canoe, Northwest Coast"

*Donor:* Peabody Academy of Science.
*Provenance:* PMH catalogue ledger.
*Current Status:* 69-9-10/1204.
*Notes:* This Aleutian kayak model was donated by Captain Thomas Meek to the museum of the East India Marine Society in Salem before 1821 and was transferred to the Peabody at Harvard in 1869. For details of the original accession, see number 35 above.

### 235. "Mask, Indians of the Northwest Coast" [A later notation describes the mask as "Tlingit."]

*Donor:* William Sturgis Bigelow, 1898.
*Provenance:* PMH catalogue ledger.
*Current Status:* 98-04-10/51671. See the color plate on page 77.
*Notes:* William Sturgis Bigelow was the grandson and namesake of Captain William Sturgis, from whom Bigelow is presumed to have inherited the mask. During the early life of this donor his grandfather was the Grand Old Man of the maritime fur trade and a leader in Boston's political and philanthropic community. Sturgis made three voyages to the Northwest Coast, and when he retired from the sea he became an influential owner and manager of Pacific-bound vessels. To illustrate a lecture he delivered in Boston in 1848, Captain Sturgis had to borrow a mask from the Salem East India Marine Society. He said at the time that he had "often noticed these masks" on the Northwest Coast and "brought home several," but did not foresee "that [he] should turn lecturer in [his] old age [and] did not preserve them."[92] The mask he borrowed was the one originally collected by Captain Daniel Cross

(number 46 above); the Bigelow mask is another in the "Jenny Cass" series, carved by the same hand as number 184. It may have been located later by Sturgis, or it could have been presented to him by another mariner-collector. For a discussion of a possible scenario for the collecting of this and the similar masks, see pages 12 to 16. This mask is also described and illustrated in *Soft Gold*, number 60 (pp. 96–97).

### 236. "Model of War Canoe"

*Donor:* "Some old local society."
*Provenance:* PMH catalogue ledger.
*Current Status:* 05-14-10/64702 (see illustration on this page).
*Notes:* This canoe was apparently not entered into the catalogue ledger immediately upon its entry into the PMH collection, and by the time it was recorded the donor was no longer identifiable. A label on the model indicates that it was "collected before 1837," which may refer to its inclusion in the 1837 catalogue of the East India Marine Society Museum. (Two of the models listed in the 1837 catalogue cannot currently be accounted for—see numbers 14 and 27 above.) Like the

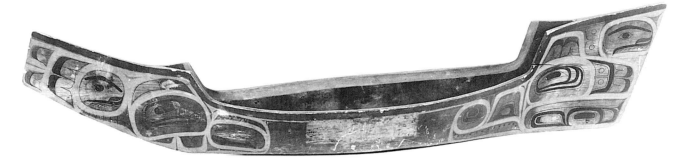

Object 236
Model of a war canoe. PMH 05-14-10/64702. 116 cm x 24.4 cm.

two canoe models described above as numbers 233 and 234, this may have been donated by the Peabody Academy of Science. Alternatively, this model may have originated at the Boston Marine Society; Holm says it was made by the same hand as that which created number 193 above. (Although it would not have been unheard of for the same mariner to have given identical gifts to the marine societies in Salem and Boston.) Holm says it may be Haida, Tsimshian, or Tlingit. See *Soft Gold*, number 13 (p. 43).

**237. Swift Blanket**

*Donor:* Lewis H. Farlow.

*Provenance:* PMH catalogue ledger.

*Current Status:* 09-8-10/76401 (see illustration on this page).

*Notes:* This geometrically patterned raven's tail robe (traditionally called the Swift Blanket) was collected by Captain Benjamin Swift, an ancestor of the donor, who made at least five voyages to the Northwest Coast between 1791 and 1809. Swift first went to the Northwest Coast as chief carpenter on the *Margaret* under Captain James Magee, whose own collecting enthusi-

asm must have inspired many of his crew. On the Northwest Coast, Swift supervised the construction of "a little craft" carried out in frames on the *Margaret*, and he then became master of the new vessel.[93] Swift would later command three voyages of the *Hazard* (1796–1799, 1799–1802, and 1803–1805) and a single voyage of the *Derby* (1806–1809). This exceptional example of Chilkat weaving is described and illustrated in *Soft Gold*, number 73 (pp. 110–111).

**Object 237**
Raven's tail robe, traditionally called the Swift Blanket. PMH 09-8-10/76401. 179 cm x 128 cm.

# Newburyport Marine Society, 1772
## (Collection, 1851)

# Historical Society of Old Newbury
## 1877

# Newburyport Maritime Society
## (Custom House Maritime Museum), 1974

The Newburyport Marine Society (NMS) was founded in 1772 but did not begin to assemble any sort of collection until 1851 when it finally settled into permanent quarters with the purchase of a building.[94]

Though the collection postdates the maritime fur trade, at least some of the items described here must have been collected on American voyages prior to 1850. The society's most significant collections from the Northwest Coast were donated by William Cushing, the scion of a trading empire in Newburyport. His father, John P. Cushing, was a partner with J. and T. H. Perkins in the ownership of a number of Columbia River vessels. Young William Cushing was a recent Harvard graduate when he went to sea in 1843 aboard the Newburyport brig *Chenamus,* a vessel owned and managed by his family. He arrived at the Columbia River in April 1844 and spent a year and a half traveling around the region.

The native population was at that point drastically reduced in numbers by disease, Cushing himself estimating that their numbers did "not exceed 900 or 1000."[95] His interaction was thus almost entirely with the members of the Hudson's Bay Company (HBC) and the missions. While Cushing was in residence, the HBC schooner *Columbia* arrived from more distant locations on the coast (the same vessel that provided the Wilkes party with their Northwest Coast souvenirs), and Cushing had an opportunity to collect artifacts from Alaska and elsewhere.

By 1906 the port of Newburyport had declined significantly and the NMS became defunct. That same year a Newburyport philanthropist donated a house to the Historical Society of Old Newbury (HSON), which had been founded in 1877, in order to consolidate the collections of the NMS with its own. Two subsequent moves brought the HSON, in

1956, into the Cushing family mansion on High Street in Newburyport, which still serves as its home.

A new institution, the Newburyport Maritime Society, was founded in 1974 to establish a maritime museum in the port's historic custom house. In 1975, eleven hundred objects from the old NMS collection were deposited by the HSON at the Custom House Maritime Museum (CHMM).

Four different manuscript sources document the collection as it moved from one institution to another. The oldest is an undated "Catalog of Articles in the Newburyport Marine Societie's Museum," at the HSON, presumably made during the last half of the nineteenth century when the NMS was acquiring its collection. The CHMM has an "Accessions Log, Loans from the Historical Society of Old Newbury" which describes those artifacts transferred in 1975, giving each a new catalogue number. (These numbers, identifying them as being in the first accession of 1975, do not appear in a consistent format throughout the museum's collection. Sometimes, for example, the order is denoted "1.321.1975," while else-where it is "1975.1.260.") Catalogue cards appear for many but not all of the objects transferred in 1975, and a final list of the NMS objects was made in 1989, when the loan of the collection became permanent.

# OBJECT LIST

**238. "2 dresses made from the entrails of the Walrus on the N.W. coast, Russian Possessions; 1 petticoat of the Chinook Indian Women—Columbia River"**
*Donor:* "William Cushing, Esq."
*Provenance:* "Catalog of Articles in the Newburyport Marine Societie's Museum" and CHMM accession book and card.
*Current Status:*
  A. *Two dresses made from the entrails of the walrus:* At least one of these kamleikas received the number "1.297.1975" in the transfer of artifacts from the HSON to the CHMM. The other is probably 1.321.1975, though the connection to William Cushing is not specified.
  B. *Petticoat of the Chinook Indian women:* This was probably made of cedar bark, and it unfortunately does not survive.
*Notes:* With reference to the "Columbia River Petticoat," Cushing wrote in his journal; "The women sometimes use a gown but most commonly a shirt or blanket, with a nondescript sort of garment made of the bark of trees or grass twisted & knotted at the ends—this answers the double purpose of petticoat & bustle, being tied around just above the hips & extending down to the knees."[96] While he must have collected the Chinook item himself, Cushing did not go to Alaska, and consequently probably received the Aleut kamleikas from the Hudson's Bay Company traders. The reference to the "Russian Possessions" indicates that Cushing knew their origin.

**239. "2 Indian warclubs; 1 Indian bow and arrow; 3 fish hooks, one line, 2 Indian fans; 1 neck ornament; 1 string wampum; . . . 1 piece of platted line, 7–12 fathoms long, made by Indians; 1 Indian mat, worn by women"**
*Donor:* "William P. Creasy."
*Provenance:* "Catalog of Articles in the Newburyport Marine Societie's Museum" and CHMM accession book and card.
*Current Status:* It cannot be known for sure how many of the artifacts described here originated on the Northwest Coast. A halibut hook entered the CHMM records as 1975.1.260, and is described as "brought back by Capt. Phillip Creasey." Neither Phillip nor William P. Creasy (or Creasey) has been located on a Northwest Coast voyage.

**240. "1 War Club from the N.W. Coast; 1 bird spear from the N.W. Coast."**
*Donor:* "Captain Frank Tilton."
*Provenance:* "Catalog of Articles in the Newburyport Marine Societie's Museum."
*Current Status:* Unknown.

**241. "Native Sword from Columbia River (made of shark's teeth & c.)"**
*Donor:* "J. J. Johnson."
*Provenance:* "Catalog of Articles in the Newburyport Marine Societie's Museum."
*Current Status:* Unknown.
*Notes:* The Columbia River attribution here is almost certainly in error, and this shark's-tooth-edged sword was probably a Gilbert Islands *kiribati*.

# NOTES

*General Note on the Text:* Within quotations extracted from shipboard sources, idiosyncratic spelling and capitalization have been preserved.

### Introduction

1. Viola, *After Columbus,* 89.

2. Kaeppler, *Cook Voyage Artifacts,* and *"Artificial Curiosities."*

3. King, *Artificial Curiosities.*

4. Vaughan and Holm, *Soft Gold.*

5. Wyatt, *Shapes of Their Thoughts.*

6. Cole, *Captured Heritage,* 6. By "Maritime Museum" Cole means the Peabody Essex Museum, formerly the East India Marine Society.

7. Kaeppler, "U.S. Exploring Expedition," 143.

8. Suttles, ed., *Handbook of North American Indians,* Vol. 7, *Northwest Coast.*

9. Lohse and Sundt, "History of Research," 88.

10. See number 210 on page 133 in Part II for details.

## PART I

### Chapter One

1. Kaplanoff, ed., *Brigantine* Hope, 152–153.

2. The log of the *Margaret* survives only in several reproduction copies. For a full accounting of this document, see the description of *Margaret* manuscripts in Malloy, *"Boston Men,"* 129–130. See also Howay,

"Ship *Margaret,"* 34–40. Ingraham's quote is on page 234 of his published *Journal of the Brigantine* Hope, edited by Mark Kaplanoff.

3. There is, of course, the occasional exception. Ebenezer Johnson said (in *Short Account,* 17) that the natives of Norfolk Sound "are very much alike in their manners, they speak a number of languages; they are a hardy robust set of people, about a middle size, resembling our Indian very much, of a tawny complexion."

4. The *Margaret* log, which survives in reproductions only, was consulted at the Massachusetts Historical Society.

5. Haswell's "First Log," in Howay, ed., *Voyages of the* Columbia, 37. Another man from the same place was on board the *Hope,* under Ingraham. He ran away in the Queen Charlotte Islands and was returned to the ship by the Indians. See Kaplanoff, ed., *Brigantine* Hope, 109.

6. Because few official crew lists survive from this trade, it is difficult to accurately determine the racial composition of the crew, but other New England maritime trades at this time consistently had about 20 percent of the berths filled by African-Americans. See Malloy, *African Americans.*

7. Kaplanoff, ed., *Brigantine* Hope, xiii.

8. Journal of John Walters, "Boswain on board the Brig *Pedlar* Capt John Meek on voiage to the North West coast of amarica and round the world," in the collection of the Dauphin County Historical Society, Harrisburg, Pennsylvania.

9. Hayes, ed., *Log of the Union,* xxvi.

10. Howay, ed., *Voyages of the* Columbia, 87–88. In his footnote to this passage, editor Frederick Howay is no more accepting, referring to the labret as "that hideous adornment" (87, n. 3). The location of this entry is unclear; Howay speculates Milbanke Sound.

11. Ibid., 372. Boit has also correctly identified cedar bark, from which traditional garments were made.

12. Ibid., 205.

13. Kaplanoff, ed., *Brigantine* Hope, 101.

14. The *Margaret* log, consulted at the Massachusetts Historical Society.

15. Malloy, ed., *"Most Remarkable Enterprise,"* 36. The manuscript for this, the second of four lectures on Northwest Coast topics by William Sturgis (1848), is at the Massachusetts Historical Society. The lectures were published in Malloy, ed., *"Most Remarkable Enterprise."*

16. Howay, ed., *Voyages of the* Columbia, 373.

17. Kaplanoff, ed., *Brigantine* Hope, 150.

18. Dixon, *Voyage Round the World,* 171–172.

19. Green, *Journal of a Tour,* 42.

20. Separated from female society for long periods of time, sailors often indulged in unrealistic, even adolescent, notions about women anyway. This topic has been explored at some length in Malloy, "Sailor's Fantasy," 34–43.

21. Howay, ed., *Voyages of the* Columbia, 208.

22. Kaplanoff, ed., *Brigantine* Hope, 132–133.

23. Green, *Journal of a Tour,* 44–45.

24. Bancroft, *History of the Northwest Coast,* 1:367n. Bancroft refers to "one American captain of 1825" who "tells us that native women were regularly admitted to the ships to sleep with the crew," but he gives no source and the reference has not been otherwise located.

25. Bartlett, "Life of John Bartlett," 298.

26. Walters journal for 2 March 1821.

27. Green, *Journal of a Tour,* 68.

28. Kaplanoff, ed., *Brigantine* Hope, 132–133.

29. For a full description of these masks see King, *Portrait Masks,* 20–21, 46–47, 50–53, 56–58.

30. For details on these two masks, see numbers 46 and 184 on pages 73 and 122 in Part II.

31. Sturgis's second lecture, 1848, quoted in Malloy, ed., *"Most Remarkable Enterprise,"* 35.

32. Vaughan and Holm, *Soft Gold,* 97.

33. This migration was noted by Americans because it affected the pattern of their trade. For instance, Captain Joseph Ingraham of the *Hope* noted on 6 July 1792 at Cunneyah that he had encountered one of his "old friends whose name was Goi. This man informed me Cow, a chief of whom I made frequent mention when in this port last season, was not dead as Cunneyah informed me but that he had withdrawn his tribe from Cunneyah's and lived on the main at a place they called Kywannee." See Kaplanoff, ed., *Brigantine* Hope, 196.

34. These villages are referred to by many variant spellings in American shipboard records. For details see the gazetteer in Malloy, *"Boston Men."*

35. [Cross], "Brig *Rob Roy,*" entry for 5 March 1822.

36. Malloy, ed., *"Most Remarkable Enterprise,"* 35.

37. While these carvings often incorporate totemic images, especially the crests of individuals or families, they just as often tell stories with no specific "totemic" significance. Nonetheless, as Hilary Stewart says, "many years of common usage and the want of a better word have made it acceptable" (Stewart, *Totem Poles,* 12).

38. George Dixon, quoted in Stewart, *Totem Poles,* 19.

39. Beaglehole, ed., *Journals of Captain James Cook,* 319–320. This possibly refers to the carved wooden figures currently at the British Museum; see King, *Artificial Curiosities,* 75.

40. Howay, ed., *Voyages of the* Columbia, 105.

41. Ibid., 69.

42. Ibid., 391.

43. Kaplanoff, ed., *Brigantine* Hope, 103.

44. Howay, ed., *Voyages of the* Columbia, 234.

45. Bartlett, "Life of John Bartlett," 306.

46. Magee, "Journal of the *Jefferson.*"

47. Howay, ed., *Voyages of the* Columbia, 237.

48. Haskins, "Journal of the *Atahualpa.*"

49. Kemp, "Log of the Brig *Otter.*"

50. Green, *Journal of a Tour,* 84.

51. Ibid., 43–44 and 46.

52. [Cross], "Brig *Rob Roy,*" entry for 5 March 1822.

53. Howay, ed., *Voyages of the* Columbia, 65.

54. Green, *Journal of a Tour,* 66. Samuel Burling on the *Eliza* in 1799 also thought that the images on poles were portraits of specific individuals. At Kaigani he said that he "rose at day light, and having taken a sketch of the two houses to save the length of description, and seen two images that were at a short distance from them which Altatsee told me were intended to represent two Chiefs that were his relations (or rather they were his ancestors for they looked as if they were upwards of a hundred years of age) that had been killed in battle." (Jackman, ed., *William Sturgis,* 56.) Unfortunately, Burling's original journal does not survive, and the sketches he describes here can no longer be located.

55. Green, *Journal of a Tour,* 29, 31.

56. Letter from William Sturgis, *Boston Daily Advertiser,* 20 February 1822.

57. Jonaitis, *Art of the Northern Tlingit,* 90–93. Jonaitis gives a complete discussion of the place of land otters in Tlingit cosmology.

58. Martin, *Keepers of the Game.* Martin's thesis, while interestingly posed, breaks down when the Cree declare war on the beaver (p. 107), and what had been a novel ethnological reading becomes bogged down in anachronistic ecological ideology. His claim

that the thesis can be used to interpret the fur trade in other parts of the continent has been refuted in Shepard Krech III, ed., *Indians, Animals, and the Fur Trade.*

59. "Extracts by Henry Meigs from John Jacob Astor's Agent's Journal Kept at Astoria," a document in the Meigs collection at the New York Historical Society.

60. Howay, ed., *Voyages of the* Columbia, 65.

61. Green, *Journal of a Tour,* 46.

62. Ibid., 66.

63. Howay, ed., *Voyages of the* Columbia, 64–65.

64. [Cross], "Brig *Rob Roy,*" entry for 5 March 1822.

65. Kaplanoff, ed., *Brigantine* Hope, 153, 156.

66. Howay, ed., *Voyages of the* Columbia, 66.

67. Boas, *Religion of the Kwakiutl Indians,* 57–174.

68. Boas, "Social Organization" 427–443; See also the brief description in Holm, "Kwakiutl: Winter Ceremonies," 378–384.

69. Green, *Journal of a Tour,* 48.

70. Ibid., 49 n.

71. Ibid.

72. Sturgis, "Ship *Levant.*"

73. Coues, ed., *Greater Northwest,* 828.

74. Mackenzie, *Voyages from Montreal,* 335.

75. Cook, *Voyage to the Pacific Ocean,* 3:327.

76. See discussion of Chinookan carving in Holm, "Art," 622–623.

77. Irving, *Astoria,* 387–388.

78. Green, *Journal of a Tour,* 39.

79. Cushing, "Brig *Chenamus.*"

80. Sturgis's third lecture, 1850, quoted in Malloy, ed., *"Most Remarkable Enterprise,"* 67–69 and 62.

81. See, for example, the discussion of Marius Barbeau's theory of the relationship between Haida argillite carving and the scrimshaw of American whalemen in number 148 on page 113 in Part II.

82. Pagden, *European Encounters,* 186.

83. This era of collecting is very completely documented in Cole, *Captured Heritage.*

*Chapter Two*

1. For a discussion of these institutions, see Whitehill, "Early Learned Societies." Collections at several of these institutions are described in Bell, et. al., *A Cabinet of Curiosities.* For a discussion of the place of these institutions in the development of American intellectualism, see Greene, *Age of Jefferson.*

2. American Antiquarian Society, *Archoeologia Americana,* 31.

3. Quoted in Whitehill, *East India Marine Society,* 19.

4. See Schoff, trans., *The Periplus of Hanno.*

5. For a full discussion, see Malloy, "Sailors' Souvenirs," 93–103.

6. Pagden, *European Encounters,* 33.

7. An excellent example of this can be seen in the cabinet of the Dutch Professor Ole Worm of Leiden, illustrated in *Museum Wormianum* (Leiden, 1655). Worm describes his "Typological Academy," which was flourishing in 1655. In an engraving of the cabinet, botanical, zoological, mineralogical, and ethnological specimens abound, including numerous examples of Eastern Arctic clothing, masks, weapons, paddles, and a kayak.

8. From a manuscript "Inventario de las Prendas combalachades con los Yndios descubiertos a la altura de 55 grados y 49 minutos por los individuos de la Fragata Santiago destinada a explorar la costa septentrional de Californias que se remiten a S.M. por el virrey de Nueva España," dated "Mexico, December 17, 1774." Quoted in Cutter, *California Coast,* 278. Some of these objects survive in the Museo de America in Madrid. Several object types are recognizable from the description. The crew of the *Santiago* must have been familiar with sennit and mistook cedar bark for "coconut burlap"; the hat described as in the "Chinese Style," is a whaler's hat from Nootka Sound.

9. Cook, *Voyage to the Pacific Ocean,* 2:267.

10. Ibid., 270.

11. Ibid., 278.

12. Ibid., 279.

13. Ibid., 530.

14. Adrienne Kaeppler has identified 91 artifacts collected at Nootka Sound and an additional 29 objects collected elsewhere along the Northwest Coast that can be traced to Cook's third voyage. These include numerous articles of clothing and hats as well as weapons, masks, bowls, and carvings. For a complete description see Kaeppler's *"Artificial Curiosities."* For those now in the British Museum, see King, *Artificial Curiosities.* For a description of the Leverian Museum, see Force and Force, *Leverian Museum.*

15. Banks, then one of the most influential scientists in England, had been on Cook's first voyage, making a large collection of specimens and supervising the naming of new botanical species. It was his plan to accompany Cook on the second voyage as well, but Banks made demands that Cook found excessive and he remained at home. After that, Banks depended on others to make his collections in the Pacific.

16. Dixon, 1789, p. 208. Engravings of this labret and other artifacts collected on Dixon's voyage appear as illustrations in his journal, along with a portrait of a labret-wearing "Young Woman of Queen Charlotte's Island."

17. For details on the Vancouver collection, see King, "Vancouver's Ethnography" and Gunther, ed., *Indian Life, appendix 1.* For information on Spanish collections, see Cabello, *El Ojo Del Totem.* Regarding the collection of the Russian-American Company, see Zolotarevskaja, Blomkvist, and Zibert, "Ethnographical Material," 221–231; and Lohse and Sundt, "History of Research," 88–89.

18. Howay, ed., *Voyages of the* Columbia, 33, 41, 72.

19. The first reference to the formation of the East India Marine Society "Cabinet" is in Bentley, *Diary of William Bentley,* 2:321. Bentley's personal cabinet was extensive—certainly the largest in private hands at the time—and included an astonishing array of plants, seeds, animal mounts and skins, coins, shells, relics, tools, and ethnographic specimens. He had a cane carved from wood from Cook's *Resolution,* and among his extensive network of collectors were the Northwest Coast captains Johnson Briggs and Daniel Bacon. Bentley's cabinet records are in the collection of the American Antiquarian Society, Worcester.

20. Bentley, *Diary of William Bentley,* 174. Bentley refers here to the ship *Columbia,* not the Columbia River, which was named after that vessel on Gray's second voyage in 1792. Bentley apparently did not know that John Kendrick and Robert Gray had traded commands on the Northwest Coast, and that Kendrick arrived in China in the *Washington,* not the *Columbia.*

21. Kaplanoff, ed., *Brigantine* Hope, 156–158.

22. Ibid., 154–155.

23. Sturgis's voyages were as a green hand on the *Eliza,* 1798–1800 (on the Northwest Coast he transferred to the *Ulysses* as a mate), as mate and later captain on the *Caroline,* 1800–1803, again as captain on the *Caroline,* 1803–1806, and as captain of the *Atahualpa,* 1806–1808. With his partner, John Bryant, he owned or operated the *Ann, Becket, Cordelia, Griffin, Lascar, Llama, Mentor, Rob Roy,* and *Volunteer* on voyages to the Northwest Coast between 1818 and 1825.

24. Sturgis's second lecture, 1848, quoted in Malloy, ed., *"Most Remarkable Enterprise,"* 38, 39.

25. "Extracts by Henry Meigs from John Jacob Astor's Agent's Journal Kept at Astoria," a document in the Meigs collection at the New York Historical Society.

26. Massachusetts Historical Society, *Proceedings,* vol. 1, entry for Nov. 1795.

27. Roderic McKenzie's name is spelled variously in the records as Roderic or Roderick and MacKenzie, Mackenzie, and McKenzie. I have chosen the spelling used to sign the letter by which he made his gift to the Antiquarian Society. For details on his gift, see the American Antiquarian Society entry in Part II on pages 115–116.

28. American Antiquarian Society, *Archoeologia Americana,* 1.

29. Corney, *Early Voyages,* 149.

30. Vancouver, *Voyage of Discovery,* 2:132.

31. Corney, *Early Voyages,* 172.

32. Ibid., 140.

33. Ibid., 164–165.

34. Kaplanoff, ed., *Brigantine* Hope, 205.

35. Massachusetts Historical Society, *Proceedings,* vol. 1, entry for 28 Oct. 1794.

36. East India Marine Society, "Catalogue" (1831), 74.

37. Haskins "Journal of the *Atahualpa,*" 29 May 1802.

38. Ibid., 23 October 1801.

39. Magee, "Journal of the *Jefferson,*" 2 January 1794.

40. Howay, ed., *Voyages of the Columbia,* 260.

41. Jackman, ed., *William Sturgis,* 34. (Jackman erred in attributing this journal to William Sturgis. For a full discussion of this attribution, see Malloy *"Boston Men,"* 98–100.)

42. Quoted in Ronda, *Lewis and Clark,* 199. This hat was given to the Peale Museum in Philadelphia and was later transferred to the Peabody Museum of Harvard. See numbers 211 and 212 on page 133 in Part II for details.

43. Lewis and Clark were particularly interested in this information as they hoped to make a connection with one of the vessels. They had been instructed by Thomas Jefferson to "send two of your trusty people back by sea . . . with a copy of your notes; and should you be of opinion that the return of your party by the way they went will be eminently dangerous, then ship the whole, & return by sea, by the way either of cape Horn, or the cape of good Hope, as you shall be able." (Jackson, ed., *Letters,* 65.] Though Lewis and Clark never made contact with any of the American vessels then on the coast, they left a letter to be delivered by the Chinook, which was received by Captain Samuel Hill of the Boston brig *Lydia* on 15 July 1806.

The *Lydia* had only recently rescued John Jewitt and John Thompson from their captivity at Nootka Sound, where they had been held by Maquinna after the capture and destruction of their ship, *Boston,* in 1803. Jewitt described seeing medals left by Lewis and Clark in his *Adventures and Sufferings:* "We proceeded about ten miles up the river, to a small Indian village, where we heard from the inhabitants, that Captains Clark and Lewis, from the United States of America, had been there about a fortnight before, on their journey overland, and had left several medals with them, which they showed us" (Stewart, ed., 174).

Thompson's journal includes a description of receiving the explorers' note: "at 4 PM the skipper & his Lady went on Shore to pay the Chief a visit. the Natives returned a paper on board that Capt. Clark Had left with them declaring them citizens of America they tell us he Left them in April he says the Natives here have treated him verry Civil on his travels through." (Thompson and Walker, *Log of the* Lydia, entry for 15 July 1806.)

44. Quoted in Ronda, *Lewis and Clark,* 199.

45. See, for instance, Thwaites, ed., *Original Journals,* 3:294, 296, 360; 4:23, 94–95; Bergon, ed., *Journals,* 306, 353; and Ronda, *Lewis and Clark,* 191, 199–200. Sadly, none of the Chinook-made hats collected by the Lewis and Clark expedition can be identified today. The basketry hats now at the Peabody Museum at Harvard that are associated with the expedition were all made further north on the coast. See numbers 211, 212, 213, 215, and 216 on pages 133–134 in Part II for details.

46. The hats described here are probably among those given to the Peale Museum by Lewis and Clark and later transferred to the Peabody Museum at Harvard. For details on a basketry "sailor hat" see number 215 on page 134 in Part II; for similar information on a basketry "top hat," see number 216 on page 134 in Part II.

47. "Bill Of Lading Of 10 Canoes From Fort George, Apr. 4th. 1814" in Coues, ed., *Greater Northwest,* 2:876.

48. Merk, *Simpson's Journal,* 171.

49. This is possibly the same individual referred to as "Cow" and "Keow" in other journals, "the principal Chief of Kigarnee." William Sturgis, who had known him some twenty years earlier, referred to him as "upon the whole the most intelligent Indian I met with. He was a shrewd observer—of keen perception— with a comprehensive and discriminating mind, and insatiable curiosity. He would occasionally pass several days at a time on board my ship, and I have often sat up half the night with him, answering questions and listening to his remarks" (Sturgis's Second Lecture, 1848, quoted in Malloy, ed., *"Most Remarkable Enterprise,"* 45). As Sturgis was an owner of the *Rob Roy,* he may have encouraged Captain Cross to do the same.

50. [Cross], "Brig *Rob Roy.*"

51. MacNair, ed., "Log of the *Caroline,*" 169.

52. For a more complete description of Bradshaw's donation to the East India Marine Society, see number 67 on page 86 of Part II.

53. Ogden, *Sea Otter Trade,* 57.

54. Black, *Aleut Art,* 157.

55. East India Marine Society, "Catalogue" (1821), 77.

56. East India Marine Society, "Catalogue" (1831), 93.

57. Ibid., 174

58. Kaplanoff, ed., *Brigantine* Hope, 131.

59. Dixon, *Voyage Round the World,* 189.

60. The acquisition, commodification, and collection of this object is well described in Kaplan and Barsness, *Raven's Journey,* 78–90.

61. Hudson, "Schooner *Tamana,*" 5 July 1806; this manuscript, and another of the same voyage, are in the collection of the Huntington Library, San Marino, California.

62. Dana, *Two Years Before the Mast,* 297–299. These California encounters were not always peaceful. During the time Dana was on the coast, two Boston brigs, the *Convoy* and the *Griffin,* both encountered trouble with the Northwest Coast Indian crews of other vessels. According to the American trader George Nidever, the "Northwesterner was aggressive, would fight fiercely for the full possession of his hunting grounds, and would strip the seas of all the otters in his path" (from George Nidever, "Life and Adventures," a manuscript in the collection of the Bancroft Library, University of California at Berkeley, quoted in Ogden, *Sea Otter Trade,* 124–125.) According to Ogden, "A real battle occurred on Santa Rosa Island in 1836 between Northwest Indians and hunters of Nidever's party."

63. Howay, ed., *Voyages of the* Columbia, 225.

64. Swift commanded three voyages of the *Hazard* in 1796–1799, 1799–1802, and 1803–1805 and a single voyage of the *Derby,* 1806–1809.

65. This pipe "presented by Samuel Brazer Esq. of Worcester" is first acknowledged in AAS MS, "Donors and Donations," 19.

66. East India Marine Society, "Catalogue" (1831), 177.

67. Green, *Journal of a Tour,* 44.

68. Ibid., 86.

69. Jewitt, *Nootka Sound* and *Adventures and Sufferings.*

70. Jewitt, *Adventures and Sufferings,* 46.

71. Ibid., 50.

72. See, for instance Jewitt, *Nootka Sound,* 12.

73. East India Marine Society, "Catalogue" (1831), 178. Another dagger, given at the same time, is described as "a dagger used by the natives of the N.W. coast. The copper came from Cook's Inlet." Osgood does not appear to have traveled to the Northwest

Coast or Alaska, but Meek was a regular there, especially in Russian territories, such as Cook Inlet. It seems likely that Osgood was once again the courier for his friend's donation. (By the 1831 catalog of the EIMS, Meek was no longer associated with other artifacts brought in his name by Osgood.) See especially numbers 58 and 59 on pages 76 and 85 in Part II.

74. The Richardson contribution, donated in 1807 and described in the 1821 East India Marine Society catalogue as an "iron dagger, used by the natives on the N.W. coast of America" has been attributed in museum folklore to Jewitt as well. It is, in any case, an extremely early iron dagger of Euro-American manufacture. See number 25 on page 68 in Part II.

75. Massachusetts Historical Society, *Proceedings,* vol. 1, entry for 27 January 1801.

76. For a more complete account of this event and its aftermath, see the description of these scalps in number 90 on page 99 of Part II.

77. Sturgis's second lecture, 1848, quoted in Malloy, ed., *"Most Remarkable Enterprise,"* 47.

78. Bartlett, "Life of John Bartlett," 297.

79. Quoted in Bean, "Visions of India," 3.

80. Hawthorne, "Virtuoso's Collection," 196.

81. Quoted in Whitehill, *East India Marine Society,* 49.

82. Quoted in Cole, *Captured Heritage,* 111.

83. Bean, "Visions of India," 1.

84. Ibid., 13–14.

85. Todorov, Conquest of America, 14–50.

86. Greenblatt, *Marvelous Possessions,* 11–12.

87. Though this argument might be relevant in some colonial relationships and in some of the later collecting of Native American artifacts in the United States and Canada. The confiscation of important religious symbols or emblems of rank and status could potentially allow a colonial power to symbolically gain the authority associated with the objects.

88. Letter from Ebenezer Davis to Peabody Museum of Archaeology and Ethnology, dated 9 June 1869, in the collection of the Peabody Museum at Harvard.

## PART II

1. *East India Marine Society,* "Catalogue" (1821), 3.

2. Ibid., 4.

3. Manuscript, "The Committee Appointed at a Late Meeting of the Society to Procure a New Catalogue of the Articles in the Museum—Beg Leave to Report. Salem East India Marine Hall, July 5th 1820," Peabody Essex Museum collection.

4. Ibid.

5. Ibid.

6. *East India Marine Society,* "Catalogue" (1821), 30.

7. Manuscript, "Report of Stephen White, Abijah Northey and N. Rogers, Salem, January 7, 1824," Peabody Essex Museum collection.

8. Ibid.

9. Richards and Malloy, "United States Trade," 11.

10. Bartlett, "Life of John Bartlett," 287–343; the manuscript that includes Bartlett's voyage on both the *Massachusetts* and the *Gustavus III* is at the Peabody Essex Museum.

11. Swan, *Northwest Coast,* 423–424. Information about the *Hetty* is difficult to pull out of the available records, and it and one or two other Philadelphia vessels, the *Kitty* and the *Arctic,* are easily confused. For a complete discussion of Captain Briggs and his vessel, see Malloy, *"Boston Men,"* 73.

12. Though the number 26 does not appear in the earliest manuscript catalogue of the East India Marine Society, that number does appear on an old tag on a canoe model, and such a model is listed without a number in the catalogue; the model also has the number 605 painted on it.

13. See note number ten for information on the publication of Bartlett's journal; the crew list of the *Nautilus* is included in Roe, *Captain Charles Bishop,* 307.

14. Howay, ed., *Voyages of the* Columbia, 150.

15. Barbour, *Naturalist's Scrapbook,* 207; see also Whitehill, *East India Marine Society,* 110–131.

16. For additional discussion on this manuscript, see Macnair, Joseph, and Grenville, *Shimmering Sky,* 66–67.

17. See Malloy "Souvenirs of the Fur Trade," 30–35, 74.

18. A copper is a shield-shaped piece of beaten copper, decorated with a crest design, representing the wealth distributed at a potlatch. Each copper had its own name and gained in value each time it was exchanged, thereby representing enormous prestige to the person who could dispose of it.

19. Black, *Aleut Art,* pl. XX.

20. Wyatt, *Shapes of Their Thoughts,* 43.

21. Massachusetts Historical Society, *Proceedings,* vol. 1:x, xi.

22. Ibid., vol. 1:xii.

23. Ibid., vol. 1:xi. John Pintard, who hoped to see several related societies established throughout the country, became a Corresponding Member and founded the New York Historical Society in his own city.

24. The *Third Annual Report of the Trustees of the Peabody Museum of American Archaeology and Ethnology* (1870) notes the agreement made between the two institutions on 10 January 1867 and the completion of the transfer of the collection in April.

25. Massachusetts Historical Society, *Proceedings,* vol. 1:148.

26. Ibid., vol. 1:194.

27. Ibid., vol. 1:222.

28. From the diary of William Bentley, quoted in Tucker, *Massachusetts Historical Society,* 39. Turell later donated a few Northwest Coast artifacts that may have originated at the MHS to the Deerfield Academy Museum. See number 107 for a description.

29. *First Annual Report of the Peabody Museum of American Archaeology and Ethnology* (1868).

30. This is the system that was used for all of the PMH collections. From 1867 to 1932, as each individual item came into the collection it was given a sequential catalogue number. In 1932 the museum began to designate each group of objects that had been given at the same time with an accession number that indicated the year the collection was acquired and a sequential number to differentiate the group from other accessions of that year. Another number was added to identify the geographical region from which the artifact came. The number "10," indicating North America, can be found as the third component in all of the Peabody Harvard collections from the Northwest Coast.

31. Howay, ed., *Voyages of the* Columbia, 149, 452, 455, 463.

32. The accession card for 29-16 (material exchanged with the Museum of the American Indian/Heye Foundation in New York, 1929) indicates that one of the three hats numbered 67-10-10/268 was traded away at that time.

33. A card in the accession file at the PMH indicates that it was hat number 67-10-10/268c that was traded to Denver (although that is the same number used in the AMNH exchange; see note 34 below). At any rate, it seems clear that three of the five hats numbered 67-10-10/268 were traded away from the collection, and they could well have been the three collected by Magee.

34. The last mentioned, with the Magee attribution, now bears the AMNH number 16/795 and is identified as being formerly number 268c at the PMH. It is illustrated in Jonaitis, *Land of the Totem Poles*, 29.

35. Vaughan and Holm, *Soft Gold*, 75.

36. Bill Holm says that "A.S." is probably Alan R. Sawyer (private communication, August 1999).

37. Bentley, *Diary of William Bentley*, 174. Bentley refers here to the ship *Columbia*, not the Columbia River, which was named after the vessel in 1792. Bentley apparently did not know that John Kendrick and Robert Gray had traded commands on the Northwest Coast and that Kendrick arrived in China in the *Lady Washington*, not the *Columbia*.

38. Ibid. In Bentley's manuscript catalogue list, in the collection of the American Antiquarian Society, this mysterious item is further described as "3 ft. 8 in. long. Weight 4 1/2 lbs. Shaft 5 inches in circumference. Handle with figures. Club—knobs lengthways measuring on their circumference 12 inches. 1808."

39. Sturgis's second lecture, 1848, quoted in Malloy, ed., *"Most Remarkable Enterprise,"* 47.

40. Dorr, "Logbook of the Brig *Hope*."

41. Vaughan and Holm, *Soft Gold*, 75.

42. Bowen, *Pioneer Museum*, 11–12.

43. For a history of the institution and this collection, see Flynt, McGowan, and Miller, *Gathered and Preserved*.

44. See Green, *Journal of a Tour*.

45. Malloy, ed., *"Most Remarkable Enterprise,"* 35

46. Chapin, *Citizens of Old Springfield*, 181.

47. Among the members was Rev. John Eliot, who had given "A Bow, from the Northwest Coast [and] Curious Pipes from different parts of the world" to the MHS in 1802 (see object number 91 on page 99).

48. For a complete history of the formation of the institution, see Boston Athenaeum, *Athenaeum Centenary*.

49. Ibid., 26.

50. Quincy, *History of the Boston Athenaeum*, 28.

51. From a "printed sheet" published when the Tremont Street building opened, quoted in Ibid., 35.

52. Including the vessels *Alexander, Caroline, Derby, Eclipse, Eliza, Globe, Hazard, Hope, Houqua, Levant, Margaret, Nautilus, Pearl,* and *Vancouver*.

53. *First Annual Report of the Trustees of the Peabody Museum of American Archaeology and Ethnology* (1868).

54. White and Lewis, *Captain Josiah Sturgis, of the United States Revenue Service* (Boston, 1844).

55. *Sheet Anchor* (Boston), 18 Jan. 1845, 3:2.

56. Vaughn and Holm, *Soft Gold*, 156. All subsequent comparisons to objects discussed and illustrated in *Soft Gold* include page references but no endnotes.

57. The Canadian anthropologist Marius Barbeau wrote in some detail about a possible connection between Haida argillite carving and the shipboard "scrimshaw" of American whalemen, and "SJG" may have either influenced or been influenced by Barbeau. Barbeau acknowledged that the argillite pipe-carving tradition could be dated to "about 1820" but then erred when he placed Yankee whaleships in the vicinity of the Northwest Coast at that early period, and he presumed more than can be documented when he placed Haida Indians among their crews (even if one corrects the possible date of such an event by adding several decades to the date of the earliest argillite pipes). In fact, the earliest documentable pieces of engraved American scrimshaw are of roughly the same age as the earliest documentable argillite carvings. Prior to 1820, sperm whale teeth were a valuable commodity in the China

trade, often being carried to the Marquesas and other South Pacific islands to be exchanged for sandalwood by the very same ships that then continued on to the Northwest Coast for sea otter pelts. They were simply too valuable as a trade commodity to be distributed to the crew for sailors' scrimshaw; the kind of scrimshaw to which Barbeau refers was, accordingly, a phenomenon that postdated the advent of Haida argillite carving. For Barbeau's theory, see *Haida Myths*, vii–5. For a history of scrimshaw on American whaleships see Frank, "Pictorial Scrimshaw," 509–521. The cargo manifest of the Boston ship *Sultan*, bound for the Northwest Coast and Canton in 1815 and carrying sperm whale teeth among other items, is quoted in the Frank article.

58. American Antiquarian Society, *Archoeologia Americana*, 1.

59. Ibid., 31.

60. American Antiquarian Society, *Address to the Members of the American Antiquarian Society*, 32.

61. For a discussion of the origins of argillite pipes, see Macnair and Hoover, *Magic Leaves;* Wright, "Haida Argillite Ship Pipes" and "Haida Argillite: Carved for Sale"; and Barbeau, *Haida Myths*.

62. *Worcester Fire Society 100 Years* (Worcester, 1870), pp. 19-20.

63. The inscription on the back of this mask is transcribed as "'Jenna' Cass" in the PMH accession records and has often been quoted as such (see, for instance, Cole, *Soft Gold, 2000 years..., Portrait Masks,* etc.), but a close examination in 1993 revealed a faint but unmistakable "y" at the end of the first name.

64. Haskins, "Journal of the *Atahualpa*," various dates.

65. For a reprint of the *Courant* article, see Howay, *Atahualpa*, 2. The *Annual Register* account is quoted in the same publication, page 11, and in Howay, "Trading Voyages."

66. See *Proceedings of the American Antiquarian Society, 1812–1849* (Worcester, 1912), p. 241, note 2.

67. Baker, *Boston Marine Society*, 5. "The Box" was the fund made up of contributions and membership fees.

68. Ibid., 8.

69. Ibid., 123.

70. Among the men who owned or commanded voyages to the Northwest Coast, the following were members of the Boston Marine Society: Daniel Bacon (who served as president of the society from 1837 to 1840), Seth Barker, John Boit, John De Wolfe, Nathaniel Dorr, Crowell Hatch, Robert Haswell, Samuel Hill, Stephen Hills, Joseph Ingraham, John Lambert, James and Bernard Magee, Lemuel Porter, John Salter, William Shaler, Josiah Sturgis, William Sturgis (who was president of the society from 1824 to 1826), John Suter, Benjamin Swift, and Dixey Wildes. For a complete list of members, see Appendix VIII to Baker, *Boston Marine Society*.

71. Thomas Lamb (treasurer of the Boston Marine Society), letter to the Mercantile Library Association, 17 January 1845, quoted in *Report of the Board of Directors of the Mercantile Library Association from the Origin of the Institution in 1820, to Its Incorporation, in 1845* (Boston, 1845), 39–40.

72. Ebenezer Davis (president of the Boston Marine Society), MS letter to Thomas P. Bowie, 9 June 1869, Archives of the Peabody Museum, Harvard.

73. *Third Annual Report of the Trustees of the Peabody Museum of American Archaeology and Ethnology*, 6.

74. See Vancouver's *Voyages* (1801 ed.), vol 5, pp. 134f.

75. For a history of the museum, see Sellers, *Mr. Peale's Museum*.

76. Thwaites, ed., *Original Journals*, 6:279–280.

77. Ibid., 4:94–95.

78. The full list appears in Sellers, *Mr. Peale's Museum*, 314–318. Unfortunately, Peale's actual museum catalogue cannot be located. (Peale's correspondence and other papers are at the American Philosophical Society in Philadelphia, where some letters related to the museum survive.)

79. New England Museum and Gallery of Fine Arts, "Records."

80. McGlinchee, *First Decade*, 28–29. For a description of the theatrical end of the Boston Museum, see Ryan, *Old Boston Museum Days*. McGlinchee gives the date 1803 for the founding of the Columbian Museum, but a famous broadside advertising a live elephant, newly arrived in Boston and on exhibit through the efforts of Mr. Bowen, is dated 18 August 1797 and printed "by D. Bowen, at the COLUMBIAN MUSEUM PRESS." The broadside warns that "the Elephant having destroyed many papers of consequence, it is recommended to visitors not to come near him with such papers" (collection of Robert M. Frank).

81. Boston Museum, *Catalogue* (1844).

82. Undated broadside (ca. 1847), Boston Public Library.

83. Boston Museum, *Catalogue* (1847), 35.

84. McGlinchee, *First Decade*, 57.

85. For a complete description of this acquisition, see Watson, Dorhout, and Rogers, "Pacific Collections," 57–68.

86. Roe, ed., *Captain Charles Bishop*, 121.

87. Ibid.

88. Ibid., 139.

89. For Lewis's and Clark's descriptions, see Thwaites, *Original Journals*, 3:294, 296, 360; 4:23, 94–95.

90. Lewis and Clark noted the popularity among the Chinook of "sailor jackets, overalls, shirts and hats independent of their usual dress." The Chinook had at that time a "considerable quantity of sailor's cloaths, as hats coats, trousers and shirts." Bergon, ed., *Journals*, 313, 346.

91. Thwaites, ed., *Original Journals*, 3:359–60.

92. Malloy, ed., *"Most Remarkable Enterprise,"* 35.

93. This was mentioned in a letter from Thomas H. Perkins to his children and is quoted in Briggs, *History and Genealogy*, 467.

94. See Bayley and Jones, comps., *Marine Society of Newburyport*.

95. Cushing, "Brig *Chenamus*."

96. Ibid.

# BIBLIOGRAPHY

*Note:* For a complete list of American vessels engaged in the sea otter pelt trade on the Northwest Coast and of manuscript material related to them, see Mary Malloy, *"Boston Men" on the Northwest Coast: The American Maritime Fur Trade, 1788–1844.*

American Antiquarian Society. *Archoeologia Americana: Transactions and Collections of the American Antiquarian Society.* Worcester, Mass.: American Antiquarian Society, 1820.

———. "Donors and Donations to the American Antiquarian Society." MS and Typescript.

———. *Address to the Members of the American Antiquarian Society; Together with the Laws and Regulations of the Institution, and a List of Donations to the Society since the Last Publication.* Worcester, Mass.: American Antiquarian Society, 1819.

Anonymous. "Journal of a Voyage Round the World in the Brig *Rob Roy.*" MS. Peter Foulger Library, Nantucket Historical Association.

Baker, William A. *A History of the Boston Marine Society, 1742–1981.* Boston: Boston Marine Society, 1982.

Bancroft, Hubert Howe. *History of the Northwest Coast.* 2 vols. San Francisco: The History Co., 1886.

Barbeau, Marius. *Haida Myths Illustrated in Argillite Carvings.* Ottawa: National Museum of Canada, 1953.

Barbour, Thomas. *A Naturalist's Scrapbook.* Cambridge: Harvard University Press, 1946.

Bartlett, John. "A Narrative of Events in the Life of John Bartlett of Boston, Massachusetts, in the Years 1790–1793, During Voyages to Canton and the Northwest Coast of North America." In *The Sea, the Ship and the Sailor: Tales of Adventure from Log Books and Original Narratives.* Salem, Mass.: Marine Research Society, 1925.

Barton, Benjamin Smith. *New Views of the Origin of the Tribes and Nations of America.* Philadelphia, 1797.

Bayley, Captain William H., and Captain Oliver O. Jones, comps. *History of the Marine Society of Newburyport, Massachusetts.* Newburyport: Marine Society, 1906.

Beaglehole, John C., ed., *The Journals of Captain James Cook on His Voyages of Discovery.* Cambridge, England: Hakluyt Society, 1967.

Bean, Susan. "Visions of India: Curiosities at the Salem East India Marine Society's Museum, 1799–1867." Paper presented at American Ethnological Society and the Council for Museum Anthropology Annual Meeting, Santa Fe, N.M., April 1993.

Bell, Whitfield J., Jr., et al. *A Cabinet of Curiosities: Five Episodes in the Evolution of American Museums.* Charlottesville: University Press of Virginia, 1967.

Bentley, William. *The Diary of William Bentley, D.D., Pastor of the East Church, Salem, Massachusetts.* Salem, Mass.: The Essex Institute, 1905–1914.

Bergon, Frank, ed. *The Journals of Lewis and Clark.* New York: Penguin Books, 1989.

Black, Lydia T. *Aleut Art: Unangam Aguqaadangin.* Anchorage: Aleutian/Pribilof Islands Association, Inc., 1982.

Boas, Franz. *The Religion of the Kwakiutl Indians.* Columbia University Contributions to Anthropology, no. 10. New York: Columbia University Press, 1930.

———. "The Social Organization and the Secret Societies of the Kwakiutl Indians." In *Report of the U.S. National Museum for the Year Ending June 30, 1895,* 311–738. Washington, D.C.: Government Printing Office, 1897.

Boon, James. *Tribes and Scribes: Symbolic Anthropology in the Comparative Study of Cultures, Histories, Religions and Texts.* Cambridge: Cambridge University Press, 1982.

Boston Athenaeum. *The Athenaeum Centenary: The Influence and History of the Boston Athenaeum from 1807 to 1907 with a Record of its Officers and Benefactors and a Complete List of Proprietors.* Boston: Boston Athenaeum, 1907.

Boston Museum. *Catalogue of the Paintings, Marble and Plaster Statuary and Engravings, Comprised in the Collection of the BOSTON MUSEUM and Gallery of Fine Arts, Corner of Tremont and Bromfield Sts.: Together with a Descriptive Sketch of the Institution and Its Collection.* Boston: Tuttle and Dennett, 1844.

———. *Catalogue of the Paintings, Portraits, Marble and Plaster Statuary, Engravings & Water Color Drawings, in the Collection of the BOSTON MUSEUM, Tremont, near Court Street, Boston, Together with a Descriptive Sketch of the Institution and General Summary of the Natural History Specimens, Curiosities, &c.* Boston: Stacy, Richardson, Filmer & Co., 1847.

Bowen, W. Wedgwood. *A Pioneer Museum in the Wilderness.* Hanover, New Hampshire: Dartmouth College Museum, 1958.

Briggs, L. Vernon. *History and Genealogy of the Cabot Family, 1475–1927.* Boston: C. E. Goodspeed and Co., 1927.

Cabello, Paz. *El Ojo Del Totem: Arte Y Cultura de los Indio de Noroeste de America.* Madrid: Ediciones Turner, 1989.

Chapin, Charles Wells. *Sketches of the Old Inhabitants and Other Citizens of Old Springfield.* Springfield, Mass.: Press of Springfield Binding and Printing, 1893.

Cole, Douglas. *Captured Heritage: The Scramble for Northwest Coast Artifacts.* Seattle: University of Washington Press, 1985.

Cook, James. *A Voyage to the Pacific Ocean; Undertaken by the Command of His Majesty, for Making Discoveries in the Northern Hemisphere. . . .* Vol. 3 by James King. London: Published by Order of the Lords Commissioners of the Admiralty, 1784.

Corney, Peter. *Early Voyages in the North Pacific, 1813–1818.* 1821; Reprint Fairfield, Wash.: Ye Galleon Press, 1965.

Coues, Elliot, ed. *New Light on the Early History of the Greater Northwest: The Manuscript Journals of Alexander Henry, Fur Trader of the Northwest Company, and of David Thompson, Official Geographer and Explorer of the Same Company, 1799–1814.* 3 vols. New York: Harper, 1897.

Cox, Ross. *Adventures on the Columbia River.* 1831. Reprint San Francisco, California State Library, 1941.

[Cross, Captain Daniel.] "Journal of a Voyage on the Brig *Rob Roy*" (1821–1825). Manuscript. Peter Foulger Library. Nantucket Historical Association, Nantucket, Massachusetts.

Cushing, William. "Journal Kept Aboard the Brig *Chenamus* of Newburyport" (1843–1846). Manuscript. Western Americana Collection. Beinecke Library, Yale University, New Haven.

Cutter, Donald C. *The California Coast: A Bilingual Edition of Documents from the Sutro Collection.* Norman: University of Oklahoma Press, 1969.

Dana, Richard Henry, Jr. *Two Years Before the Mast: A Personal Narrative of Life at Sea.* New York: Harper & Brothers, 1840. Reprint Penguin Classics, 1986.

Dixon, George. *A Voyage Round the World, but more particularly to the North-West Coast of America: performed in 1785, 1786, 1787, and 1788.* London: Geo. Goulding, 1789.

Dorr, Ebenezer. "Logbook of the Brig *Hope*, Commanded by Joseph Ingraham" (1791–1792). Manuscript. Dorr Collection, Detroit Public Library.

East India Marine Society. "Report of Stephen White, Abijah Northey, and N. Rogers, Salem, January 7, 1824." Manuscript. Peabody Essex Museum, Salem, Mass.

———. "The Committee Appointed at a Late Meeting of the Society to Procure a New Catalogue of the Articles in the Museum—Beg Leave to Report, Salem East India Marine Hall, July 5th 1820." Manuscript. Peabody Essex Museum, Salem, Mass.

———. "Catalogue of the Articles in the Museum." In *The East India Marine Society of Salem*, pp. 30–90. Salem, Mass.: East India Marine Society, 1821.

———. "Catalogue of the Articles in the Museum." In *The East India Marine Society of Salem*, pp. 43–178. Salem, Mass.: East India Marine Society, 1831.

———. Manuscript catalogue of the collection, 1799–1820. Peabody Essex Museum, Salem, Mass.

———. *Supplement to the Catalogue of the Articles in the Museum.* Salem: East India Marine Society, 1837.

Fanning, Edward. *Voyages to the South Seas, Indian and Pacific Oceans, China Sea, North West Coast, Feejee Islands, South Shetlands, &c . . . 1830–1837.* New York, 1838.

Flynt, Suzanne, Susan McGowan, and Amelia F. Miller. *Gathered and Preserved.* Deerfield, Mass.: Pocumtuck Valley Memorial Association, 1991.

Force, Roland W., and Maryanne Force. *Art and Artifacts of the 18th Century: Objects in the Leverian Museum as Painted by Sarah Stone.* Honolulu: Bishop Museum, 1968.

Franchére, Gabriel. *Rélation d'un Voyage à la Côte du Nord-ouest de l'Amérique Septentrionale, dans les Annees 1810–14.* Montreal: Impr. de C. B. Pasteur, 1820.

———. *Adventure at Astoria,* 1810–1814. Hoyt C. Franchére, ed. and trans. Norman: University of Oklahoma Press, 1967.

Frank, Stuart M. "The Origins of Engraved Pictorial Scrimshaw." *The Magazine Antiques* 142(4):509–521.

Green, Jonathan S. *Journal of a Tour on the North West Coast of America in the Year 1829, Containing a Description of a Part of Oregon, California and the Northwest Coast and the Numbers, Manners and Customs of the Native Tribes.* Hearman's Historical Series No. 10. Reprint New York: C. F. Hearman, 1915.

Greenblatt, Stephen. *Marvelous Possessions: The Wonder of the New World.* Chicago: University of Chicago Press, 1991.

Greene, John C. *American Science in the Age of Jefferson.* Ames, Iowa: Iowa State University Press, 1984.

Gunther, Erna. *Indian Life on the Northwest Coast of North America, as Seen by the Early Explorers and Fur Traders During the Last Decades of the Eighteenth Century.* Chicago: University of Chicago Press, 1972.

Haskins, Ralph. "Journal of the *Atahualpa* of Boston" (1800–1802). Manuscript. Western Americana Collection. Beinecke Library, Yale University, New Haven.

Hawthorne, Nathaniel. "A Virtuoso's Collection." *Boston Miscellany of Fashion and Literature* (May 1842).

Hayes, Edmund, ed. *Log of the* Union: *John Boit's Remarkable Voyage to the Northwest Coast and Around the World, 1794–1796.* Portland: Oregon Historical Society, 1981.

Holm, Bill. "Art." In *Handbook of North American Indians,* Vol. 7, *Northwest Coast,* edited by Wayne Suttles, 602–632. Washington: Smithsonian Institution Press, 1990.

———. "Kwakiutl: Winter Ceremonies." In *Handbook of North American Indians,* Vol. 7, *Northwest Coast,* edited by Wayne Suttles, 378–386. Washington: Smithsonian Institution Press, 1990.

Howay, Frederick W. "The Trading Voyages of the *Atahualpa.*" *Washington Historical Quarterly* (January 1928).

———. *The* Atahualpa: *Which Vessel was Attacked by Natives on the Northwest Coast of America in June of 1805.* Fairfield, Wash.: Ye Galleon Press, 1978.

———. "The Ship *Margaret:* Her History and Historian." In *Hawaiian Historical Society 38th Annual Report,* 34-40. Honolulu, 1930.

Howay, Frederick W., ed. *Voyages of the* Columbia. Boston: Massachusetts Historical Society, 1941.

Hudson, John T. "Journal of the Schooner *Tamana*" (1805–1807). Manuscript. Huntington Library. San Marino, California.

Irving, Washington. *Astoria: or Anecdotes of an Enterprise Beyond the Rocky Mountains.* 1836. Reprint Norman: University of Oklahoma Press, 1964.

Jackman, S.W., ed. *The Journal of William Sturgis.* Victoria, B.C.: Sono Nis Press, 1978.

Jackson, Donald, ed. *Letters of the Lewis and Clark Expedition, with Related Documents, 1783–1854 .* Urbana: University of Illinois Press, 1962.

Jewitt, John R. *A Journal Kept at Nootka Sound.* Boston: Printed for the author,1807.

———. *A Narrative of the Adventures and Sufferings of John R. Jewitt.* Middletown, Conn.: Seth Richards, 1815.

Johnson, Ebenezer. *A Short Account of a Northwest Voyage Performed in the Years 1796, 1797, & 1798. 1798.* Reprinted with an introduction by Basil Stuart-Stubbs and edited by M. S. Batts, Vancouver: The Alcuin Society, 1974.

Jonaitis, Aldona. *Art of the Northern Tlingit.* Seattle: University of Washington Press, 1986.

———. *From the Land of the Totem Poles: The Northwest Coast Indian Art Collection of the American Museum of Natural History.* New York: American Museum of Natural History, 1988.

Kaeppler, Adrienne L. "Anthropology and the U.S. Exploring Expedition." In *Magnificent Voyagers: The U.S. Exploring Expedition, 1838–1842,* edited by Herman Viola and Carolyn Margolis. Washington: Smithsonian Institution Press, 1985.

———. *"Artificial Curiosities": Being an Exposition of Native Manufactures Collected on the Three Pacific Voyages of Captain James Cook, R.N.* Bishop Museum Special Publication 65. Honolulu: Bishop Museum Press, 1978.

———. *Cook Voyage Artifacts in Leningrad, Berne and Florence Museums.* Honolulu: Bishop Museum Press, 1978.

Kaplan, Susan A., and Kristin J. Barsness. *Raven's Journey: The World of Alaska's Native People.* Philadelphia: University of Pennsylvania, 1986.

Kaplanoff, Mark D., ed. *Journal of the Brigantine* Hope *on a Voyage to the Northwest Coast of North America, 1790–1792, by Joseph Ingraham.* Barre, Mass.: Imprint Society, 1971.

Kemp, Robert. "Log of the Brig *Otter,* Samuel Hill Master" (1809–1811). Manuscript. Phillips Library. Peabody Essex Museum, Salem, Mass.

King, J. C. H. *Artificial Curiosities from the Northwest Coast of America: Native American Artefacts in the British Museum Collected on the Third Voyage of Captain James Cook and Acquired through Sir Joseph Banks.* London: British Museum Publications, 1981.

———. *Portrait Masks of the Northwest Coast.* New York: Thames and Hudson, 1979.

———. "Vancouver's Ethnography: A Preliminary Description of Five Inventories from the Voyage of 1791–1795." Paper presented at Vancouver Conference on Exploration and Discovery, Simon Fraser University, October 1992.

Krech, Shepard III, ed. *Indians, Animals, and the Fur Trade: A Critique of Keepers of the Game.* Athens: University of Georgia Press, 1981.

Lohse, E. S., and Frances Sundt. "History of Research: Museum Collections." In *Handbook of North American Indians,* Vol. 7, *Northwest Coast,* edited by Wayne Suttles, 88–97. Washington: Smithsonian Institution Press, 1990.

Mackenzie, Alexander, Esq. *Voyages from Montreal . . . through the Continent of North America to the Frozen and Pacific Oceans; in the Years 1789 and 1793. With a Preliminary Account of the Rise, Progress, and Present State of the Fur Trade at that Country.* London: Printed for T. Cadell, Jr., 1801.

MacNair, H. F., ed. "Log of the *Caroline* by Captain Richard J. Cleveland." *The Pacific Northwest Quarterly* 29 (April 1938).

Macnair, Peter, and Alan Hoover. *The Magic Leaves: A History of Haida Argillite Carving.* Victoria: British Columbia Provincial Museum, 1984.

Macnair, Peter, Robert Joseph, and Bruce Grenville. *Down from the Shimmering Sky: Masks of the Northwest Coast.* Vancouver: Douglas & McIntyre, 1998.

Magee, Bernard. "Journal of the *Jefferson,* Josiah Roberts, Captain" (1791–1794). Manuscript. Massachusetts Historical Society, Boston, Mass.

Malloy, Mary. "Sailors' Souvenirs at the East India Marine Hall: 'Gathered with Cost and Pains from Every Clime'," *The Log of Mystic Seaport,* Vol. 37, No. 3 (Fall, 1985), pp. 93-103.

———. "Souvenirs of the Fur Trade, 1799-1832: The Northwest Coast Indian Collection of the Salem East India Marine Society." *American Indian Art Magazine* 11(4):30–35, 74.

———. "The Sailor's Fantasy: Images of Women in the Songs of American Whalemen," *The Log of Mystic Seaport* 49(2): 34-43.

———. *African Americans in the Maritime Trades: A Guide to Resources in New England.* Sharon, Mass.: The Kendall Whaling Museum, 1990.

———. *"Boston Men" on the Northwest Coast: The American Maritime Fur Trade, 1788–1844.* Kingston and Fairbanks: Limestone Press, 1998.

Malloy, Mary, ed., *"A Most Remarkable Enterprise": Lectures on the Northwest Coast Trade and Northwest Coast Indian Life by Captain William Sturgis.* Hyannis, Mass.: Parnassus Imprints, 2000.

"The *Margaret* Log." Reproduction. Massachusetts Historical Society.

Martin, Calvin. *Keepers of the Game: Indian-Animal Relationships and the Fur Trade.* Berkeley: University of California Press, 1978.

Massachusetts Historical Society. "Cabinet Log Book, 1791–1952." MS. Massachusetts Historical Society.

———. *Catalogue of the Cabinet.* Boston, Mass.: 1885.

———. *Proceedings of the Massachusetts Historical Society,* Vol. 1., *1791–1835.* Boston: Massachusetts Historical Society, 1879.

McGlinchee, Claire. *The First Decade of the Boston Museum.* Boston: Bruce Humphries, Inc., 1940.

Meigs, Henry. "Extracts from John Jacob Astor's Agent's Journal Kept at Astoria" (1811–1812). Manuscript. Meigs Collection. New York Historical Society, New York City.

Merk, Frederick, ed. *Fur Trade and Empire: George Simpson's Journal Entitled Remarks Connected with the Fur Trade in the Course of a Voyage from York Factory to Fort George and Back to York Factory, 1824–1825, with Related Documents.* Rev. ed. Cambridge, Mass.: Belknap Press of Harvard University Press, 1968.

New England Museum and Gallery of Fine Arts. "Records of the New England Museum and Gallery of Fine Arts, Incorporated Feb^y 3^rd 1818." MS, Theatre Collection, Houghton Library, Harvard University, Cambridge.

Ogden, Adele. *The California Sea Otter Trade 1784–1848.* University of California Publications in History, vol. 26. Berkeley: University of California Press, 1941.

Pagden, Anthony. *European Encounters with the New World: From Renaissance to Romanticism.* New Haven: Yale University Press, 1993.

Peabody Museum of American Archaeology and Ethnology. *First Annual Report of the Trustees of the Peabody Museum of American Archaeology and Ethnology.* Cambridge, Mass.: 1868.

———. *Third Annual Report of the Trustees of the Peabody Museum of American Archaeology and Ethnology.* Boston: 1870.

Quincy, Josiah. *The History of the Boston Athenaeum, with Biographical Notices of its Deceased Founders.* Cambridge: Metcalf and Company, 1851.

Richards, Rhys, and Mary Malloy. "United States Trade With China in the First Two Decades, 1784–1804." *The American Neptune* 54 (1994):10-44.

Ripley, S. Dillon. *The Sacred Grove: Essays on Museums.* Washington, D.C.: Smithsonian Institution Press, 1969.

Roe, Michael, ed. *Journal and Letters of Captain Charles Bishop on the North-west Coast of America, in the Pacific and in New South Wales, 1794–1799.* Cambridge: Hakluyt Society, 1967.

Ronda, James. *Lewis and Clark among the Indians.* Lincoln: University of Nebraska Press, 1984.

Ryan, Kate. *Old Boston Museum Days.* Boston: Little, Brown, and Co., 1915.

Samuel, Cheryl. *The Raven's Tail.* Vancouver: University of British Columbia Press, 1987.

Schoff, Wilfred H., trans., *The Periplus of Hanno: A Voyage of Discovery Down the West African Coast, by a Carthaginian Admiral of the Fifth Century B.C.* Philadelphia: Commercial Museum, 1912.

Sellers, Charles Coleman. *Mr. Peale's Museum: Charles Willson Peale and the First Popular Museum of Science and Art.* New York: W. W. Norton & Co., 1980.

Stewart, Hilary. *Looking at Totem Poles.* Seattle: University of Washington Press, 1993.

Stewart, Hilary, ed. *The Adventures and Sufferings of John R. Jewitt: Captive of Maquinna.* Seattle: University of Washington Press, 1987.

Sturgis, Josiah. "Extract from the Journal kept on board the Ship *Levant* on a Voyage from Boston to the North West Coast and China in the Year 1818." Manuscript. Oregon Historical Society, Portland, Ore.

Suttles, Wayne, ed. *Handbook of North American Indians.* Vol. 7. *Northwest Coast.* Washington: Smithsonian Institution Press, 1990.

Swan, James G. *The Northwest Coast: Or, Three Years' Residence in Washington Territory.* New York: Harper & Brothers, 1857.

Thompson, John, and William Walker, Jr., *Log of the* Lydia, *1805–1807.* MS. Western Americana Collection. Beinecke Library, Yale University.

Thwaites, Reuben G., ed. *The Original Journals of the Lewis and Clark Expedition.* 8 vols. New York: Dodd, Mead & Co., 1904–1905.

Todorov, Tzvetan. *The Conquest of America: The Question of the Other.* Translated by Richard Howard. New York: Harper & Row, 1984.

Tucker, Louis Leonard. *The Massachusetts Historical Society: A Bicentennial History, 1791–1991.* Boston: Massachusetts Historical Society, 1995.

Vancouver, George. *A Voyage of Discovery to the North Pacific Ocean, and Round the World; In Which the Coast of North-west America Has Been Carefully Examined and Accurately Surveyed.* 3 vols. London, 1798.

Vaughan, Thomas, and Bill Holm. *Soft Gold: The Fur Trade & Cultural Exchange on the Northwest Coast of America.* Portland: Oregon Historical Society, 1982.

Viola, Herman. *After Columbus: The Smithsonian Chronicle of the American Indian.* Washington: Smithsonian Institution Press, 1990.

Walters, John. "Journal on board the Brig *Pedlar,* Capt John Meek on voiage to the North West coast of amarica and round the world" (1819–1822). Manuscript. Dauphin County Historical Society, Harrisburg, Pa.

Watson, Rubie S., Nynke J. Dorhout, and Juliette R. Rogers. "Pacific Collections at the Peabody Museum of Archaeology and Ethnology at Harvard University: The Early Years." *Pacific Arts,* nos. 13 & 14 (July 1996):57–68.

White, William, and H. P. Lewis. *A Brief Sketch of the Character and Services of Captain Josiah Sturgis, of the United States Revenue Service.* Boston: William White and H. P. Lewis, 1844.

Whitehill, Walter Muir. "Early Learned Societies in Boston and Vicinity." In *The Pursuit of Knowledge in the Early Republic: American Scientific and Learned Societies from Colonial Times to the Civil War,* edited by Alexandra Oleson and Sanborn E. Brown. Baltimore: Johns Hopkins University Press, 1976.

———. *The East India Marine Society and the Peabody Museum of Salem: A Sesquicentennial History.* Salem, Mass.: Peabody Museum, 1949.

Wright, Robin. "Haida Argillite Ship Pipes," *American Indian Art* 5(1):42–47, 88.

———. "Haida Argillite: Carved for Sale," *American Indian Art* 8(1):48–55.

Wyatt, Victoria. *Shapes of Their Thoughts: Reflections of Culture Contact in Northwest Coast Indian Art.* Norman: University of Oklahoma Press, 1984.

Zolotarevskaja, I. A., E. E. Blomkvist, and E. V. Zibert. "Ethnographical Material from the Americas in Russian Collections." In *Proceedings of the 32d International Congress of Americanists, Copenhagen, 1956,* 221–231. Copenhagen: 1958.

# ILLUSTRATION CREDITS

The index below provides information about the sources of and transparency or negative numbers for the illustrations included in this text, as well as the catalogue numbers of the objects shown therein. PMH photographs were taken by Hillel Burger and are copyrighted by the President and Fellows of Harvard College, Peabody Museum, Harvard University. PEM photographs were reproduced courtesy of the Peabody Essex Museum, Salem, Massachusetts. The MHS photograph of Robert Haswell's journal was reproduced courtesy of the Massachusetts Historical Society.

| Page | Photo | Source | Catalogue No. | Transparency/ Negative No. |
|------|-------|--------|---------------|----------------------------|
| Cover | Haida mask | PMH | 98-04-10/51671 | T716-3 |
| | Argillite pipe | PEM | E3497 | A9055 |
| | Wooden canoe model | PMH | 69-20-10/1246 | T714-4 |
| | Nootkan hat | PMH | 99-12-10/53079 | T2511 |
| | Haida carved figure | PMH | 99-12-10/53093 | T709 |
| iii, x | Haswell title page | MHS | | 76 |
| 1, 57 | Argillite pipe | PEM | E3497 | A9055 |
| 67 | Object 22 | PEM | F.3484 | A9169 |
| 68 | Object 25 | PEM | E3561 | A9095 |
| 69 | Object 28 | PEM | E3235 | A9056 |
| 71 | Object 38 | PEM | E3662 | A9101 |
| 72 | Object 39 | PEM | E3493 | A9098 |
| 74 | Object 48 | PEM | E3497 | A9055 |
| 76 | Object 55 | PEM | E3498 | A9098 |
| | Object 56 | PEM | E3499 | A9098 |
| 77 | Object 235 | PMH | 98-04-10/51671 | T716-3 |
| 78 | Object 70 | PEM | E3648 | A10297 |
| | Object 83b top | PMH | 67-10-10/255 | T722-2 |
| | Object 83b bottom | PMH | 67-10-10/256 | T722-2 |
| 79 | Object 215 | PMH | 99-12-10/53083 | T721-2 |
| | Object 89e | PMH | 67-10-10/275 | T719A-2 |
| 80 | Object 46 | PEM | E3483 | A10299 |

| Page | Photo | Source | Catalogue No. | Transparency/ Negative No. |
|------|-------|--------|---------------|----------------------------|
| 81 | Object 73 | PEM | E3492 | A10300 |
| | Object 226 | PMH | 99-12-10/53093 | T709 |
| 82 | Object 51 | PEM | E3646 | A10303 |
| | Object 52 | PEM | E3486 | A10302 |
| 83 | Object 211 | PMH | 99-12-10/53079 | T2511 |
| | Object 195 | PMH | 69-20-10/1246 | T714-4 |
| 84 | Object 67 | PEM | E3647 | A10301 |
| 85 | Object 59 | PEM | E3559 | A9095 |
| 87 | Object 71 | PEM | E3624 | A10156 |
| 88 | Object 72 | PEM | E7344 | A9335 |
| 89 | Object 75 | PEM | E939 | A9017 |
| | Object 76 | PEM | E7349 & E3563 | A10138 |
| 94 | Object 82f | PMH | 67-10-10/269 | N30141 |
| 95 | Object 82g | PMH | 67-10-10/266 | N30158 |
| 96 | Object 82p top | PMH | 67-10-10/254 | N34607 |
| | Object 82p middle | PMH | 67-10-10/253 | N34607 |
| | Object 82p bottom | PMH | 67-10-10/250 | N34607 |
| 97 | Object 82p left | PMH | 67-10-10/253 | N34609 |
| | Object 82p right | PMH | 67-10-10/254 | N34609 |
| 112 | Object 127 | PMH | 67-9-10/130 | N30059 |
| 113 | Object 148 | PMH | 67-9-10/163 | N34610 |
| 117 | Object 158a | PMH | 95-20-10/48393 | N30103 |
| 118 | Object 161 | PMH | 95-20-10/48405 | N30058 |
| 119 | Object 165 | PMH | 90-17-10/48410 | N28059 |
| 121 | Object 182 | PMH | 95-20-10/48403 | N30139 |
| | Object 183 | PMH | 95-20-10/48404 | N30146 |
| 122 | Object 184 | PMH | 10-47-10/76826 | N26805 |
| 123 | Object 189 | PMH | 95-20-10/48406 | N30132 |
| 126 | Object 193 | PMH | 69-20-10/1244 | N30124 |
| 127 | Object 199 | PMH | 69-20-10/1251 | N34611 |
| | Object 208 | PMH | 69-20-10/1330 | N30064 |
| 134 | Object 213 | PMH | 99-12-10/53081 | N30077 |
| 135 | Object 216 | PMH | 99-12-10/53176 | N30131 |
| | Object 220 | PMH | 99-12-10/53087 | N34612 |
| 137 | Object 224 | PMH | 99-12-10/53091 | N30079 |
| | Object 225 | PMH | 99-12-10/53092 | N30072 |
| | Object 227 | PMH | 99-12-10/53094 | N30060 |
| 138 | Object 232 | PMH | 99-12-10/53136 | N27650 |
| 140 | Object 236 | PMH | 05-14-10/64702 | N30155 |
| 141 | Object 237 | PMH | 09-8-10/76401 | N28168 |

# INDEX